EX LIBRIS

Matthew Hackett

MY LIFE WITH THE LEICA

Walther Benser

HOVE
FOTO
BOOKS

My Life with the Leica
Walther Benser

First published in Great Britain October 1990 by
Hove Foto Books
34 Church Road
Hove, Sussex
BN3 2GJ

British Library Cataloguing-in-Publication Data:

Benser, Walther
 My life with the Leica.
 1. Photography - Biographies
 I. Title
 770.92

ISBN 0-906447-58-5

Design & Layout: Wendy Bann, Twyford, Berks
Typesetting: Brighton Typesetting, Sussex
Printed by Cantz, Osfildern, West Germany

CONTENTS

CONTENTS

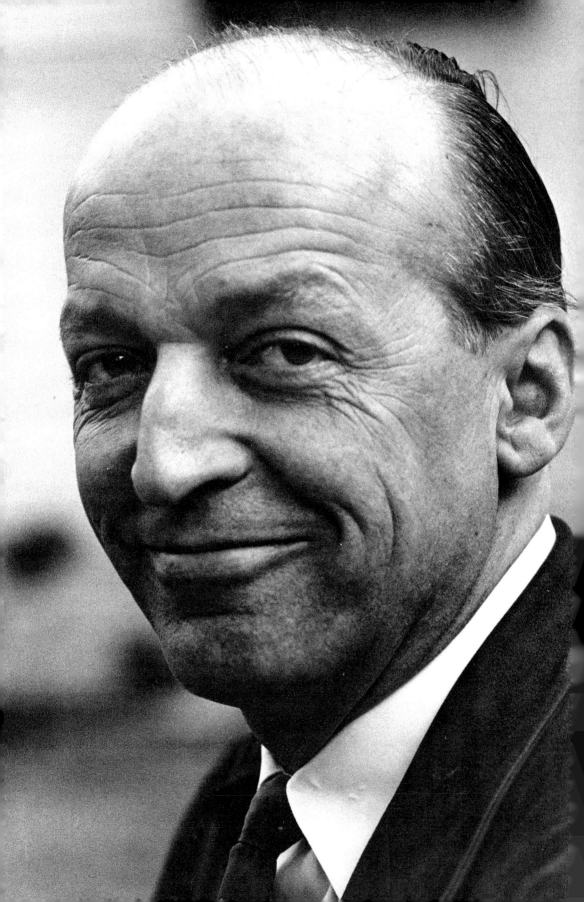

INTRODUCTION

I am grateful to Dr. Ludwig Leitz, who is 82 years old and one of the last of the Leitz generation I knew, for much information and advice which confirmed and augmented my own memories of Oskar Barnack and the early years of the Leica. As the son of the managing director, Dr. Ernst Leitz II who died in 1956, he contributed considerably to the development of the Leica.

From the start of production of his camera in 1925 only nine more years were granted to Oskar Barnack to take part in the consolidation and development of his invention. He died on 16th January 1936 at the age of 57, after having to give up active work because of his lingering illness.

After Barnack's death efforts continued apace to improve the Leica system and make it even more universal and reliable. Dr. Ludwig Leitz contributed decisively to this development until about 1974 when the need to seek external finance caused the Leitz company to pass out of the control of the family.

CHAPTER 1

"No Need to Knock"

"Don't knock – Enter" read the notice on the door to the office of Dr. Ernst Leitz, the head of the company!

I had an appointment for a job interview and had arrived in good time. I was at a loss – there was no ante-room, no secretary, no one asked me who I was. There was nothing to guide me, in my ignorance, as to where to go or what I should do.

Was I really supposed simply to go through this door, without so much as a polite knock? I had been told that on the other side of this door was a friendly, jovial gentleman. The very same man who, barely five years ago, had taken the risk of building a totally revolutionary camera, against all the warnings from many quarters. I was standing outside the office of Dr. Ernst Leitz II, the overall boss of the optical company, Ernst Leitz of Wetzlar.

On entering, I found a white-haired, elderly gentleman, sitting at his desk, looking me over in a friendly manner. He indicated a chair opposite him and invited me in a totally informal manner. "Take a seat." And added. "Did you have a pleasant journey from Berlin?" I was still hesitating at the door but his kind words overcame my shyness. I approached and replied. "It only took three days." His surprised expression elicited my further explanation. "By motor bike."

He seemed amused, his expression inviting me to tell him more. I hesitated, I was not sure whether I should mention that the journey by train would have been too expensive, but I continued. "Twenty litres of petrol for my two-stroke bike for the 500 kilometres plus two nights in youth hostels at three marks was cheaper than a third-class rail ticket."

Dr. Leitz listened to my reasoning attentively and remarked. "And the motorbike, that cost nothing?" I blushed a brilliant red and

she was in a good position to judge which films were suitable for me and which were not. For example I was not allowed to see Murnau's *Nosferatu*. The subtitle alone − *Symphony of Horror* − made every responsible parent shiver with apprehension. To me, on the other hand, the title was very fascinating. My elder brother, a law student at the time, did not suffer my worries. To my great chagrin he even had a say in questions concerning my upbringing. It was all right for him, his interests were different to mine; he read a lot and was quite critical of the cinema. I had to wait 60 years to see *Nosferatu* on late-night TV on the occasion of Murnau's 100th birthday.

Towards the end of 1927 the last of the silent films were being shown in the palatial cinemas on the Kurfürstendamm and the elegant Tauentzienstrasse. It was the end of the silent era. It also meant the end of the cinema pianists, who had so ably accompanied the action on the screen. The giant UFA Productions even used to offer a 65-man orchestra with conductor for premièrs of important silent films. The composers of such film music were sometimes more highly lauded by the critics than the film itself.

My mother in her relatively small cinema had to provide the musical accompaniment alone at the piano. At far as I remember, she used to be provided with a musical score suitable for the particular film. She did not always use it as she preferred to improvise once she was familiar with the action of the film. She had a great repertoire from her long career as a pianist and I suppose this opportunity for improvisation helped her to get through the six hour ordeal on the piano. She was often rewarded with spontaneous applause, particularly if she managed to find suitable chords to conclude a performance.

As she was the sole bread-winner for us three children, I found myself a job after school to earn a little extra pocket money. I used to deliver freshly-pressed trousers and hand-made suits for a well-known bespoke tailor to his well-heeled customers. Most of them belonged to a generous circle of illustrious figures in the artistic world and I found the job rather rewarding.

I soon became indispensable to my Polish-born employer as his German was still quite poor. I became his interpreter. Answering the telephone became one of my regular duties but I was often addressed as "Fraulein" because of my treble voice.

I also mastered the art of typing. Tapping away on an ancient typewriter with two fingers, I used to compose reminders and polite requests for payment depending on how great an amount the customer owed and how long it was overdue. I enjoyed my new

status and this was further enhanced by the frequent encounters with famous stars of stage and film. Many came for fittings; Max Ophuls (*La Ronde – der Reigen*) who became quite famous later on, Conrad Veidt, the unique actor of particularly sinister and gruesome roles, unfortunately only in 18+ films. Later at home I said. "Conrad Veidt came for a fitting today and he wore only long-johns!" My brother who was known for his dry sense of humour remarked. "… a very small line divides the sublime from the ridiculous!"

The famous Werner Krauss came several times. He once gave me a ticket for Max Reinhardt's "Deutsches Theater" as a reward for my services – un unforgettable event! Kraus played the title role in *Hauptmann von Köpenick* for which he was celebrated in his time.

During the course of my duties around the film and stage world I heard that two young directors were on the look-out for an extra for a documentary. The chance actually to take part legitimately in UFA Productions' Film City at Neubabelsberg seemed too good to be true. Consulting the customer list of my Polish boss, I phoned several persons connected with the film world, receiving the vague answer that the directors in question could be Robert Siodmak and Wilhelm Wilder, better known later as Billy Wilder. Eventually I found out that they planned to make a documentary showing the everyday life of typical Berliners, using ordinary people rather than actors, and on a very low budget. I obtained a telephone number and Mr. Siodmak answered. He invited me to come round. I was really surprised at the matter-of-fact way in which he explained his plans for making a film under the title *People on Sunday*.

As they had no capital they could not afford a studio but the situation suited their topic. One only had to wait for dry, and if possible, reasonably sunny weather. He mentioned a site in the zoo, which was familiar to me, as the script required some scenes to be shot there. "Why don't you come on a sunny day, it need not be a Sunday" he said jokingly "I can use a young man like you."

Thereafter I boasted that I had been discovered by a film director in his hunt for talented lay-actors – a pardonable exaggeration because the wish was the father of the thought.

At the end of May the weather was almost always good. In view of the title of the film I put on my best suit and went to the Zoo. I soon found the spot and a small group of people were gathered there but they did not look like "film" people at all! Robert Siodmak was busy with an elderly couple; then he asked me to come to the camera. My "appearance" consisted of a short laugh, which I had to try out several times, before they took the shot. Duration one and a half

replied. "I bought it from my earnings as an errand boy in Berlin."

It seemed that Dr. Leitz had my application that I had sent in the late summer from Berlin, right in front of him. He read me a sentence from my letter that I dearly wished I had never written. "I want to learn film-making at Leitz because I don't want to stay at school."

Dr. Leitz cleared his throat. Before I had a chance for further explanations he said. "I have already written to you with regard to your interest in film-making and I do understand to some extent your reluctance to stay at school."

I was relieved at his tact. "Dr. Leitz, even when I was in the sixth form in Wetzlar I felt the same, I could not get on with my form teacher, Mr. (I managed to mumble the name so that he would not understand), I felt his quick hand more than once."

There, I had said it! I had managed to tell the boss that this was not the first time I had been in Wetzlar. I knew he understood my reluctance to stay at school. We had both had the same traumatic experience in 1923 with the galloping inflation in Germany. The value of money had depreciated at a terrific rate so that the national bank was no longer able to print and distribute sufficient quantities of banknotes. For me it had had a profound effect on my family, for Dr. Leitz the worry was for his "family" of workers. He had issued his own company money, signed personally by him. These Leitz "credits" were issued in units of 10, 20, and even 50 milliard marks (1,000,000,000 RM). Inflation rose at such a terrific rate that at one point, just before the currency reform, Leitz issued a quarter of the wages in the form of credits, which were in units of Pfennigs and Marks. These credits were accepted in four bakeries and twelve groceries in Wetzlar for the purchase of basic foods. (A loaf of bread, for example, by then cost "only" 80 Pfennig.) These goods, that were obtainable only by Leitz employees, were bought with the help of foreign currency earned by Leitz from goods they exported.

Compared with the other factories in Wetzlar, the 1500 Leitz employees had been well off. My father, who was a qualified engineer employed at the Buderus Steel Works, used to receive his salary in daily instalments. It was then my job after school to run with mother's shopping list to father's office, collect his wages, and run as quickly as possible to the shops. The most important item was always bread. This was usually sold out by the evening or else the price had risen.

Before inflation was finally stabilised, the value of one billion marks (1,000,000,000,000) was set at one (new) Rentenmark.

Naturally I knew better than to burden Dr. Leitz with the memories

of Wetzlar from the point of view of an 11-year-old. After all, he knew a lot more than me, but his readiness to listen and to tell of those days was quite genuine. He occasionally cupped his hand behind his right ear in a silent plea for me to speak louder. I had been prepared for this and kept my Berliner dialect well under control.

However, the reason why I had the fortune to start my career as a Leitz apprentice was due to a lucky misunderstanding. But first I must relate some earlier experiences.

Move to Berlin

My mother and we three children moved to Berlin in the summer of 1924, but my father stayed behind in Wetzlar. The explanation we were given for this move was quite reasonable, but untrue. My parents had decided to get divorced but for the time being this was to be kept secret from us. They were right because knowledge of the proposed separation of our beloved parents would have affected us deeply. We were still quite young, my brother was 14, my sister 6 and I was not quite 12. We children readily accepted the reasons given to us; our father had to stay with his secure employment in Wetzlar as it was unthinkable for him to move in those uncertain times but my mother had to be near her aged parents to care for them.

I had not been long in Berlin when I experienced the cinema for the first time and I was only 12 years old! I got to see all the important films, except those I was not allowed to see because of my age, and they were wonderful! I secretly vowed to "be in the movies" when I was older.

At last I was 16, but to my great sorrow my voice had still not broken. My treble voice belied my assurances that I was older than I appeared. To avoid the repeated question of "How old are you?" I would ask total strangers to buy the ticket at the box office for me and in that way got to see films that were "only for persons over the age of 16".

My mother also helped me. She had a job at the Wilmersdorfer "Amor-Lichtspiele" (cinema) in Berlin. It was a strange occupation for a former concert pianist – she accompanied the action on the flickering screen on the piano. I find it hard to imagine now how she managed the endless improvisations day after day, from 5 p.m. to 11 p.m. if it was a popular film, for weeks on end.

However, mother's work at the cinema brought me some advantages; I was able to see a lot of films free of charge. Naturally I was not allowed to see everything. As she had to see every film several times

seconds. Afterwards the cameraman just said. "Dead!" In a satisfied manner. Later I found out that this meant that the take was o.k. in film jargon.

Robert Siodmak happened to be nearby and he came up to thank me. Spontaneously I clutched his outstretched hand, pulled myself close to him as if I wanted to confess a secret, and hissed under my breath the all-important words. "I want to be in the movies!" He put both his hands on my shoulders and said very seriously. "If you really want to be in the movies you should first try to be a cameraman."

That was enough for me!

A Motorbike and the Origins of the Taxi Meter!

About this time I left school — which I had never particularly cared for — with a medium grade certificate. I began an energetic search for reliable information on the best way to become a cameraman.

In the meantime, using savings accrued from my wages and tips, I fulfilled a long-cherished ambition — I bought a motor bike. Not just any old bike but a genuine racing machine; one that had already taken part successfully in races on the Berlin AVUS in 1925/26. Strangely enough, the bike had been produced in a Berlin meter-gauge factory, which normally manufactured taxi meters. In 1924, the deteriorating industrial situation, due to the economic crisis, prompted them to diversify and build a motor bike which was very interesting in its design. The petrol tank consisted of a single pipe, which at the same time served as the main frame support. The way this tank pointed diagonally upwards from the low saddle to the handlebars gave the bike the appearance of a rocket on wheels, with the massive radiator grille lending it a particularly professional air! It bore the same trademark as the taxi meters; "T.X.".

I should now like to take you back briefly to the year 1919 when, scarcely seven years old, I sat on the knee of the director of this taxi meter firm and listened breathlessly to reports of his adventurous travels through Italy in the latter years of the previous century. In those days anybody who was in a hurry to get to the railway station travelled by hansom cab and the fare would be agreed upon in advance. This system proved difficult when abroad because, in order to be able to haggle over fares, you had to understand a little of the language. Herr Bruhn, the old director, told me about the terrible row he had with a cab driver in Rome when the man had demanded much more than the journey was worth. Recalling the violent dispute

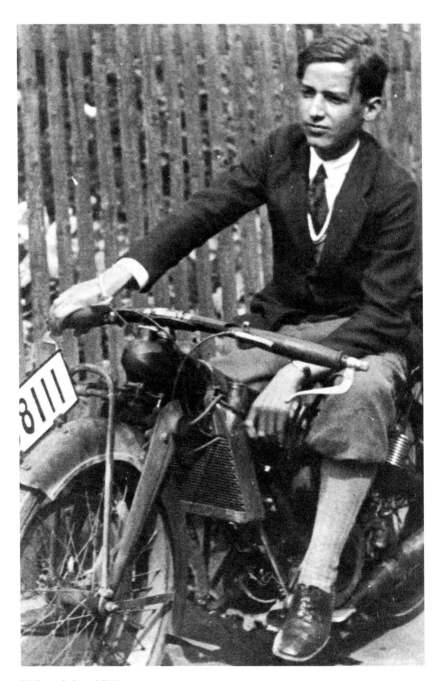

With my beloved T.X.

which ensued, the old gentleman gesticulated excitedly in the air with both hands and came out with a string of foreign words. "Carozza, troppo caro, non possible and porcheria miseria." Apparently these all formed part of the fare negotiations to which sometimes even the police had to be summoned!

Vexation and injustice haunted Herr Bruhn. On his return to Germany, he had an idea which he discussed with a skilled clockmaker. He spent a long time working on a special meter which registered the wheel rotations of a vehicle in metres by means of a special mechanism and converted these measurements into fares, or taxes. In this way the terms taxi and taxi meter were coined and the vehicles thus equipped put an end, world-wide, to haggling over fares. Throughout this exciting story I sat on the knee of the inventor of these ingenious taxi meters and was very proud of my beloved grandfather.

When I wished to buy a T.X. motor bike from his factory in the spring of 1929 my grandfather had been dead for two years. His successors, who had since had to give up the production of motor bikes, enjoyed the stories of my youth in Berlin. They sold me the last remaining racing machine at a price which was almost a giveaway. The friendly chief designer and former works rider, Rudolf Pohle, assured me that my bike had reached a top speed of 90 km/h on the AVUS. I never found out the details of those racing successes but, besides the exciting roar of the exhaust, they were the reason I bought the bike although I never admitted it.

In the eyes of my employer, the Polish tailor, my new transport was completely unsuitable for the delivery of quality tailored suits and so we parted company. I then thought of an idea which would utilise the bike and pay off its costs at the same time. This was to deliver packages of tubes, bags, packets and glass jars to customers for a local spice wholesaler.

Unfortunately my plan fell flat because the luggage rack of the bike was very small and not very well padded and I soon suffered breakages with jars of capers, which spilled all over the other paper packages. The spice merchant furrowed his brow and I promised to improve. When I suffered another mishap, caused by the bike falling over, I concealed the damage and bought replacements from the grocery department of a large department store. These, of course, were more expensive than they would have been from my wholesaler but I could hardly buy the stuff in the shops where I made my deliveries! I had to borrow the money for this emergency purchase from my mother. Following sober consideration within the family

circle I finally gave up this job after my brother remarked wryly. "We can't afford to let Walther earn money!"

Off to Wetzlar

In the meantime my mother had lost her job in the cinema as a result of the arrival of the first sound films. To us, her liberation from that peculiar drudgery seemed more important than the loss of income. She started giving piano lessons again. Occasionally she played a duet with Frau Leitz from Wetzlar, who was a friend. Both women were mothers so they naturally discussed their children and the problems with their upbringing. They also discussed my ambitions in the world of cinema and films. Both agreed that the big city of Berlin in the late 1920's was not the right environment for my further development. A proper commercial technical apprenticeship in less turbulent surroundings would be a better base for me.

Frau Leitz advised my mother to write quite frankly to her husband regarding such an apprenticeship. She must have also told her of a "totally novel camera, which worked with cinema film". My mother, totally innocent of all matters photographic, was happy to commend Wetzlar to me and, in spite of the pains of parting, glossed over the prospect of three years apprenticeship with the attractions of a Leitz-built "cine film camera". I was left to discover for myself with rather less enthusiasm that they were "only" manufacturing a still camera in Wetzlar which was loaded with cine film for taking individual pictures. So I wrote what seemed a futile application concerning "my training to become a cine-cameraman". My explanation that "I can't be bothered with school any more" would probably have ruined my chances of ever receiving an answer from any other firm, but I did not have to wait long for a reply. In his friendly letter Dr. Leitz informed me that it was not possible to provide training as a film cameraman in Wetzlar, but that there was an opportunity to learn about an entirely new still camera, a camera that had been responsible for a complete revolution in photographic technology over the past 5 years.

His account whetted my appetite to know more about this new camera called "Leica". After talking to my brother, who was interested in photography himself and knew a little of this "revolutionary small camera with cine film" I decided to accept the invitation to start as a commercial technical apprentice in the Leitz works.

I remembered Wetzlar from my school days. I thought less of my strict form teacher and more of some good friends that I had left

behind. I would have liked to have been near my father but unfortunately he was no longer in Wetzlar. He had taken the opportunity to work for a scientific institute in the Ruhr where he had moved two years earlier.

In an acceptance letter I agreed that I would present myself on the 1st November 1929 at the office of Dr. Ernst Leitz. Earlier letters to friends from my days at the secondary school renewed old contacts. It would be good to know some people in the first few weeks. I would travel by motorbike to Wetzlar. I obliged my worried family and underwent some "training for the journey" with a trip to the Baltic coast which proved that the furthest I could expect to travel in one day would be 150km. The roads in Germany in those days cannot be compared with modern main roads. There were many − in the truest sense of the word − unforeseeable pot-holes and obstacles that presented a real danger to my two-wheeled mode of transport.

I started two days after my 17th birthday and the journey took three days, staying overnight in youth hostels. My former school friends put me up for a few days after my arrival but I soon found a furnished attic room to rent. It had an old-fashioned heater, a tin wash bowl on three legs and cost 30 Marks per month, which was reasonable in view of my meagre means.

To compare living costs and prices then and today one can generally use a conversion factor of 1:6 as this gives a reasonable comparison for most things. My monthly income consisted of the 30 Marks wages I received as an apprentice plus 100 Marks which my mother contributed to my upkeep. This is equivalent to about 780 DM today and represents the breadline for a single person. However, I did not consider myself a needy case. Statistics and comparisons are not always realistic.

My whole world seemed to collapse around me on my move from the big city to a small town of a mere 14,000 inhabitants. Every day I stood for eight hours at my bench in the apprentice workshop. Every new apprentice, even if he was destined for administration, had to start there. I was one of thirty apprentices, each one of us in blue overalls, lined up against a row of benches. On my bench was a vice and several tools which I had to learn to handle and use properly.

I don't want to go into great detail about my work over the next few months. This time is suppressed in my memory as I was very bored and was driven by the desire to put this part of my apprenticeship behind me as quickly as possible. My first task was to file an iron cylinder, as large as a fist, into a perfectly uniform cube.

I attacked the piece of iron in my vice with great eagerness. I thought I could perform my task without too many problems; all I had to do was finish all six surfaces with perfect right angles on each corner. However, my frustration grew from day to day as the piece of iron got smaller and smaller with every correction I had to apply as yet another side was not quite right. In my desperation I saw my piece of iron shrinking to the size of a beef cube before I would be able to produce a perfect result.

One evening I took the offensive piece of metal home and persuaded a kind mechanic to finish it off for me, which took him no time at all. Next morning I had to perform a little show to convince the others that it was indeed my own handiwork. I passed the file very lightly over the piece, being careful not to mark the finished surfaces, ostensibly measuring all the corners. Then I took the finished piece for "acceptance testing", inwardly cringing with guilt. I have kept this act of deception a secret for the past sixty years so these pages contain my confession! I would like to take this opportunity to express my respect and admiration for the mechanical and optical precision work that is performed at Leitz. Although my own experience in the apprentice workshop was relatively short, I have had reason over the past sixty years to confirm and strengthen this opinion.

My First Pictures with the Leica

Spring had come. The melting snow and a lot of rain caused the Lahn, generally a harmless river, to burst its banks. The rising water began to spill over the access roads to Wetzlar. This was a sight I had never seen before in my life. Eye witnesses reported that some drivers, ignoring the driving ban in the Braufelserstrasse, were travelling through the still quite shallow flood with the water spraying high in the air on both sides of the vehicle. I had to go and photograph this spectacle. The weekend was imminent; we were fortunate at Leitz because Saturday was a half-day, most of German industry still worked a full day on Saturdays.

In anticipation of the events that awaited me I became excited. My mood; my "high water" mood, so to say, became greater as time went by. Secretly I hoped that the flood waters would rise even higher. I thought of the dramatic situation in 1920 when Oskar Barnack took the pictures with his original Leica, of boats negotiating their way through the flooded streets of Wetzlar, which have been published so often since.

"NO NEED TO KNOCK"

My borrowed Leica I with FOFER⁺
rangefinder attached.

On this occasion I sensed that Dr. Leitz might approach me for a chat. The apprentices nearby would then overhear everything that was said. No doubt the boss would ask me what had become of my passion for the cinema, and whether I had followed his advice to borrow a Leica and practise taking pictures. What I feared even more was that he might have heard, through the wife of the Commercial Director, how I had put the precious Leica on the pavement when I had played reporter near the flood waters of the river Lahn. So I decided to slip quietly away before I could be involved in any discussion! I quickly picked up one of the wooden trays that we used to carry spare parts from the stores and made my way past the boss, who was engrossed in animated conversation with one of the other apprentices.

On Saturday morning in the apprentice workshop, during a break, I unwisely expressed this hope for a really good flood that would be photographically effective. Our otherwise mild tempered supervisor became very angry after some well-meaning friend slipped this remark in his direction. I had to calm him down which took some persuasion. How could I know that his parents' house stood in the very street where every house was under water.

I had been able to borrow a Leica I for a certain period, a privilege

available to all staff at Leitz, and I arranged a crash course in Leica photography with another apprentice who was more experienced. At Leitz we used to refer to the Leica I as "Model A" to distinguish it from the Leica with Compur shutter, which we called "Model B". I was not too happy about the FOFER rangefinder, because it was attached to the top of the camera vertically, like a periscope, making the whole unit impossible to accommodate in a trouser pocket, although recently Leitz had introduced a different rangefinder which could be attached horizontally to the camera.

My apprentice instructor, Julius, was already quite adept at handling his camera. His father, who also worked at Leitz, had inspired him in his early years to be a Leica fan. He soon taught me the basics of taking photographs; load the film, measure the distance, ascertain aperture and shutter speed. He called our activity "exercise and dry run", then he left me two new rolls of film and sent me on my way to the flood waters.

I wandered through the picturesque streets of Wetzlar with "my" Leica, which was still without film as I considered this first excursion an extension of my previous supervised "dry run". With serious demeanour I pointed my camera at all sorts of subjects, tried various viewpoints in upright and horizontal format. I felt as if I had been elevated to great heights of importance, looking like a visitor to the

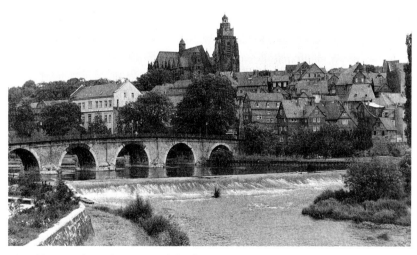

The old town of Wetzlar, scene of the floods which were the subject of my very first Leica pictures. The light-coloured building on the left is the Hausertorwerke where I worked in the Leica calibration department. The main Leitz works lie behind the camera position on the other side of the Lahn river.

town and admired by the Saturday afternoon crowd.

I was still busy emulating a photographer in front of a scene when a stranger approached me. With a gentle smile he pointed at the camera and said. "It helps to take the lens cover off if you want to take a picture!" His voice was devoid of ridicule which helped me to overcome my embarrassment. "Oh God, thank you — this is the first time I have held a camera, I am just out practising and there is no film loaded anyway!" I stammered in an endeavour to save myself from this embarrassing situation.

That very same evening I began to study some Leica literature in the form of a very good book on photography by the Leica enthusiast Fritz Vith, who also came from Wetzlar. This confirmed one suspicion — written instructions were very difficult for me to understand, this also applied to the instruction booklets available at that time — I really needed the direct guidance of an expert. If Julius had not already explained to me beforehand how the metal cassette had to be inserted into the camera I would never have succeeded in performing this action purely by following the written instructions.

On Sunday morning I was ready. Like a huntsman on the trail, camera loaded, I was on my way. My target: the flooded street. Passers-by pointed the way. Despite the fact that my camera was dangling from its strap round my neck, I also clutched it carefully against my chest. Having arrived at the scene I felt in my element — the professional at work! I started to snap away. I use the somewhat derogatory term "snap" quite intentionally to make it absolutely clear how green and inexperienced I was. After a short time my film was used up — full of nonsense.

Suddenly the crowd stirred. Hooting loudly, a car proceeded down the road and crossed the little ford, sending up a high spray on both sides, the watching crowd fleeing from the deluge — a perfect picture for the hopeful photographer — and my Leica? No film!

Hoping for a repetition of this scene, I quickly rewound the film and removed the rangefinder from the top of the camera. Naturally there was no suitable surface where I could lay down the camera to insert the new film, as practised many times at home. There was nothing else for it; I knelt on the dry pavement with my camera before me, opened the base-plate and took out the film cassette. I then started the process of loading a new reel of film. Just when I had managed to slide the carefully threaded film leader and the cassette into the camera, a woman's voice shrieked above me. "Are you mad, putting your Leica in the dirt like that?" When I looked up my heart seemed to drop right down into my shoes. I recognized the wife of

our Commercial Director in the figure that towered over me. I was speechless with fright but at the same time glad that someone could hold the camera while I finished loading the film. I completed my task but the excitement and sense of adventure had gone so I broke off my photographic session and made for home, head low like a scolded dog. The next few days passed most uncomfortably as I waited for the reprimand over the careless treatment of the loaned camera but nothing happened.

"The Boss is coming....!"

...A fellow apprentice on the work bench next to mine, hissed into my ear. I was working at that time in the Leica adjustment department in the Hausertorwerke. I turned towards the door at the back of the very large workshop. There stood Dr. Ernst Leitz II, the boss. He had just entered through the double doors and taken a few steps inside. I was already aware — having been warned by a young mechanic who had been appointed to help me to adjust Leica cameras — that visits from the boss were never announced in advance. He always decided to walk round on the spur of the moment and never planned his inspection tours. It was his habit to walk systematically up and down the rows of work benches before visiting the supervisor in his office.

The tall figure embarked on his usual ceremony, which had become something of a tradition. He first removed his peaked cap — an item he wore also by tradition — and clamped it under his left arm. Then, bare-headed, he stood with his right hand holding a walking stick, silently looking around. Then he nodded his head in a general greeting and started his tour.

Naturally, Dr. Ernst Leitz II could not stop at every work bench. In the summer of 1930 the number of apprentices had grown far too large for this. However, this distinguished gentleman, now in his sixty-first year, was sure to give salutations to anyone he recognized, or even offer his hand to those he remembered by name. The way he greeted us individually could range from the formal to the quite familiar. Young mechanics, often the sons or even grandsons of trusted and loyal employees, were frequently addressed by their Christian names, or sometimes by a familiar. "Well boy, how are you getting on?"

Quite regularly this would lead to an intimate little chat about the whole family, perhaps involving the grandfather who had long since been considered a trusted member of the Leitz establishment. Ernst

Leitz would tell some anecdotes of his own youth, going back to the end of the last century and perhaps involving the grandfather or even the great-grandfather of the young apprentice he was chatting to. These rounds provided our boss with the opportunity to find out a lot about the families in Wetzlar and he was always happy to offer advice and help. These visits made it clear to me why there was such a strong feeling of belonging together. We all used to feel like the members of a large family, and this was undoubtedly due to the personal efforts of this venerable and kind gentleman.

On this occasion I sensed that Dr. Leitz might approach me for a chat. The apprentices nearby would then overhear everything that was said. No doubt the boss would ask me what had become of my passion for the cinema, and whether I had followed his advice to borrow a Leica and practise taking pictures. What I feared even more was that he might have heard, through the wife of the Commercial Director, how I had put the precious Leica on the pavement when I had played reporter near the flood waters of the river Lahn. So I decided to slip quietly away before I could be involved in any discussion! I quickly picked up one of the wooden trays that we used to carry spare parts from the stores and made my way past the boss, who was engrossed in animated conversation with one of the other apprentices.

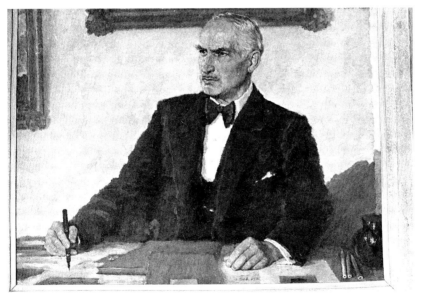

Dr. Ernst Leitz II

T.X. – A Minor Sensation in Wetzlar

Now that you have read of my first failure as a photo reporter with the Leica you may be asking yourself the question why had I not taken my motorbike and driven around the area to explore for photographic subjects. The reason is that in my inexperience and naivety the idea to go after the subject did not occur to me.

There was another reason why I did not use my T.X. motorbike more often. When I had thundered through the narrow streets of Wetzlar with my noisy T.X., every time I stopped I was surrounded by admirers. I patiently answered all kinds of questions and got involved in many discussions. I found out that the well-known racing driver, Fritz von Opel from Berlin, had attained very fast speeds in his rocket-driven racing car which was called "Rak One". My motor bike was honoured with the same name.

One day I saw our beloved chief, Dr. Ernst Leitz, as he slowly crossed the Kornmarkt in his usual fashion, walking-stick in hand. I drew some elegant circles around him, winding the engine up to howl in Rak One manner. Later I had to listen to his reprimand that the streets of Wetzlar were not a race track. The nickname Rak One stayed with me for some time.

Fifty-nine years later I returned to Wetzlar to see if I could find any former colleagues and friends to help refresh my memory before writing this book. The foreman of the Leica Justierabteilung (Assembly Department), where I had worked in 1931 and learnt to assemble the Leica, could not remember me. And why should he? To liven up the conversation I recounted how I came by bike from Berlin and that I rode to work every day, rattling through the gate of the works every morning. I accompanied my tale by gestures indicating the movement on the handlebars and the appropriate howling sounds. This demonstration refreshed his memory – he flung his arms in the air and shouted. "Rak One, that Berliner is here on his motorbike!"

CHAPTER 2

Conversations with Oskar Barnack

I have recounted my first contact with my boss, Dr. Ernst Leitz – he had been charming and informal. My first encounter with Oskar Barnack, the inventor of the Leica, was similarly pleasant. I looked forward with a mixture of trepidation and excitement to the day I was supposed to meet him. I had heard a lot about Mr. Barnack even before I was transferred to his workshop. He must have known about my unusual journey from Berlin to Wetzlar but he never referred to my motorbike by its nickname. He chatted to me about Berlin, where he had been to school and served his apprenticeship as a mechanic. He had been born not far from the capital in the Mark Brandenburg. He talked in a quiet, shy manner, his demeanour calm and attentive. He pointed out that he, like me, came from northern Germany. He grew more animated when we spoke about Berlin with its theatres and the development of the cinema.

As we spoke I felt relieved. I had been afraid that Mr. Barnack might start talking about photography when I would have to admit to my sketchy knowledge, particularly on the Leica. Quite the opposite happened. I soon realized that he was only too happy to talk about the movies. The intensity with which he aired his knowledge on the subject was a clear indication of his interest. He never talked down to me, in fact he sometimes even questioned the wisdom of his own opinions. The cinema was obviously close to his heart. I tried hard to keep our conversation going as I was most interested to hear his opinion about talking pictures, which were still a novelty in 1930. He revealed his understanding of all the technical advancements that accompanied the introduction of sound, but he also expressed his fear that he could discern signs of a decline in standards. This was particularly noticeable in American revue-type films which seemed to indulge in a kind of craze for noise. He asked

me if I had heard the derogatory remarks made by the well-known director Ernst Lubitsch, who had expressed his anger at the increasing fashion for chatter in sound films. I had not, but the talk of my home town made me think of my days at the Polish tailor and I felt quite homesick.

Barnack then mentioned the most recent picture that had been released in Frankfurt. It was *Sous les toits de Paris* by the esteemed director René Clair. This was, he said, a masterpiece and, although it was a sound picture, it contained no dialogue. The critics, who had praised it so highly, even questioned whether the absence of dialogue did not represent a protest by the director against talking pictures!

I too was of this opinion, but Barnack thought of a practical reason. Since the introduction of sound the cameraman had to work in a sound-proof cabin. This made filming cumbersome just as it had been in the early days. René Clair would have had to shoot his picture without making use of his great expertise in directing the camera. He therefore adopted a compromise and included the title song by the temporary relinquishment of camera movement. This song quickly became a hit contributing to the film's success. Naturally neither of us had any idea that one day synchronization of picture and sound would be possible.

As we talked Mr. Barnack consulted his watch in order not to miss his habitual chess game. He smiled and shook my hand in a friendly good-bye, saying that he had enjoyed our talk about the movies and that we should continue our conversation sometime. I thanked him and said that I found his remarks on the changes in film-making techniques since 1909 most interesting. The truth behind this rather banal remark was that the esteemed Mr. Barnack had really inspired me by his deep knowledge of cinema history and I desperately wanted to continue our conversation because of my dreams of becoming a cameraman.

Immediately after that meeting I went home to my attic room and wrote a summary of the events and my conversation with Mr. Barnack in my diary. Many years later it was to prove fortunate that I had taken to keeping a diary after I arrived in Wetzlar. I did this at my brother's request so that I could send an account of everyday occurrences in Wetzlar back to my family in Berlin at regular intervals. As my brother was then studying Law in Kiel, we had both agreed to do this to try and alleviate our mother's sadness because both her sons were away from home.

An even more incredible piece of luck was associated with these diaries. I thought they had been lost under the ruins of our old

apartment in Berlin but in 1988, completely by chance, an old suitcase came to light which had been held in safe-keeping all those years by some relations. It contained the pages from my diary with the accounts of my conversations with Oskar Barnack and my life in Wetzlar as well as diaries from my time as a war correspondent in Russia and Italy.

On the Origins of the Leica

During the following weeks I haunted Oskar Barnack to seek any opportunity to continue our conversation but also I wanted to be better prepared. In particular I needed to know more about the year 1911, which Oskar Barnack had mentioned. There were still a number of contemporaries around from those years before the war when Barnack had started work at Leitz — surely someone would be able to tell me something of those days — but how could I approach these gentlemen? It was the custom at Leitz, as in similar firms, for sons to follow their fathers into the company, sometimes three generations working together. Through the agency of some of my apprentice friends I was able to interview their fathers and even their grandfathers. I was particularly interested to know how Mr. Barnack started at Leitz. In the early summer months of 1930 I managed to compile an almost complete life history of Mr. Barnack by talking to a number of his contemporaries. Most of what I had learnt I kept to myself, particularly when talking to Mr. Barnack. I would not let on that I knew a story that he was about to tell me but listened attentively. This was how I managed to put together a history of the Leica which should interest not only all those who consider themselves Leica enthusiasts but anyone interested in that turning point in the history of photography. But I fear the true Leica fanatic who wants to know exactly how Mr. Barnack invented the Leica camera will not find my account in this book definitive enough.

Before he came to Wetzlar Barnack had worked for Carl Zeiss in Jena. In 1911, on the recommendation of Emil Mechau (a former colleague of Barnack in Jena but now working at Wetzlar) Dr. Ernst Leitz I asked Barnack to join his company.

The period between the invitation to come to Wetzlar and his actual start at Leitz was marked by an episode which would be inconceivable today. The story was published in an article by Curt Emmermann in *Die Leica* in the 30's but Oskar Barnack himself never spoke of it. Apparently Barnack hesitated to take up the invitation because he thought it would not be in the firm's interest to employ someone

who, apart from having to familiarize himself with a variety of new tasks, would need to take one or two months' leave of absence each year because of poor health. Moreover, he could not meet the medical expenses out of his own pocket. In view of this Ernst Leitz I initially offered Barnack one week's trial engagement only. That this was then made permanent says a lot for the tolerance and extreme understanding of Dr. Ernst Leitz I, whose attitude towards his new recruit was to some extent paternalistic.

At first Barnack worked on the construction of cine projectors but within a year he became head of the department of microscopic research at the Leitz Institute. He used to spend his free time, in 1913/14, experimenting with his "Ur(original)-Leica", but that was not its name then of course.

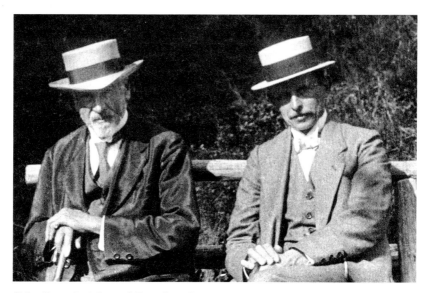

Oskar Barnack, right, with Ernst Leitz I

An important aspect in the development of the Leica camera is often forgotten, or mentioned only as an aside. It was Barnack's intense interest with the professional cine camera. Barnack built a camera entirely of metal which was a totally new concept at a time when cine cameras were constructed from wood.

A major problem with cine photography then was uncertainty about the exposure of the film. The film speed was stated in "degrees Scheiner" and could differ from one batch of film to the next. Barnack saw only one solution to prevent incorrect exposure of whole reels of

film — a sample of each batch of film would have to be tested by exposing it. Barnack built a small camera in which the film was moved forward, frame by frame, and exposed in an 18x24mm format by a simple slit shutter (such shutters had been well developed by that time). The exposure determined in the still camera then had to be correlated with exposure in the cine camera. It needed to be ascertained how sector aperture and frame frequency in the cine camera could be compared with shutter slit width and its speed of travel in the still camera. To express Barnack's considerations in simple terms: if I obtain a correctly exposed picture with such and such a slit width and a particular aperture setting then using the same film I must be able to obtain the same result with the cine camera.

From a series of successful trials Barnack soon realised that he was well on the way to constructing a small still camera in the form of this "apparatus" which he had constructed entirely for his film testing purposes. This new camera, although it incorporated some characteristics of the large-format, focal-plane shutter cameras of the time, in other respects was completely different. The use of perforated cine film with the resulting small negatives was an entirely new concept. Barnack described the birth of the Leica in an interesting contribution for Curt Emmermann's publication *Die Leica* in its first issue of May/June 1931 (pp4-8), but his description was not as extensive as the one you can read in these pages. Still I think it is important that I cite some of his most significant remarks in his article *How the Leica came into being*. Barnack described how he undertook strenuous photographic expeditions with one of the large plate cameras in his pre-Leitz period. The idea of a "small negative — large picture" was born then.

"Meanwhile, my professional activities changed." Barnack continued. "When I joined the optical works of Ernst Leitz at Wetzlar in 1911. My duties included, among others, cinematographic technology. In 1912 I constructed my first still camera. The initial decisions were relatively easy and dictated more or less by the finer grain of the cinematographic film. However, cine film format was too small, and because of the by then standardised size, it could not be produced any wider so I had to make use of its length to be able to utilize its advantages. I decided on twice the width of cine frame and it worked very well indeed. The consequent Leica format — 24mm wide and 36mm long — was therefore not the result of prolonged consideration, as was the case later with some seemingly minor camera parts. The linear ratio of 2:3 was most suitable — I thought it to be very pleasing and I still think so."

Barnack stated. "The actual construction of the Leica camera could begin. I was allowed my preference for the unusual. In my new job I was not restricted by a contract, as would be usual in modern development laboratories. I was driven by my own interests which propelled me along unusual and hitherto untried paths. As I used hardly anything that was then deemed necessary in the construction of a good camera, I came up with this entirely new type of camera construction."

I have cited Barnack's own words quite intentionally, just as they appeared in this article of 1931. It confirms my own assessment that Barnack, possessed of his rich talent for innovation, invented and realized quite independently the solution to his initial idea of "small negative – large picture". It is quite obvious how Barnack's decision came about to take the 18x24mm format, quite sufficient for cine cameras, and double it to 36x24mm to make the Leica format. This was his "egg of Columbus". If I take the liberty, during the course of this history lesson, of declaring my admiration for the talent of the man, I shall nevertheless allow myself one heretical comment too: a large number of exponents of 35mm photography would be happier if Oskar Barnack had decided on a less oblong format. Many would have preferred a 24x32mm or even a 24x30mm frame. These desires are determined to a great extent by modern requirements, for example advertising and press work. Users of 35mm film often have to crop their pictures to fit the formats required for magazines, posters, etc..

I shall not repeat here the tales often-told of successes that Barnack had with his original Leica, which he continually improved and modified. Dr. Ernst Leitz II, who was particularly well disposed towards Barnack, had taken one of the prototypes with him to the United States in spring 1914. Despite the visual evidence of the astounding performance that this entirely new camera was capable of, there was no intention of including such a camera in the manufacturing program. Leitz' production then was confined mainly to microscopes, projectors and field glasses.

As the general economic situation deteriorated during the early years after the end of the 1914-18 war the firm was threatened with having to lay off workers. The idea of putting the new camera into production then finally took shape.

In 1923/24 the first 31 cameras were produced by hand as prototypes. Initially they were not called Leica, their only identification was their serial number of 100 to 130. These prototypes were intended to be used for some market research. The lens, the Leitz

Anastigmat 50mm,f/3.5, was designed by Professor Max Berek, a scientist with a lot of experience in the design of excellent lenses. The focal plane shutter in the camera automatically compensated for the difference in speeds of the two blinds. A double exposure prevention mechanism was introduced for the first time in the history of photography.

Some of the prototypes were sent to professional photographers, photo specialists, scientists, etc. to be tested. The opinions diverged sharply: renowned professional photographers rejected the new concept. Even within the company opinion divided into pro and contra camps. The decision was taken at a meeting in 1924, which went on late into the evening. Dr. Ernst Leitz II settled it with the words. "We are going to build Barnack's camera!" Series production of the Leica Model A (also known as Leica I without interchangeable lens) could begin; initially with the five-element 50mm,f/3.5 Leitz Anastigmat lens, later renamed Elmax, which was soon substituted by the 50mm,f/3.5 Elmar.

This is how the Leica saw the light of day. The story has been told many times but my close contact with Mr. Barnack's contemporaries gave me a more intensive and intimate knowledge of its life history.

The Image is the Message

Several weeks after our first conversation I again had the opportunity to be in Oskar Barnack's workshop and I found an excuse to approach him. I told him that it had come to my knowledge that a well-known professional photographer from the Rheinland had publicly denounced "the new-fangled way to take pictures with this tiny camera called Leica". At Leitz we were experiencing a growing sense of confidence in our product which led to an expectation that "those up there", i.e. our superiors, ought to start hitting back at the critics. By offering this piece of information I had hoped to draw Mr. Barnack out of his reserve.

I could not have been more wrong. Barnack knew exactly what I was talking about and he did not seem to be put out in the least. He replied in his serious but indulgent manner. "Thank God that I am no professional photographer with a well-known studio. If I was, I am afraid that I might hold similar opinions although I would be a little more careful in the way I expressed them!"

I was astonished at his tolerance. This led us straight into a conversation as he seemed to be prepared to furnish me with an explanation for the resistance of the professional photographers. He

remarked. "Since the beginning of the 20's we have been living in an era which particularly esteems the proper use of materials. Technique has been improved from year to year. So-called material studies are the fashion and advertising has taken it up in a big way. Objects of metal, wood and other materials are being illustrated from closer and closer viewpoints. The sharpness of the images has become exceedingly good mainly through the use of large plate formats and improvements in lens technology. But (and at this point his voice assumed a trace of derision) these champions of the large format did not hold with enlargement. They were not even prepared to enlarge from a 13x18cm negative. Now, tell me yourself, what will their reaction be when they see enlargements from a 24x36mm negative and no-one cares about the larger grain, particularly if many say that this makes the pictures even more realistic?"

The name of Dr. Paul Wolff was then mentioned. This well-known photographer had been a Leica pioneer and Barnack spoke of him with great respect, calling his pictures "exceptional". He failed to mention, however, that Dr. Wolff had had to be won over; this I heard a few days later when I asked my instructor, Julius, about him.

All I had learnt from Mr. Barnack was that Paul Wolff, that is how he referred to him, had had good contact with Leitz since 1925 and had warned against the risks of using a small-format camera. However, he soon changed his mind after he started to use the Leica seriously. He had produced a large number of the pictures that were used by Leitz for their advertising.

My personal interest in the Leica and in photography had intensified. Still, I felt more at home talking about film and cine photography than about the Leica camera. I asked Barnack if he could recall our last conversation about the cine camera. He knew immediately what I was talking about and told me that his first involvement with moving pictures had taken place long after his apprenticeship in Berlin, but that he had seen some short films by Luis Lumière as early as 1895. Although these short films contained a lot of nonsense and slapstick, their artistic standard was of a much higher standard than most others of that time. "The name Lumière may not mean much to you now." He said. "But I am sure you will come across it if you study the history of photography since Daguerre. His experiences in the studio must have influenced his attempts at moving pictures. It was Lumière who had demonstrated the power of editing by his newsreel-like short films. The technique of editing developed in those days from the necessity to produce film reporting." Barnack went on to explain that up to about 1908 the

script in a film was exactly the same as might have been used in the theatre. The camera took the position of a viewer in the stalls and did not move. Each "film scene" — called a "take" nowadays — had the same length as a scene in the theatre.

He took a little book on film history from his desk and read from it. It told a how an Englishman called David W. Griffith transcended the restrictions of film aesthetics that then existed. He did not go as far as actually moving the camera during shooting but he changed the shooting position after a scene had been cut. A film by Griffith included close-ups of the actors and also distant shots for setting the scene.

Griffith also recognized the suggestive nature of light. Up to that point most film makers were quite happy to light their artificially-constructed scenes with artificial lighting. It was important not to get any unwanted shadows and details that receded into shadow were not tolerated. Light was used in the way a *bourgeois* citizen might light his living room with a strong bulb in the central light-fitting.

As early as 1909 Griffith was already considered a revolutionary film maker. He was the first to use the mood-enhancing and dramatic effect of light. This led to disagreements with his producers who dismissed his "stupid attempts that cost a lot of money" and wanted to stop his experiments.

Oskar Barnack regretted that he had not had the opportunity during the war to follow the development of film making. However, he had shot movies with his own cine camera, constructed in 1912-1913, and taken stills with the prototype Ur Leica. He had had to neglect his hobby after the war when work on the new Leica took up a lot of his time. However, he did learn a lot about American and English film production and the name of David W Griffith cropped up again. Griffith made a film in 1916 called *Intolerance* for which he reconstructed a Babylonian temple 1.6km long with 70m towers. The film also included the military camp of the Babylonian King Belsazzar which cost $250,000 to reconstruct and took about 160,000 extras to represent the army! To be able to capture these colossal scenes Griffiths sent his cameraman, a Mr. Bitzer, up in a balloon tethered by ropes by which it was moved across the scene. Griffith was moving towards pure film language in which the meaning was conveyed entirely by the film image without intermediate titles. This was finally achieved in the 1920's with the veritable masterpiece by F.W. Murnau, entitled *The Last Man*.

"I Feel Underexposed!"

Meantime I was transferred, with some other apprentices, from the so-called photo-montage department to the projection department. This was situated in the Leitz Hausertorwerke together with Barnack's workshop. It was the policy at Leitz that the proper education and training of a technical/commercial apprentice should also include knowledge of projectors. Apart from two tiny small-frame projectors, we only manufactured large-slide projectors and epidiascopes.

We had the small ULEJA projector for film strips. This was made as early as 1926. It used an 80mm lens and an ordinary 100w bulb and its appearance reminded me of my magic lantern at home with its candle illumination. But the instrument for me was the ULIOS version with its slide carrier for 5x5cm slides for Leica-size transparencies.

My apprenticeship in this department seemed endless. I used to glance enviously towards the Leica departments as these seemed to be much more important but it was to no avail, I had to get through this phase! I used to see Oskar Barnack occasionally and one day I met him on the stairs where he greeted me in his usual way. "How are things?" He must have noticed by the expression on my face that my conventional answer. "Thank you — quite well." Did not entirely ring true. He asked me to accompany him to his office where I sat for a few minutes unable to speak. As Barnack said nothing I finally broke the silence and blurted out. "I feel underexposed!" I knew that he would understand this expression as I had often heard him describe incorrect or wrongly turned-out things as "underexposed".

I spilled out my long and well hidden secret. I confessed that I had joined Leitz under a false pretext as I wanted to be a cine film cameraman or director. After a short pause, trying to keep my tears under control and at the same time noticing his slightly bemused expression, I continued. "But I do find the Leica a really fantastic camera and in any case I shall complete my apprenticeship."

My open confession of my dissatisfaction with my lot must have given Barnack the impression that I wished to save whatever I could out of this difficult situation. Anyway, he delivered a little lecture which went along the following lines. I was at the beginning of my career at Leitz. Did I really think that I had any chance at all in the film world, where I lacked any kind of connection and knew no-one who would help me? Would I not be better off pursuing a career in Leica photography at Leitz that could offer me a wide range of

opportunities? The number of Leica opponents and critics diminished daily. Was I not aware that in the very same year, in 1930, Leitz were launching a further three interchangeable lenses for the Leica camera with different focal lengths, that this heralded the beginnings of a Leica system. That the possibilities within the company were excellent? Leitz urgently needed commercial staff with a technical background for a variety of jobs. As an example he mentioned a certain Anton Baumann, who had been working as a technical draughtsman in the design department. His hobby was to copy his good Leica photographs onto transparencies and now he was very successful with the showing of these pictures in photographic clubs. Invitations literally rained upon him. His slide shows were so successful that he would soon be able to fill large halls with this excellent form of advertising. Barnack looked at me kindly and with an encouraging handshake commented. "But first you have to be patient and get to know the Leica thoroughly."

Barely four years later, in the spring of 1934, I was in charge of the Leica photo lectures in the Grosse Saal des Zoo which were usually fully booked down to the last seat. At the end of the lecture I would sit at the front of the stage and from my raised ·position I used to answer questions put by the audience. One evening I suddenly noticed, among the audience, a familiar face — Oskar Barnack was there. After recovering from my initial shock my immediate impulse was to jump up and call out with a theatrical gesture to the audience who had begun to move away. "There is Oskar Barnack, the inventor of the Leica!" Thank God I had second thoughts, instead I jumped down from the stage, made my way through the crowd and approached him. He held out his hand saying. "I am very happy for you and for us." With both hands I reached out for his hand but I was unable to utter a single word!

CHAPTER 3

Why Leica?

The second year of my apprenticeship at Leitz finished in the late autumn of 1931 after an interesting and extended period at the very popular Leica School, headed by Heinrich Stoeckler.

I could have moved to the so-called Photo Correspondence Department earlier but in the meantime I had become extremely fond of my teaching tasks at the Leica School so I was reluctant to relinquish my daily dose of success with the other pupils, some of whom, mostly older than me, had been rather sceptical about the value of this training at first.

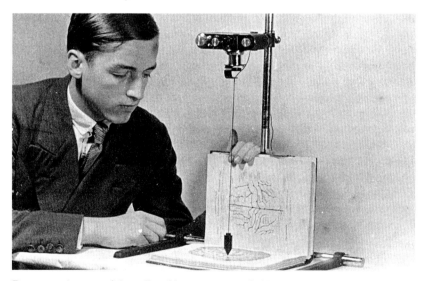

Demonstrating use of the collapsible copying stand, STARE. Note the FLOTH plumb line, suspended from its clip attached round the 50mm Elmar lens. This was used to determine the centre of the picture.

WHY LEICA?

The Leica School was in the nature of a mission. The fact that very sceptical photo dealers and serious amateurs were changing their minds by the score continued to astonish me. My later success with the Leica talks can be attributed partly to my experience in this department. I gained greater self-confidence, which I needed desperately as I had to face a thousand and more eager visitors at my Leica slide shows every evening.

But the new kind of work in the photo correspondence department became very interesting. I knew that initially my work would only be typing. The dictating of texts was only allowed for people who had finished their apprenticeship. After training in the individual craft departments was completed, a decision had to be made on whether to opt for a career in microscopy or in photography and projection. By the end of my time as an apprentice the Leica had grown into an entire system of products by the development of all manner of accessories and in particular a range of lenses of different focal lengths. It now outstripped the other departments in terms of turnover. For me it was a natural choice: I decided on the photo department and I had been clear in my mind about my decision for a long time, probably due to the strong influence and almost prophetic remarks of Oskar Barnack.

At that time we all worked close together in a big hall in the main works. So many people crammed into one office would be unthinkable today. Our working environment created a very strong visual impression on me during a decisive period of my development at Leitz and now I only need to close my eyes and I can imagine myself entering the room on the third floor. On the right-hand side I remember over twenty men sat in rows of desks, two abreast, while on the left-hand side there was a single row of desks for eight female typists. There were also three female clerks for file registration who stood at a long counter, handing over files as and when they were requested. The files were not allowed to be taken away but had to be studied there.

One of the ladies was the very amicable and helpful daughter of Oskar Barnack. In cases of emergency you could rely on her busy fingers hurrying over the keys when a hastily composed letter had to be ready for dispatch.

Delays were often due to Mr. Ahl, the head of the photo correspondence department, as he noticed every missing comma, every grammatical error and every spelling mistake. If you wanted to avoid the embarrassment of being corrected with the whole room listening you certainly were well advised to follow his instructions to

use clear diction and style and to avoid sentences with complicated structures.

Disputes often arose when I tried to simplify the often-criticised instructions issued with the cameras. Thanks to the profound experience I had gained at the Leica School, and due to the fact that punctilious Mr. Ahl had only theoretical knowledge of what went on in the Leica School, I was able to settle differences of opinion. Mr. Ahl was an understanding person when contradictory arguments were presented to him in a factually but patient way. I see him in my mind's eye as an important master and exponent of clear language.

In 1932 the equivalent of modern marketing and advertising departments did not exist in technical companies such as Leitz – neither did the concept of a properly planned and conducted advertising campaign. However, there was a department concerned with printed matter which used to commission the necessary work, usually from Leipzig. There exists a Leica advert dating from 1925 which may be considered a classic today. It consists of a drawing by the Munich advertising designer, Ludwig Hohlwein, showing a corpulent man smiling broadly, with his glasses pushed up on his forehead, and a Leica camera raised to his eye. This poster was displayed for years in the dining cars of express trains and it was deliberately aimed at customers belonging to the solid middle class.

Despite the comparative lack of advertising Leica quickly became known and it owed its success on the one hand to word-of-mouth recommendation and on the other hand to the very popular and successful slide shows by Anton Baumann. This became apparent as more and more orders arrived from the towns where Anton Baumann had held his Leica shows. In those days nobody talked about 35mm photography, only the terms "Leicaformat" and "Leicafilm" were used. However, this happy state of a new camera dominating the market could not last forever.

In 1932 Zeiss-Ikon introduced their Contax camera. Leitz reacted with equanimity to the new competitor because they thought it was no real competition for the Leica but, despite the obvious differences between the two cameras, dealers were not sure which product to go for and representatives were also uncertain – they needed Leitz' support in arguing for the Leica.

In May 1932, Director Dr. Dumur, who knew about my efforts for budding Leica pioneers and good quality Leica photographs, called for me. He informed me about his plan to draw people's attention to the special advantages of the Leica cameras by issuing a brochure. He explained his idea through various examples which he intended

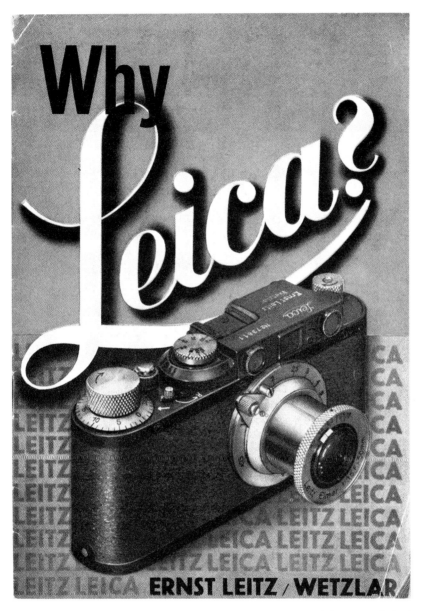

Why Leica? The brochure I was asked to write by the Commercial Director at Leitz in 1932.

to include in the brochure and asked me to think about it.

Spontaneously I came up with the title *Why Leica?* for this special

brochure and my idea found full approval. Thereupon I sat bent over my typewriter endeavouring to write down, with two fingers, twenty advantages of the Leica against the spectre of the competition that reared its head in Jena. The focal plane shutter of the Contax was made of metal and travelled vertically, therefore I claimed under advantage No.11 that the horizontal travel of the Leica focal plane shutter was of paramount importance in view of the fact that objects should always be photographed in the direction of their movement. For example while racing cars should be taken in horizontal format a high jumper should be taken in upright format.

So far, so good, but then I got lost in the jungle of theory although I had managed at the start to stay in the open country of reality — "If such fast movements are to be photographed free from distortion with a focal plane shutter, the slit must run against the movement of the image on the film. Therefore, when photographing a racing car moving from right to left, owing to the inversion of the image the shutter should also travel from right to left — which it does when you hold the camera in the normal way — but if the racing car moves from left to right you will have to turn the camera upside-down. Holding the camera in this position you will have to press the shutter from below using your thumb." — Oh God! I squirm now at the ridiculous photographic tips I gave in those days. I realised a long time ago that it made no sense to blame the quality of the picture on whether the subject was moving from right to left or the other way round.

Now I wish to tell of an experience which I had three years later. In 1935 I had a chance to go to the famous Nürburg circuit to watch in admiration the racing cars being driven by Rudolf Carraciola, Bernd Rosemeyer and Nuvolari, who was known as the "Little Devil". A former student of the Leica School had managed to get me access to the press stand which was exactly opposite the starting grid. On both my left and my right sat photo reporters, all veritable experts on photographing car races. A few of them already used the Leica IIIa, which had come onto the market only a short time before. When I was introduced by my former pupil as an expert on Leica cameras from the Leica School I felt rather ashamed that I only had an "old" 1933 model Leica III round my neck because although the only facility this model lacked, compared with the IIIa, was a top shutter speed of $1/1000$ sec, I imagined that it would be the decisive factor between success and failure in this situation.

However, by watching these very experienced photo journalists round me, I was introduced to the trick of panning the camera and I understood how they managed to keep their moving subject in the

centre of the viewfinder. They pointed the camera at the racing car and followed it by bodily swinging around, releasing the shutter at some suitable point.

One of the reporters had some particularly interesting Leica pictures with him. They were exemplary in their panning technique because although the driver and car were more or less sharp, the background was quite blurred, creating the impression of enormous speed. He intended to present these pictures to Rosemeyer, who could be recognized quite easily in spite of the fact that they had been taken during one of the last races where top speeds of nearly 300 km/h had been reached.

How much I could learn from these people became obvious when I started to praise the $\frac{1}{1000}$ sec of the Leica IIIa. I was soon told that $\frac{1}{1000}$ sec was much too fast because it would freeze the movement of the car, bringing it to a standstill, while the pictures of Rosemeyer bore witness to the fact that a very slight movement blur is necessary to convey the impression of speed. It was pointed out that an experienced photographer would be able to get quite acceptable pictures by panning even with $\frac{1}{250}$ sec. Panning the camera makes it possible to create the desired blurred background for racing cars as well as other horizontal movement.

The "niner" (9cm) lens was just right for the distance from the race track. Two or three photographers already had their Leicas equipped with the RASUK frame-finder, which became available for the first time in 1933. It indicated the frames of the 3.5, 5, 7.3 and 9cm lenses. Others used the foldaway optical frame-finder, SEROO, another recent addition to the Leica system. This reflected-frame, or Albada-type, finder delineated the limits of the 9cm frame. Frame-finders are ideal for observing a moving object before it enters the viewfinder frame. I learnt that panning the camera causes the moving object, in this case the racing car, to be depicted sharply with the surroundings unsharp. The blurred background, due to the movement of the camera, conveys the same impression that we get from a passing car when we follow its movement by turning our eyes or our head.

Now let me get back to the end of 1932 and my early attempts to teach and learn. In those days the highly acclaimed Leica II in the small *Why Leica?* brochure continued to sell well so luckily I did not have to eat my words later. A colleague from the photo correspondence department, who was a wit, saw the roughly sketched title page on my desk and he placed a sign alongside in big letters saying *Why Not Contax?*.

Naturally I had listed a number of rather convincing advantages of

the Leica in this brochure – for example, the "built-in warranty card", because of the fact that the oldest Leica could be modified to the latest model, a promise that was kept for twenty years or so in the U.S.A. However, after the transition from the drawn sheet metal of the earlier models to the die-cast body of the Leica IIIc, modification was no longer possible. An extended guarantee of this kind was unique among the flood of new models coming on the market every year.

Pity the modern Leica fans, whose fathers and grandfathers had taken advantage of the opportunity to have their 1925 Leica I, with its 5cm Elmax and hockey-stick infinity catch, modernised for quite a reasonable price. It is ironic now that the heirs to these wonderful conversions are rather distressed about them but then how could their forefathers know that untouched, in their original condition, these old Leicas would be worth their weight in gold today!

Perhaps you will bear with me when I add another remark to my rather extensive summary: it seems strange that under the advantages listed in the *Why Leica?* brochure that the imperviousness of the shutter blinds against cold and heat was mentioned, which was quite justified, but there was no mention of the nearly noiseless travel of the focal plane shutter. The reason was that nobody mentioned the silent Leica in those days. However, in the 1960's a veritable flood of new SLR cameras came on the market and their mirror reflex systems were considered to be state-of-the-art but, despite all the important advantages of these SLR cameras, their noisy release was always a great inconvenience. It is due to this fact that the Leica M is considered to be the most unobtrusive camera. For example it is the only camera admitted into some U.S. court rooms.

Concerning a Small Leica Picture Library

The text in the *Why Leica* brochure was to be illustrated with a few examples. Therefore I asked to see the picture archive which, at that time, was still unorganised, comprised only a few hundred photographs. It was administered but not cared for in the Printed Matter Department.

I carefully examined the pictures. Some of them were of good quality while others seemed outdated. They were obviously from the late 1920's. I recognized when a photograph had been taken, not only by the larger grain of the picture, but also by the differences in fashion and hairstyle as well as the way people arranged themselves for the camera. I already had a certain idea of what kind of pictures were required to present a logical structure for my PR lectures.

WHY LEICA?

I finally had an opportunity to visit a Leica slide show near Frankfurt, presented by Anton Baumann. On the day I crept away from my office without saying a word to anyone and went to Frankfurt by train. The large hall, which was part of the zoo, was crowded and I stayed in the background. Against my expectations, Baumann did not stand on the stage but stood beside his projector in the middle of the hall and delivered his commentary from there. This arrangement created a better impact because he was in closer contact with his audience who listened most attentively. He was in charge of the speed at which he presented each slide, adjusting it to the flow of his speech, which conveyed his strongly-held convictions to his audience. He only showed slides that he had taken, some of them of good or even excellent quality. However, I became convinced that it could be at least as effective to use pictures from other photographers as it was just as important to sell the Leica through pictures as well as words. On the whole though his lecture was very informative.

Much later, when Anton Baumann left Germany to emigrate to the United States, the following anecdote was told in Wetzlar. Baumann had shown a slide, taken by another photographer, with the comment. "This picture was not taken by me but nevertheless it is a good one!"

My wish to put together another slide series took shape. Mr. Stuckert, the chief photographer at the Leitz studio, afforded me valuable assistance. After work I was allowed in his dark room to develop excellent slides with the ELDUR slide copier. A big reading lens and a fine hair brush were available to remove any blemishes from the negatives, the copying of which was a similar process to developing pictures from the enlarger. I made sure that I developed the slides for long enough, i.e. for at least 2 minutes in a normal metol-hydroquinone paper developer. They could also be developed to be slightly more dense and then bleached in a weak Farmer's solution.

Mr. Stuckert knew of my plans for the future but he kept them to himself. He advised me not to tell anyone in the Photo Correspondence Department as envious colleagues might have blown the whistle on me. What I was planning was in the interest of the company but it might not have been recognized as such at the time.

A further danger was that our boss could easily have turned up if he noticed the light was on in the studio late at night. Dr. Leitz was a person who always liked to discover new things and I am sure that he would not have minded my being there if I could have said, with

some conviction, that I wanted to learn more about studio photography. Only a few days before Dr. Leitz had stood in the studio to watch how the new Leica Model II, with the whole range of lenses from 35 to 135mm, had been laid out for promotional photographs. As this preparation had taken a good half an hour Dr. Leitz remarked on the paradoxical situation of how the little Leica seemed to be well-behaved, like a good mother surrounded by all her children, next to the large plate camera used in the studio. Stuckert claimed that a Leica would never be able to achieve the same pin-sharp advertising shots which the traditional cameras could produce. Although he obviously could not foresee what the photographic industry would be able to do in the future, he was partly right because a large-format camera is still essential for certain types of studio work.

The old photographer was prompted to tell us an amusing story that had happened a few years before. It was Dr. Leitz' habit to stay a whole week shooting on his estate where he would be in his hide deep in the woods by day and in his hunting lodge at night. In this way he recuperated his strength in the peace and quiet of the countryside. Late on a Friday afternoon, before the office closed for the weekend, he would phone up and ask the book-keeping department to place a certain amount of money in an envelope on the desk of Mr. N., the book-keeper.

In the evening Dr. Leitz would drive from his hunting lodge to the office to collect it. On that particular night, he went to the first floor but did not switch on the light; he used the torch still hanging from a button of his jacket after a walk in the woods. The room where he expected to find his money did not seem to be the right one. The adding machines normally on the desks were not there. Suddenly he remembered that some offices had been moved. Poor Dr. Leitz wandered through several rooms, unlocking each one and carefully relocking it again, without being able to find the book-keeping department. As he was about to leave two cleaning women came in so he asked them whether they knew where the book-keeping department was. They looked first at each other and then at him with astonishment, remarking. "But you are the night watch-man, you should know!"

This funny story which has been told many times is reminiscent of another much-told anecdote which demonstrates the character of our Dr. Leitz. When he visited his old friend Franz Bergmann, the Leitz representative in Berlin, they walked together on the Kurfürstendamm. Franz took the liberty of admonishing his old friend. "Ernst, you are not on a shoot now, but you are wearing your old coat and

heavy boots." To which Dr. Leitz replied. "Never mind, Franz, nobody knows me here."

Some time later Franz Bergmann visited his friend Ernst in Wetzlar and they wandered into the old town. Franz saw that Ernst was again dressed as if he were going on a shoot and, remembering the reason Ernst had given before, asked. "And here in Wetzlar you let yourself be seen dressed like this?" The answer came back. "Don't worry, everybody knows me here!"

Apprenticeship Ends — Real Life Begins

I was thinking more and more about my plan to deliver a lecture that would further the advertising efforts of our company. I had copied some 150 selected Leica negatives onto glass slides in Mr. Stuckert's dark room. It was already the beginning of October 1932, the last month of my apprenticeship at Leitz. I could hardly wait to see my apprentice's pay of 50 Marks per month — a rather miserable amount — go up. I also wondered whether my change in status from a mere apprentice to a fully qualified technical clerk would be recognized.

I succeeded in meeting the famous Dr. Paul Wolff that October. I went to Frankfurt to take him a repaired Leica which he needed urgently. He had also been promised a new 90mm Elmar but this could not be delivered until January 1933. It was the so-called "thin" Elmar but optically it was the same as the "fat" 9cm Elmar that had come on the market in 1931. We understood each other from the very first moment and I was glad, thanks to my long experience in the Leica School, that I was reasonably well-versed in the discussion of photographic matters. Wolff was very surprised when I mentioned a certain series of photographs which he had recently sent to the small photo library in Wetzlar. Although the very interesting photographs of industrial plant were not before me, I was able to describe them in detail and I asked him to give me a brief explanation on his photographic technique. Needless to say I had already made slides from his negatives and they had become an essential part of my projected lecture. Because of the convivial manner in which we had started our acquaintance I was sorely tempted to entrust my future lecture plans to him but I resisted the idea.

The day after my visit to Paul Wolff I found a letter on my desk from the mayor's office in which the secretary of the town council drew my attention to the "Wetzlar Week of Lights" that was planned for the middle of November. Between 14th and 20th November 1932, various concerts and theatre performances were planned but it was

also intended to draw public attention to local products. In this context, Leitz was asked to arrange "one of their popular Leica slide shows for the event". It was no accident that this letter ended up on my desk. The colleague responsible for arranging Anton Baumann's lecture tours was on holiday and Mr. Ahl thought I would be suitable for the task ahead.

I had to find a strategy to prevent Baumann coming to the Wetzlar Week of Lights. I called the administration office of the big hall in the Wetzlar Archery Garden and was told that there were still three evenings free − fortune was on my side − I booked 16th November, the day when Anton Baumann was scheduled to hold a Leica lecture in Vienna.

I then called the secretary at the Town Hall in Wetzlar, introduced myself as responsible for this event and suggested 16th November to him. He was pleased to have obtained such a quick decision from Leitz, enabling him to announce the event under the title *Marvellous World of Leica Photography* where about 200 slides would be projected. The posters had to be printed about a fortnight in advance. To avoid further correspondence on this matter I asked him to telephone me with any queries. I thus gained a little time before I would be faced with some unavoidable questions. I tried to convince myself that my underhand dealings were all in the interests of the company. My only thought was to prove that I too could present myself as a "Leica expert" just like Baumann.

At the beginning of the first week in November the Commercial Director, Henri Dumur, suddenly called for me. I knew then that the time bomb, primed by myself, was just about to go off! I knocked on his office door and entered. The first person I saw was Dr. Ernst Leitz and I immediately thought I was in for an unpleasant grilling by these two gentlemen. Thus I was greatly astonished when Dr. Ernst Leitz congratulated me on the successful completion of my apprenticeship and when the Commercial Director added that he would like to keep me on in the Photo Correspondence Department, I was near to tears.

I nearly lost my self-control and stammered. "I have to make a confession. Without asking anybody I have arranged with the town council to present a Leica slide show during the Wetzlar Week of Lights." But as this was only half the truth I carefully watched the expressions on their faces. They seemed to be more astonished than outraged. The Director remarked dryly that I had taken on quite a challenge to try and find favour with the critical people of Wetzlar.

They were right to be sceptical as I must have cut rather a pathetic figure, unsure of myself and stammering. However, after I had

collected myself, I assured them in a firmer voice. "I beg you to believe me, I have worked for a long time developing many pictures for such a slide show as this. I am convinced that you will not be disappointed by my presentation."

Dr. Leitz responded. "We wish to extend our best wishes to the young, newly qualified Leica employee and camera enthusiast Walther Benser and to encourage him in his future project − when did you say the lecture was? − oh yes, 16th November."

My First Leica Slide Show

I did not keep a diary in those exciting days before the Wetzlar Week of Lights. If I had, it would have consisted of entries like "Day and night deep in thought with my slides... last slides from excellent Wolff pictures... will the hall be full?... is Dr. Leitz going to attend?".

The posters announcing the festival programme were everywhere. The title of the Leica slide show on 16th November at 8 p.m. was included but not the speaker. Whether this omission was missed by the public I don't know but most people would have expected Anton Baumann to be the presenter.

On the day of the show a very kind and helpful colleague assisted me in setting up the screen and projector. He was called Arnold and was the son of the Leitz representative in Switzerland. He had been working for some time in the various departments and I will never forget the way he imitated the voice of Mr. Dumur, our Commercial Director, a fellow-countryman from the French-speaking part of Switzerland, who had a high-pitched and sing-song voice and a habit of reverting to French every now and then.

It was Arnold who helped me overcome my fear of total failure. We agreed that during the slide show he would sit at the table on which the projector was placed and from there he could assist me by focusing the slides. He could also act as my prompter and indicate with discreet gestures if I spoke too quickly or not loud enough.

I preferred to deliver my talk standing next to the projector as this gave me the opportunity of operating it to show the correct slide at the right time as well as being able to use notes. I knew each slide and the picture sequence by heart. We had been well trained during my apprenticeship at Leica School on how to deliver speeches on the Leica camera in demonstrations and short talks.

Well before 8 o'clock I was sitting behind the stage curtain in the artists' lobby. Arnold peered through a tiny opening in the curtain down into the hall. People had begun to stream in and he whispered

a commentary on the proceedings, making amusing remarks about several colleagues, calling them by their nicknames.

Whenever I try to remember the important details of that evening I find that I can only remember trivial incidents. For example, that Arnold adjusted the knot of my tie at the last minute; or my flushed face in the mirror when he pushed me, quite terrified, onto the stage. I moved awkwardly to the front of the stage and bowed to the audience. The audible whispering in the hall indicated that each asked his neighbour who this person was. I had finished my introductory address and was just about to begin projecting the slides when Arnold had to remind me in a low whisper. "Don't forget to introduce yourself." So, standing in the dark next to the projector, I hastily had to include myself in the flow of my explanations!

Under cover of the darkness I quickly regained my composure. The one and a half hours of my lecture, in which I showed about 220 slides, was reasonably uneventful. Later some colleagues assured me that the evening had been a total success. All the pictures were totally unknown and thanks to the full explanation I had given in relation to the considerably extended Leica system, the show was regarded as very instructive. However, I did make another *faux pas* before it was over – a few witnesses of that day in November 1932 still remember it quite clearly. I commented on a slide of an interior at Versailles showing the magnificent bedstead of King Louis XVI by describing it as a "sprungbett" (spring bed) instead of a "prunkbett" (four-poster bed). I then made matters worse by correcting myself and calling it a "sprungbrett" (spring board) which was greeted with uproarious laughter.

These accidental slips of the tongue towards the end of my talk gave it an unintentionally humourous touch. Arnold, who could hardly stop laughing, once more projected the offending slide at the audience and earned himself a bonus round of applause.

After that evening Dr. Ernst Leitz asked me to present further slide shows in the photo clubs of the Rheinland, in the territories of the Leitz representatives. In those days the Rheinland was about the same size as today's Nordrhein-Westfalen.

The Group Photograph

An amusing incident occurred in May 1934 that clearly demonstrated the gulf between the old and the new type of photography brought about by the Leica; the place was Wiesbaden. In the large hall of the Kurhaus the projector and screen were in place so I decided to go for

a walk in the pleasant park surrounding the Kurhaus.

As I stepped onto the wide, white marble steps, I chanced upon a curious scene. About forty gentlemen, all dressed in their Sunday best, were arranging themselves into a group — obviously to be photographed — as there was a large solid wooden tripod on the terrace at the foot of the steps. Hidden beneath a voluminous black cloth was the photographer, adjusting his camera for the shot. He must have been an older exponent of the art, judging by the long white beard that protruded from the edge of the cloth. It was a most splendid beard, reaching down to his waist.

He emerged after a while to rearrange his subjects more favourably in front of the camera and I moved discreetly aside, pretending to be an innocent but nosey bystander, my Leica II hidden behind my back.

The gentlemen seemed to be members of a choir. I concluded this by the fact that they had settled their disputes with short bursts of operatic arias. One of their number who obviously did not want to stand in the front row, although he was too short to stand at the back, countered some disagreement by singing. "Nie sollst du mich befragen!" (Never you shall ask me — an aria out of Wagner's *Lohengrin*) in a thunderous voice.

At last everybody was in place and the white beard disappeared again under the cloth. It seemed he had to make some further adjustments and he indicated his instructions by gesticulating wildly with his head still under the cloth. This presented a rather amusing picture; arms flapping, beard waving in the breeze, bent under the large black cloth.

In the meantime I had crept behind the photographer so that the entire scene was in front of me I started taking photographs until some of the men noticed me and found it difficult to keep a straight face which meant it was time to disappear before I spoilt the photographer's carefully arranged group. In any case I had already taken 20 shots and was quite satisfied.

I went straight to the photographic lab that had helped me with the arrangements for the evening's lecture where they allowed me to develop my pictures. Luckily they were suitably equipped and I was able to make ten slides from my negatives with their ELDUR slide copier. I looked forward to the lecture when I would show these slides to my unsuspecting audience.

Of course everybody was very amused and the evening progressed amid much laughter as most of the guests knew the old photographer and the members of the choir. It took only a few minutes to show my afternoon's exploits but the advertising effectiveness for the Leica

– to use a modern term – was enormous. However I have to admit the way I obtained those picture was rather tactless and unfeeling.

A few days later I was summoned by the Commercial Director who showed me a letter of complaint received from the photographer in Wiesbaden. I confessed to my misdeed and explained the circumstances while the Director listened to me, trying to keep a straight face, but he could not manage to suppress a slight smile.

Leitz offered their own plus my apologies to the old gentleman and presented him with a Leica. Naturally I never showed those pictures in public again.

CHAPTER 4

Three Diverse Leica Pioneers

This is an appropriate point to talk about three photographers, all of whom I have greatly admired, who in their own very individual way did so much to establish the Leica, and through it, 35mm photography.

Dr. Paul Wolff

A highly successful exhibition of 60x80cm Leica prints by Dr. Paul Wolff which I accompanied with lectures in the towns concerned, in 1935, another meeting with the famous Leica pioneer.

He must have watched me, unnoticed, at the exhibition in Frankfurt. I had got into a typical debate with some visitors about the making of large-format Leica prints. They were claiming that such enlargements were impossible without an intermediate negative. As I knew better, having personally supervised the enlargements in the Wetzlar darkroom, I eagerly entered the heated discussion about the actual process. We had been able to allay similar doubts raised by people in the Leica School by asking the fairly experienced students, usually older than us, to work from their own Leica negatives with tested chemicals and the Leitz enlargers. Our budget did not always allow for the demonstration of a 20-times linear enlargement on 60x80cm paper, but it was sufficient to enlarge a detail from the negative on 13x18cm paper to demonstrate how maximum sharpness and minimum grain were achieved.

Paul Wolff later told me with a smile how he had watched my efforts for a while with the "unbelievers". He said I had described the Leica teachings from Wetzlar most eloquently.

During those weeks I was a regular guest in Paul Wolff's house, at Frankfurt's Untermainkai, and learnt much of value from his treasury

of memories. Oskar Barnack had told me how Paul Wolff had "seen the light", and after 1926 had changed from being a sceptic about the Leica to being an enthusiast. Since then he had become the most important of the Leica pioneers. The exhibition I was now accompanying with Leica lectures carried the title of his book *My Experience with the Leica*, published in 1934.

As far as I remember, I took the first reflex housing, which was to be known by its code word PLOOT, the ancestor of the Visoflex, from Oskar Barnack's workshop to Paul Wolff in Frankfurt at the turn of 1934/35. He was specifically requested to confine work with it to his own studio, together with the new 20cm Telyt lens, as general distribution would not begin before spring 1935. This discreet advance delivery to Wolff was not only an expression of Wetzlar's great confidence in him, but also enabled them to quietly prepare the advertising for this important addition to the Leica system using Wolff's pictures. Even today I can see him carefully opening the parcel from Wetzlar and setting the whole "mirror box arrangement" – as we called it then – on his lap. He examined this latest creation from Barnack's workshop almost tenderly.

I still remember a later visit when he proudly showed me the results from his 13.5cm, f/4.5 Hektor and 20cm, f/4.5 Telyt, taken with the aid of the PLOOT. He had been forced to use his tripod when he reduced the minimum focusing distance, of only three metres, to a little over one metre with the aid of the extension tubes supplied. Wolff knew how to turn the disadvantage of minimal depth of field into a virtue. He would sometimes place the sharply focused centre of his subject, such as a blossom, behind an intentionally out-of-focus, nebulous foreground of leaves.

In the light of this development of the Leica as a reflex camera, we discussed other cameras designed on the focusing screen principle. "The focusing screen forces you to think more about the appropriate composition of a shot" he said, reflecting on his work with large plate cameras in earlier years. He added sharply. "You young folk snap around far too wildly for my taste. Sometimes I wish I could push you under the black cloth and keep you there until you've mastered the ABC of photography!" I did not feel unduly upset by this sudden burst of criticism as I had shown him only a few of my own pictures. Perhaps he was referring to the embarrassing story of the old white-bearded photographer on the steps at Wiesbaden? But I had been careful not to relate that one to him!

It was not long before I accompanied Paul Wolff on his photographic assignments whenever the opportunity arose. Sometimes I

only had a few hours to spare, sometimes several days. I was the ideal assistant for him, familiar with Leica techniques, but only doing what he needed. My respect for the master's experience, coupled with an urgent desire to acquire more Leica practice, made me restrain my impetuousness. This was made easier because Paul Wolff had skills which I found myself envying. Without any optical aid from the Leica viewfinder, or the new reflex housing, he could dissect the surroundings with his naked eye in the search for a suitable subject and position. He invariably picked on the perfect spot for taking the picture with the focal length he had already selected.

The following little anecdote demonstrates a typical Wolff comment. We were wandering around a small picturesque town in Hessen, which reminded me of Wetzlar, when Wolff happened to catch sight of me bent over the PLOOT, trying to find interesting framings through the 20cm Telyt, panning roofs, sills, friezes and timbered gables. He commented caustically on my "periscopic panoramic search" with the words. "You'll have to learn to see first, Walther, or you'll never learn photography!"

I followed in his footsteps, his faithful assistant, with the two Leica bags. I had learned how much he appreciated a helper who asked little but observed much. Wolff suffered, albeit silently, from the handicap of having to put on his reading glasses to set aperture and shutter speed on his Leicas. But his long sight was excellent; he did not need correction lenses in the viewfinder of the Leica IIIa. Their screw lens mounts did not allow rapid lens changes, unlike the more modern bayonet mount, so for speed a second camera body loaded with the same film type was usually taken along. When Wolff had me at his side, he merely had to say "the niner please" or "the thirteen-five, f/8 with a hundredth" and the lens was at hand, set on aperture f/8; or it would already be screwed into the second camera body, with correct aperture and speed set. I was so well trained that I would even look after the small parallax correction on the VIDOM universal viewfinder if I could see, for instance, that he wanted to take a portrait of a peasant woman in the market square. I rarely had to measure the exposure times and if I did the result usually confirmed Wolff's own estimate based on his long experience.

Wolff knew how to approach his "prey" very discreetly. He was a master at keeping his photographic intentions undetected for as long as possible. He never carried the camera in front of his body in the usual manner but kept it, suspended on its strap, hidden behind his back with his right hand. This had become second nature to such an extent that he kept his right hand behind his back even when he was

not holding a camera.

My memories of Wolff's discreet appearance inevitably remind me of Henri Cartier-Bresson's work with "velvet paws and eagle eyes". At least that is how the work of this talented Frenchman was described to me. His methods show certain parallels to Wolff's, although his hunt was exclusively for humans, and that in a singular manner.

Henri Cartier-Bresson

When Oskar Barnack was working on his prototype Leica 75 years ago, he could not have known that photography was about to receive a gigantic impetus and that the Leica would revolutionize our expectations of the photographic image. In 1925 photography was released from the infection of pictorial paralysis into the freedom of producing lifelike images. The portrayal of people in realistic pictures became the Leica's historical achievement, without which today's newspapers and magazines would be unrecognisable.

One of the most important and best-known photographers who captured the human image in the liveliest manner was the Frenchman, Henri Cartier-Bresson. I first learnt about Cartier-Bresson from one of his countrymen, the Leica photographer Georges Viollon, who was not able to display his own photographic talent until after the war. Viollon, who unfortunately died young, looked up to his fellow countryman as a model of almost unattainable photographic greatness.

Henri Cartier-Bresson began his work with the Leica when he was 22 in 1930 and for him it became a pure medium of vision, enabling him to capture reality spontaneously. He never worked with any other camera. To him photography with the Leica meant the "immediate photographic representation of a moment". Like every photojournalist, he waged a constant battle against the time constraints for certain images he wanted to capture photographically. He had to act before the spontaneous "event" was over, before it was too late; because missed opportunities could never be repeated.

This insight made Cartier-Bresson a true master in grasping decisive moments. One of the books containing excellent examples of his work bears the title *The Decisive Moment*. All his creative powers were concerned with the subject of man in his environment; whether he tracked it down in Europe, India, Mexico or Bali. People dominated his work and the unmistakable style of his pictures.

It is not surprising that he was one of the founder members of the

famous photographic agency *MAGNUM*. Initially New York based, *MAGNUM* later established itself in Paris, uniting a comparatively small number of the best and most famous photographers.

Henri Cartier-Bresson shows people in their glamour and in their glory, in their need and in their sorrow. It is obvious from many of his photographs that their creation depended on a single, irrevocable moment, that 125th of a second when the camera shutter was open.

Georges Viollon aptly related how Henri Cartier-Bresson regarded the Leica as his "extended eye, without which he could not longer exist". With a sharp eye and an alert spirit he used to go through the world as if on tiptoe. Always prepared to "catch life in the act", to capture the essential, the famous "decisive moment".

In conversations about the decisive moment in portraits of people, Cartier-Bresson commented. "A poet or writer can think about an important phrase, shape and polish it like a piece of metal, and finally write it down. But if the photographer misses the decisive moment, his opportunity is irretrievably gone. For this reason photographer and camera should become as one. They have to move inconspicuously in order to succeed. Being as one with the camera requires the photographer to master in his sleep the few things which make the camera ready to shoot; similar to the way in which certain movements in driving a car become automatic. This is as far as the function of technology goes where the creation of a convincing image is concerned. In this context Cartier-Bresson is amused by people who regard photographic technology as an end in itself and believe that very sharp pictures are closer to reality. Thus it is not surprising that Cartier-Bresson uses very few accessories with his Leica. Neither does he like flash, which is not only intrusive and inappropriate but also destroys the atmosphere. Retouching and image manipulation are inimical to his understanding of photography. His laboratory has strict instructions not to alter the framing of the negative, which frequently corresponds to the frame of view of a 50mm lens. Variations are found in the occasional choice of more sensitive films and faster lenses.

Established Leica enthusiasts, remembering techniques learned from experience with all the useful accessories, should look at Cartier-Bresson's careful choice of wide apertures: the camera, pointed quickly at the decisive subject, fades unimportant detail out of focus and leaves everything unessential out of its composition!

Hans Saebens from Worpswede, a competent landscape photographer unfortunately long dead, described Henri Cartier-Bresson. "A photographer who on his world travels takes unrepeatable

pictures at the decisive moment with uncommon sensitivity; quietly and with alert sharpness of eye. Concentrated in their atmosphere, surprising in their message, seen spontaneously and photographed intuitively. These are exceptional photographs, never mundane."

In the face of the now octogenarian Frenchman's extraordinary talents, the question inevitably arises of parallels and comparisons with the much-quoted Leica pioneer, Dr. Paul Wolff. A close study of Henri Cartier-Bresson's photographs shows that his and Paul Wolff's perception of photography were worlds apart. The totally different starting point of the two Leica pioneers must not be forgotten: Wolff had virtually to climb down from the giant, originally indispensable 24x30cm view camera and become acquainted — at first reluctantly — with the totally different 35mm format. Wolff's Leica photographs were soon much in demand at Wetzlar. They became the basic theme of Leica advertising in the 1930's. Wolff had a rapidly growing group of disciples in the readers of his articles and books, with their incredible examples of Leica pictures. His expanding picture library from 1937 onwards served clients who frequently bought or commissioned images for commercial purposes. They were expertly produced by Paul Wolff and his highly talented partner, Alfred Tritschler, with considerable efforts involving people and technology, with talented — sometimes professional — models. His promising enterprise, a picture library of colour photographs, similar to that founded by myself ten years later, went up in flames during the war. Then Wolff's poor health resulted in his early death in 1951.

For the young Cartier-Bresson, however, the Leica was his very first camera. He had previously depicted his surroundings in drawings and paintings. His sole subject was people from all walks of life. It would not have occurred to him to influence his pictures in any way which would have determined the form or content of his work. He also rejected colour, because he could not control it as directly as his black-and-white work. I believe some of his objections to colour were later rendered invalid by better emulsions. Cartier-Bresson's photographs may be old now, and in monochrome, but they have not lost any of their fascination. It is worth looking though a book of his images slowly, page by page, to understand the impact of that "decisive moment".

Julius Behnke

In the summer of 1936 I held more lectures in Holland. On the way to the lecture hall in Haarlem I was side-tracked into a small detour

of the photogenic and typically Dutch Volendam by the desire to enrich my slide presentation with more of my own pictures.

On continuing the drive to Haarlem I was brought to a lengthy halt by a raised bridge over one of the canals that are everywhere in Holland. Hitch-hikers always gathered at these bridges to solicit their next lift. I was approached by a suntanned youth carrying a guitar. The young German from Wiesbaden had noticed my Rhineland license plates and hoped for a lift to Germany. Julius Behnke, that was his name, had just returned from Narvik, in Norway, travelling as a stowaway on an iron-ore carrier. On his hiking tour of Norway he had helped with the harvest and won friends through his guitar playing. Youthful curiosity, however, had not been the sole impulse behind these foreign travels. The Scandinavian forests – close to the midnight sun – and especially the colossal elks had attracted him!

I soon learnt that he had left school at 17, just like me, in 1929 in order to enjoy the freedom of foreign travel. His plans for the future were still somewhat vague; but he was determined to work with animals in some way. I remembered the Frankfurt lectures in the zoo hall and the numerous contacts I had with important zoo administrators. The word zoo-keeper came up in the conversation and the profession of forest warden occurred to me as well.

But the boy had different ideas. He could never be content surrounded by animals confined behind bars or moats, nor in a profession which, apart from care and attention, required the shooting of animals.

I then briefly explained my business in Holland and asked him if he would like to operate the slide projector in my evening lecture. He agreed. A few hours later, while setting up the screen and projector, he instantly grasped the rhythm of a slide presentation, aided by the handy slide gate. The way in which he handled technical things showed his aptitude for such tasks.

After the lecture he seemed somewhat quiet and thoughtful during the dismantling of the apparatus. When I asked whether he had enjoyed it he looked at me pleadingly and asked if he could accompany me further. This could only be, of course, for the next few days but it would mean that I need have no further worries concerning a temporary helper for the remainder of my Dutch tour! In future planned trips abroad the Leitz agents would be available for help and it was for this reason that I had never been granted a permanent assistant.

In the following days, during which Julius lived in youth hostels and subsisted on a minute allowance, he showed by astute question-

ing a mounting interest in photography and especially the Leica. He timidly confessed to previous attempts at capturing his forest observations with a very simple camera. Somewhat embarrassed he showed me a 6x9cm print of a fleeing doe, far away, tiny and hardly visible. Unfortunately my slides did not include any wildlife taken with the longer focal lengths or a big telephoto lens but I promised him the opportunity of examining a regular "cannon" lens – the 400mm Telyt on the "mirror reflex housing" – in the Leica school at Wetzlar. That was our name in those days for the reflex attachment which later developed into the Visoflex I.

Soon afterwards I was able to introduce Julius to Heinrich Stoeckler, head of the Leica school. He too thought Julius well suited for the work but my attempt to recommend him to the management failed. The personnel office rejected my proposal with the comment. "This extremely young man, who has been roaming the world like a tramp, hardly seems suitable for dealing with Leica clients!"

It was only through Heinrich Stoeckler's far-sightedness that Julius nevertheless kept in touch with Wetzlar and even attended the instructive information classes unofficially.

In early June 1937 I went from my lectures in Vienna straight to Yugoslavia. As in Hungary and Czechoslovakia, German lectures were understood without an interpreter. Intellectuals of those countries used to bridge the immense differences in their national languages by communicating in German. This is not surprising because they had all been part of the Austro-Hungarian empire before the First World War.

I was sitting in a hotel lobby in Zagreb with the gentlemen from Vienna, Zagreb and Belgrade who had an interest in the Yugoslavian lectures when Julius suddenly appeared. In white shorts, suntanned, somewhat shy but smiling cheekily; he had hitch-hiked this far in the hope that I might be able to use his assistance in the lectures again!

I felt it necessary to explain this sudden visitation to my astonished and amused companions who included the very genial photographic dealer, Herr Froehlich, from Zagreb. I introduced Julius Behnke from Wiesbaden as a Leica enthusiast who had assisted me temporarily in Holland the year before. I asked the enterprising traveller how many days the journey from Germany to Zagreb had taken. His self-conscious gestures supplied half the answer; he had been given a lift by an Austrian from Salzburg and been dropped off in front of a luxury hotel in Bad Ischl. The hotel owner had answered his question on where to find a cheap room by offering free overnight accommodation. This had embarrassed Julius because of his unusual clothing

and dirty rucksack. His embarrassment increased after the man had involved him in a political conversation and, in a whisper, introduced himself as an admirer of Adolf Hitler (with whom Julius, as I had known since 1936, had absolutely no sympathy). He managed to extricate himself from this tricky situation by pointing out his youthful ignorance whilst still being quite happy to accept the luxury room.

The following evening in Maribor he found a Slovenian who spoke some broken German and asked directions to a bakery where he could buy a bread roll. Up to that time the abundant breakfast he had taken in the Ischl hotel had staved off hunger! The Slovenian had taken him home to his family who had welcomed him enthusiastically and treated him to wine and a plentiful meal. He was also invited to stay the night.

The friendly photo dealer, Herr Froehlich, had risen to his feet during Julius' story and now cheerfully introduced himself, inviting

Julius Behnke, when I first met him.

Julius to be his guest for that evening.

Julius Behnke was allowed to accompany me for a few days and was very helpful with the lectures. Despite the small amounts of money I was able to give him, he managed to keep a little in reserve for the return trip. This was because he found lodgings, and good board as well, wherever he went. In Subotica he was even a guest of the mayor's family, although all he had asked for at the town hall was advice on accommodation. There was another opulent meal and plenty of wine, the consumption of which sent the German guest on a fruitless search of a certain location in the middle of the night. As he could not find it in the dark his need finally forced him to misuse an empty flower vase. Later on our trip he remembered that he had neglected to dispose of its contents. I scolded him as this was not the right way to represent neat and tidy Germany.

Julius was employed by Leitz, after all, later in the very same year. He worked at Heinrich Stoeckler's side for many years in the Leica school. He was not only a "photographic/technical consultant" but also a useful studio photographer who knew how to produce pictures of apparatus on the new fine-grain 35mm films, ready for block making for catalogues and brochures.

In Julius Behnke's own words. "This picture of a Belling stag took me a whole Sunday, from six in the morning until five in the afternoon. For hours all I could see were his head and antlers as he moved back and forth in a hollow in the distance. When he finally stepped out I roared loudly at him and his reaction was the photo opportunity!"

Soon his deepest desire to take a Leica with a 400mm Telyt out hunting was fulfilled. His spare time was devoted to the rich hunting grounds around Wetzlar, where he knew the forest wardens and game tenants well. He carried his permanently spread and camouflaged tripod over one shoulder so that he could set it up at lightning speed.

Throughout his life he never killed an animal. He commented on his photographic "hunt" as follows. "I cannot make a kill like the hunter but I can shoot the same deer again and again!"

Among his friends, Julius was well known for his graphic hunting tales, and when even the best transparencies failed to convey the full experience, he would illustrate his observations in dramatic gestures, miming the sudden appearance of a stag in a clearing with five fingers spread at each side of his head.

The DJV (German Hunting Association) awarded him their annual prize for the best publicity work in 1984 in Sonthofen, Bavaria; honouring his photographic achievements in the presence of over one thousand hunters.

In April 1988 Julius Behnke died of lung cancer at the age of 69.

CHAPTER 5

"All Things Must Pass . . ."

I must now go back in time to my early Leica lectures — to 30th January 1933 when Adolf Hitler had just become Chancellor of the German Reich. I remember the occasion well, I was in the town of Kaiserslautern. The leading cameras shop had been eager to sponsor the first "Leica picture show" and had enthusiastically prepared for it with outstanding publicity. When I arrived at the shop in the late afternoon I soon realised that the owner and his wife were a bit worried about the "political circus" that had been going on in the streets all day.

Up to that day my life had been more or less apolitical. I was thoroughly wrapped up in photography and I had a strong aversion towards any form of political fanaticism. No doubt my steady contact with men of moderate political views like Oskar Barnack and Dr. Ernst Leitz had influenced me because I sensed a similar moderate attitude in the friendly owners of the camera shop. Now they spoke in soft voices but with an obvious dread of the "Nazis" out there and I noticed, with a sense of alarm, the apprehensive looks that were directed towards some customers waiting in the shop. I felt a chill go down my spine.

This was my first experience of what came to be known as "Der Deutsche Blick" (the German glance) as Hitler's regime of terror and denunciation took hold of the country. Only later did it dawn on me that the Weimar Republic had ended on that very day and from then on fear would steadily grow.

The friendly but apprehensive shop owners were concerned about my lecture that evening. They told me that although many of their customers would like to attend they were afraid of the rowdies roaming the streets, who might pick a fight on any pretext, as everyone knew everyone else in this small town.

The hall hired for the occasion was comparatively large with 600 seats. In those days photography had not yet become everyone's hobby the way it is today. Due to the special circumstances we had a much smaller turn-out than I had experienced at recent lectures but it did not worry me.

Since the introduction of the WEDYA slide changing magazine I had engaged a helper to operate the projector as this allowed me to stand at the side of the large screen, which was propped up on tables. From this vantage point on the stage I enjoyed direct eye contact with the audience and could apply some showmanship. By stepping into the beam of light from the projector, without blocking much of the huge 10x10ft screen behind me, I could create an element of surprise. A portrait of a large ape from Frankfurt Zoo was the first to appear on the screen. The audience was surprised, if not shocked, by this picture. Some muttered their disapproval, others just commented in whispers to their neighbours. At this point I suddenly stepped out into the light and with a magician's gesture extracted from my breast-pocket a small transparent envelope; from this I then pulled an even smaller piece of perforated film — the Leica negative. It measured 24x36mm and I held it over my head in a dramatic gesture. Only those in the very first row could make out the portrait of the ape and comprehend that this was the source of the 100-fold magnified picture on the screen.

After this I told my audience about the dream that Oskar Barnack had had in 1906 when, after a long and tedious trek up a mountain with a large format camera, plus tripod, on his back the idea had come to him like a vision. "Small negative, large picture!" I then pointed to the Leica negative and remarked. "And here, ladies and gentlemen, you can see the realization of that dream!" For a few seconds there was silence then someone started to clap and everyone joined in with thunderous applause.

Suddenly, from the street, we heard the roll of a large drum followed by trumpet calls, which drowned out the applause. After this martial prelude the air was rent by the commanding voice of an officer, followed by the rhythmic tramp of hundreds of pairs of boots. For the first time we heard the battle song of Hitler's SA troops, which we would hear *ad nauseam* in the years to come:

"Die Fahne hoch, die Reiehen fest geschlossen
SA marschiert mit ruhig festem Schritt..."

(Hold high the flag, close tight the ranks,
SA is on the march with firm and steadfast step...)

The ape portrait still filled the large screen, gazing down unperturbed over the startled audience. All I could do was wait until the noise subsided, as the troops marched off into the distance. I continued my talk with the words. "All things must pass....."

Seven Hours in Detention

I had a nasty experience two years later, in the autumn of 1935. The "Leica Picture Show", with its excellent pictures by Paul Wolff, had earned a lot of praise and appreciation throughout Hessen. I had taken the show through a great number of towns, amongst them Heidelberg, Darmstadt and Frankfurt, into the Rheinland, to Cologne where I found particularly well-equipped halls in the centre of town, then to Düsseldorf, Dortmund and Essen.

In Wetzlar I had repeated requested an assistant. Leitz were unwilling to provide an employee on the grounds that it would prove too expensive. They always suggested that I might hire someone on the spot to help me with erecting the equipment, arranging the show and looking after the exhibits. I was told it should not be too difficult to find someone because of the high unemployment and the wage of 5 Marks per day. Understandably I was not too keen on having to find a new assistant every day which meant I would have to keep explaining anew what had to be done. I thought of a better idea and engaged a man called Otto Wilerzol, whom I had known in Wetzlar, and found to be a pleasant and intelligent companion. By chance he was out of work so he was quite happy to accompany me on my tours. Later, on his 93rd birthday in February 1990 to be precise, when we had a chat he remembered those early days with fondness.

This was how in the town of Essen, he saw me being discreetly taken into custody by two plain-clothes officers. At first I did not know whether they were from the Gestapo but then, to my great relief, I was informed that I had been arrested on suspicion of currency dealing. I told Otto that I would make my way, as soon as possible, to the town hall where I was supposed to be giving a lecture that same evening. Apparently I was to be interviewed because of money transfers abroad and as I had a completely clear conscience I expected to be able to clear the matter up quickly.

In 1935 restrictions were in force regarding the convertibility of the German Mark. It was possible to transfer 10 marks to a foreign destination. However, I did not know that these transfers were restricted to once a month. I had hoped to accumulate a reserve fund with a friend in Belgium for my planned visit to the World Fair in

Brussels and for this purpose I had made four transfers, each of 10 marks. How wrong and naive I had been can be seen from the fact that I had made no secret of my address thus making it easy to locate me at my lodgings.

It was 11 a.m. when I was taken, not to the police station, but to the local remand prison. The officers who locked me up told me to empty my pockets and took away my belt, braces, tie and wrist-watch. They demanded my wallet, counted the money, and gave me a receipt. It was quite obvious that they had no idea why I had been arrested because they simply shrugged their shoulders when I asked them what time I would be interviewed. They did not know nor did they care. After all, I was merely a number, an unknown who had to be detained, no more, no less.

I had never seen the inside of a prison cell before. I shall not go into detail of how I felt. The scene was predictable: the small, bare room with the high, barred window and the WC in the corner.

It must have been around midday when I was given a bowl of soup which I declined to eat. With rising panic I asked the warder who came to fetch the bowl if he knew when I would be interviewed. He shrugged his shoulders and replied, without even pretending to be interested. "No idea, how should I know?"

Absolutely nothing happened in the following few hours; nothing that is except for the distant muffled sound of doors being opened and slammed shut, the characteristic sound of keys being rattled and commanding voices in the corridor. I had plenty of time to review my situation. I had to consider the possibility of being kept there for an indefinite period which would mean not being able to give my lecture. I think I could have borne my confinement with more ease if I had not been so worried about the lecture.

In my mind's eye I saw Otto preparing the equipment in the hall and beginning to wonder what had happened to me – what terrible thing I might have done or might have to endure. He would wait a few minutes beyond the 8 o'clock start time and then climb onto the stage and announce, in his very soft and gentle voice, that I had been detained but he did not know why. His voice would be much too quiet for the large hall and I could anticipate calls of "louder! louder!". I could see the hall emptying, people leaving, annoyed and disappointed, with some threatening to complain.

Luckily I knew Otto quite well and could rely on him not to give away the reason why I had missed the lecture but my thoughts then turned to Wetzlar; by tomorrow everyone would know what had happened to me as the rumour would go round town. "Benser is in

prison, he was arrested because of foreign currency fraud!"

I thought of a few colleagues who might more rightly be called my antagonists as I had had some serious political disagreements with them. Their interpretation of my misfortune might sound more like. "He must have said something about the Nazis — that's why he is inside!" Others had referred to me as a Leica clown; it was a habit of mine to simulate shooting situations, just to liven up the lecture, by lying on the floor or by pretending to shoot from some other contorted position, to demonstrate the universal "ease of application" of a Leica camera. Thus my behaviour was considered to be lacking in decorum for a Leitz representative. I had always been aware of the various criticisms but I had never taken them seriously. Now I had time to ponder my situation and those voices seemed to combine into a conspiratorial chorus against me. Once the reason for my present misfortune became known I could imagine the popular judgement against me would be. "Currency smuggler — he probably did it for those Jews who fled the country."

It must have been about 5 p.m. when I could stand it no longer. My imagination had run riot and I was desperate! I decided to make an attempt to save the situation if I could. I pounded with my fists on the door. When the warder appeared I begged him to tell his boss that I had a very important matter to discuss. The warder turned round, saying. "Just a moment." Then he went away, relocking the door behind him.

I congratulated myself on my clever ruse as the indication of "an important matter" must have persuaded the warder to seek a higher authority. Perhaps he thought that the long waiting period had softened me up and I was ready for a confession.

Indeed, another officer arrived soon afterwards, whom I addressed as Herr Direktor, although that wasn't his rank. He asked me what it was that was so important. In a desperate attempt to convince him I explained in an excited and hesitant voice that I had to give a Leica lecture that very evening at 8 p.m. in the municipal "Saalbau" (Town Hall). This lecture had been announced by posters and adverts throughout the town and I expected about 600 to 700 people to attend, many of whom had been specially invited through the photographic trade from as far afield as Essen. If I was prevented from giving the lecture it could mean the most disastrous personal consequences as it might even cost me my future career with Leitz. I suggested that they allow me to give the lecture, accompanied by a plain-clothed policeman, who could make sure I returned to the prison afterwards.

"ALL THINGS MUST PASS . . ."

The officer asked me to repeat the name of the place where the lecture was to be held. This I told him, together with the title of my lecture, in the desperate hope of convincing him of my honesty. He left with the rather noncommittal remark. "I'll see what I can do."

I was still in suspense but hopeful. I stood by the door, my ear pressed against it, in the hope of hearing something that might give me a clue. When the door was finally opened again it was only the warder with my evening meal, an unappetizing tray containing another bowl of soup with two slices of brown bread. My disappointment seemed to choke me. To my question about what time it was, he mumbled laconically. "Six."

It was at this point I broke down. The surprised man looked at me in amazement as I sank to my knees by my bunk – not exactly in front of him – entreating him to inform his superiors that in less than two hours about 1000 (!) people would assemble in the Essener Saalbau where I was supposed to give a lecture. If I was not there, all would be lost ... I broke down in uncontrollable tears.

I heard my cell door close again, the man had gone without uttering a word. I ignored the soup, staring into the corner of the cell, still sobbing like a child.

Another hour must have passed. I came to the conclusion that I had been forgotten, no-one would take any more notice of me at this time of day, not even the sympathetic officer who had come to see me earlier. I was really desperate by now and again started to hammer with my fists against the door whilst kicking it with my feet. I must have been screaming too because I was quite hoarse for some time afterwards.

I won't keep you in suspense any longer: my door finally opened and the officer, who had first come at 5 p.m., stood in front of me shaking his head in disbelief at my desperate state. "Do calm down." He said. "Our chief has decided that you can go. He has made enquiries and the people at the Saalbau confirmed your story. It may be that we have to interview you tomorrow but this will be decided at a higher level, anyway we have your address. Now go quickly and get your things from reception."

After I had clutched the hand of my saviour with both of mine in an enthusiastic gesture of thanks I went to claim my belongings; braces, belt, tie and watch as well as my wallet. The money had to be recounted and everything properly signed and receipted.

I can't remember how I got back to the hall. It was not so easy in those days to get a lift because cars were few and far between but someone must have given me one. I vaguely remember wandering

about in the middle of the road, disorientated, my tie still in my hand. There were just a few minutes to spare when I finally arrived at the hall where Otto immediately took charge of me and led me to the cloak room where he helped me to restore my appearance.

After the show we went to an exceptionally good restaurant. We had looked at the menu outside a couple of days before, not daring to go in. That evening seemed to be the right occasion to splash out and celebrate my nearly lost freedom.

Otto later told me that the lecture on that evening had been particularly lively. He was in a good position to make such a judgement because after all he listened to my lectures every night!

September 1938: Political High Tension

A new season of Leica slide shows was announced for the Swiss-German cantons of Switzerland in September 1938 by the Leica agents there. The projection of colour slides, with enlargements of up to 100-times, was totally new and the number of Leica enthusiasts who flocked to these events seemed to increase by the minute. In cities such as Zürich, Basel, Bern, and St. Gallen we had to look for larger halls than previously planned and in many places we had to stay for several days to meet local demand.

The political atmosphere was highly charged. The threatened march into Czechoslovakia by German troops caused a great deal of concern amongst the population. Luckily, the totally non-political invitation for a slide show entitled *Colour Photography as experienced with a Leica Camera* was received with real enthusiasm. This was my third visit to Switzerland and I had built up a little circle of fans as well as the support of some influential people in the photographic trade.

The interest aroused there meant I needed to produce a rather large number of slides from pictures of Swiss landscapes taken by me and other photographers. My public wanted to see pictures of scenes they could recognize so we had to show some good slides of the magnificent Swiss Alps.

I chose the classical mountain pass of St. Gotthard to find subjects for this new series. The scenery here had fascinated me two years ago when I drove down from the summit of the pass 2110m above sea level. The road passes from high above the tree line all the way down to the distant Val Tremola. It was a most exciting and strenuous drive with an occasional stop to look back over the continuous series of hairpin bends that I had found so difficult to negotiate despite my

considerable driving experience. The weather was good and settled and the forecast promised clear skies with occasional cloud − of the cumulus variety − the photographers' favourite.

From Zürich to the top of the pass is only 109km. I had to be careful though not to get side-tracked on the way by some other beckoning subject. It would easily be possible to visit other glorious sights, such as the Zürichsee, the Zuger See or the Vierwaldstätter See. In my experience it often happened that the light would be ideal in the interior regions of Switzerland whilst the view in the higher mountain regions was quite bad making photography impossible. In view of the excellent weather conditions and good forecasts I decided to make my way, without hesitation or stops, right up to the St. Gotthard pass.

The roads were quite different in those days with dangerous bends. It was a Saturday, a lovely autumn day with hardly a car on the road, and as conditions were so good I was able to park my car on almost any bend I chose. My only problem was to park it in such a way that it would not intrude into the picture. About 100m further up the slope from where I had parked I erected my wooden tripod which was fitted with a Leitz ball-and-socket head.

As it was a bright day the use of tripod may have seemed unnecessary at first sight, particularly as the then quite new Agfacolour DIN 15/11 (ASA 25) slide film was fast enough. the conditions were good enough to shoot hand-held with shutter speeds of $1/250$ sec and apertures between f/5.6 and f/8. A comparable film today would be Kodachrome 25 noted for its exceptionally fine definition. But I was not simply interested in some wide-angle shots of the hairpin bends, I also wanted to use this newly-introduced slide film in combination with various haze- and skylight filters.

To make such a sequence of test shots it is absolutely essential to use a tripod. One needs to use varying exposures while keeping the framing absolutely constant. Too many variables would render a test such as this meaningless. Hand-held shots are out of the question. A further advantage of the camera on a tripod is that changing filters and lenses is easier. It is also necessary to record the settings for each shot in a note book.

I intended to use the film remaining after the test series for a few typical pictures of the road as it wound its way towards the valley. The Leica was kept in horizontal format for the entire test series. Quite intentionally I included a proportion of sky in the frame with the winding road beneath. The sky would be an important feature in the exposure test of this new Agfacolour film. I then carried my tripod

to a new position where I could use my 35mm lens with the camera in upright format.

The first hairpin bend of this serpentine road that snaked down the massive mountain started at the top of the frame with the bends leading down into the valley occupying the bottom edge of the frame. The wonderfully clear air allowed me to use the 200mm Telyt on the PLOOT reflex housing and I managed to bring the many bends, down into the valley, close-up into the frame. The distortion of the telephoto perspective would have made it quite impossible, even for someone who was familiar with the road, to identify the location of this shot. Those of you who use telephoto lenses on a regular basis will know exactly what I mean.

The view of the very foreshortened-looking hairpin bends was suddenly enhanced by the approach of a single car that wound its way up the mountain, creating a small cloud of dust in its wake. Although I was able to take four or five shots, I regretted having left my new Leica MOOLY motor drive back in Zürich. This would have been very useful − not only for the photographic stalking of the lone vehicle but also for the exposure series.

The car finally arrived at the top bend and stopped behind my car. The driver got out and looked in my direction, starting the short climb towards me. I did not really expect that a fellow Leica photographer would be taking the opportunity of seeking a quiet chat here on the mountain side. On the contrary, his official demeanour and his serious, disapproving expression as he looked at me, my camera, and the open lens bag told a different story.

The situation was somewhat dubious and I did not quite know how to react. I knew that there were no restrictions on photography in the area, on the other hand I was a visitor to this country, furthermore I was a German one. So, although I was tempted to tell him to mind his own business in response to his unfriendly question as to what I was doing there, I replied politely that I was a photographer and that I wished to test my lenses and filters as well as the quality of the film materials.

The man seemed to know little about photography otherwise he might have been convinced of my intentions on seeing my equipment and looking at the notes I was obviously making about my activities. I did not attempt to tell him of my lectures in Zürich, nor did I invite him to the slide show the following week in the Kaufleuten-Saal where I hoped to show the slides that I had just taken.

He merely shrugged his shoulders and went away offering no further explanation. I started to pack up my equipment and as I

glanced towards the cars I noticed that he made a note of the registration number of mine.

"The Gestapo Asked After You"

Barely three weeks after my Alpine expedition, when I was spending a short time in Wetzlar prior to travelling on to Denmark, I was told that the police had called. I was supposed to report to the Direktor of the staatliche sicherheit (state security). This "invitation" was just a polite way of telling me I had to report to the Gestapo.

Only those of us who lived under the regime of the Third Reich can understand what it meant to come to the attention of the secret police. Of course they did not give any reason and I had to wait until the following day.

As I regularly travelled abroad and met so many people on my journeys, amongst whom there were some who had fled the Nazi regime, I experienced a few really uncomfortable hours in which I tried to fathom out the reason why they wanted to see me. I also contemplated the possible question of why I, an upright citizen of the German nation, was not a member of the Party.

I reported to the Gestapo offices with the obligatory "Heil Hitler" where I was welcomed by a jovial middle-aged gentleman and motioned to a comfortable leather armchair. My omission to join the party was not mentioned but, in an attempt to put me off my guard, he asked. "For whom did you take pictures in Switzerland?"

In my mind's eye I saw again the unfriendly Swiss motorist who had noted the registration number of my car on the St. Gotthard pass.

I relaxed and settled comfortably back into the chair. Having regained my internal composure I allowed myself the counter-question. "Don't you know what I do at Leitz here in Wetzlar?" His angry face indicated that he had not been informed about my activities. I told him of my long and intensive advertising activities on behalf of Leitz, which was in Germany's interest, as it earned the country urgently needed foreign currency.

I told him that I had been in Holland about two months before and that we had had to hire a large concert hall for three nights running because the demand was so great. The same applied in Switzerland and I was using every free day to look for interesting subjects to photograph for my slide shows.

After my lengthy explanation I asked if I too could ask a question – I recalled that I had been observed by a rather dour Swiss about three weeks previously as I was photographing in the mountains

along the St. Gotthard pass. This man must have thought I was a German spy because he had noted down my car registration number, therefore I concluded that it was he who had brought me to the attention of the authorities − so I leaned forward, looked my interrogator straight in the eye and asked. "Did he report me to you?"

Naturally he would not, or could not, give me an answer. I found out the truth later. The Swiss counter espionage service was heavily infiltrated by undercover Nazis. These people warned their masters of any person in Switzerland who seemed to merit their attention. Naturally I was not on the Nazi files, being a simple photographer, but they still wanted to know who ordered the photos.

However, this was not the only reason why they had invited me to report to the Gestapo. After the relatively harmless preamble, the gentleman came out with a question which I can only describe as disgraceful. He asked. "Would you undertake to photograph a house in Amsterdam, secretly, that we know is regularly frequented by emigrants?"

It would have been very unwise to refuse this request with the outrage that I felt so I quickly collected myself and managed to find a plausible reason. I explained that I would be totally unsuitable for any kind of undercover work as I was hopeless at that kind of thing. In the past, if I had tried to deceive anyone, for however harmless a reason, I always gave myself away by blushing violently. I had been told that my reaction was a far better indication than any lie-detector so I certainly didn't have the right qualifications for that kind of photo reportage.

To my great relief this explanation seemed to satisfy him and I was soon walking back to my lodgings.

CHAPTER 6

Henri Dumur

The period after the Nazis came to power in the 1930's until the end of the war was a far more difficult one for the Leitz family than for me, despite my slight but frightening brushes with this regime which I have recalled in the previous chapter. A sense of humour was needed to overcome the overwhelming feeling of oppression. In no one was this more typified than Henri Dumur, our Commercial Director, who did have the benefit of Swiss nationality. The following anecdotes about him were told to me by Dr. Ludwig Leitz when I visited him in Wetzlar while I was looking up old friends and colleagues in preparation for this book

Henri Dumur was to play a most important role in the Leitz company. He came to Wetzlar to join the family business in 1903, after graduating from grammar school in his native Swiss town of Vevey. He was the great-nephew of Ernst Leitz I, whose eldest son had died in a riding accident, and was called on to fill the resulting gap in the management. He started as a trainee mechanic and rose to become Managing Director. After his training he travelled through Germany, France, England and the USA to prepare himself for his future work in Wetzlar. With his unmistakable French accent and a high, somewhat sing-song voice, Dr. rer.nat. h.c. Dumur (who had become responsible for sales and finance when I first knew him) had the rare capability of expressing the most surprising things in a grave and serious tone which never revealed his undelying roguish and ironic sense of humour. In the period from 1933 to 1945 quite a few incidents took place that illustrated this faculty.

In the early days of the Third Reich — planned by its founders to last for 1000 years — certain laws and so-called emergency regulations were introduced that robbed the ordinary citizen of his civil liberties. To this effect a sizable group of Nazi Party members in their brown

uniforms came one day to Leitz, to "request" a massive donation to the Party from the company.

They were shown into the office of Direktor Henri Dumur who listened to their "suggestions". He then pointed to a black-and-white drawing on the wall, the portrait of a distinguished-looking man, and asked. "Do you know who this is?" They did not know so Henri Dumur proceeded to enlighten the gentlemen from the Party. "This was a very great man and I am sure the Führer admires him as much as I do. I look up to and honour this man because I respect his ideas. This, gentlemen, is Frederick the Great who once said "Man is born free and he should remain free to make his own decisions". I have listened to you with this in mind and now I shall think about your request and decide freely." He then got up and dismissed them with a courteous bow.

When Mr. Dumur recounted this story later in the close circle of his family he concluded. "And the best part about it is that Frederick the Great never said anything like that!"

The Nobel Prize

In 1937 Henri Dumur was called to the "Braunes Haus", the Nazi District Administration in Wetzlar. He knew straightaway what was in store for him as it was not the first time that he had been formally and emphatically invited to apply for German nationality. As he and his family were Swiss nationals and enjoyed the freedom of small, neutral and peaceful Switzerland, he had no intention whatsoever of accepting the citizenship of the large, but certainly not free and in no way peaceful, "Grossdeutschen Reiches".

Sure enough, he was again asked, in no uncertain terms, to make a decision. He replied. "I am told that our Führer decreed that no German citizen may accept the Nobel Prize. If I now become a German citizen then I would never be able to accept the Nobel Prize." They asked him. "Do you really think you would be awarded the Nobel Prize?" To which Henri Dumur replied. "Well, why not? I hold a leading position in a scientifically-based company, I have world-wide contacts, and I have always worked for a better understanding between nations. The Nobel prize is awarded for several disciplines every year. Name me one reason why I should not be considered."

"Moreover, my accepting German citizenship would automatically make my children German. My children are very intelligent; if they should ever be honoured with the Nobel prize, I would never forgive myself for their not being able to accept it."

This silenced the rather dim, brown-uniformed gentlemen as they had no answer to his arguments but they decided that Mr. Dumur was not exactly the right type of person that good Germans would want to know. Therefore the matter was dropped.

The Symbol of the Third Reich

It was the final, bloody days of the battle of Stalingrad, matters grew increasingly worse for the German war effort, but The Party and its propaganda machine carried on as if nothing adverse was happening.

"We were all on our way home for lunch." Dr. Ludwig Leitz told me. "As was our habit. We, that is Paps (Ernst Leitz II), my brother Ernst, me and Uncle Henri."

"Uncle Henri glanced at the front page of the *Wetzlar Zeitung* as we walked slowly up the hill towards our homes when he suddenly burst out in great amusement with his distinctive Swiss-French accent. "Ha Ha, what rubbish, who wrote that?" Then he read aloud. "Another glorious victory can be celebrated under the standard of The Third Reich and the flags of the Party dedicated to the true Aryan blood ... etc., etc., ... and above the scene hovered the sterilized eagle of the glorious Third Reich.""

"Despite the sadness around us there were still occasions when one could not help smiling. The typesetter had obviously not managed to suppress the temptation of ridiculing the system and allowed his "printing error" of substituting "sterilisiert" (sterilized) for "stilisiert" (stylized) to carry the blame (and the message)."

"Living under a dictatorship means one has to learn to read (and sometimes to speak) between the lines. This may not be understood by the younger generation in Germany and elsewhere but the older generation, who had the misfortune to live through those days, is quite aware of what I mean. Speaking one's mind was a dangerous business. It was war and one had to be careful, remaining obscure, keeping one's head down, and not falling foul of the authorities, those were the golden rules at the time."

Divine Providence

"It was another lunchtime and we were walking home together again. The papers were full of the recent attempt on Hitler's life on 20th July 1944. The Propaganda Ministry reported the event as follows. "Divine Providence saved our Führer from the shameful and dastardly attempt by a small, murderous clique."

"The comment of our Uncle Henri was something like "If its true that it was Divine Providence that saved this devil then I want nothing to do with Divine Providence!" "

After the Unconditional Surrender

Only his closest friends, the long-established members of the Leitz company, and those who lived through the years to 1945 with him, can appreciate what Dr. Dumur had achieved in all those years up to the total collapse of the Third Reich.

Outsiders may consider that the Leitz works had survived more or less intact. This was not strictly true — the enormous difficulties after the dissolution of the state, the collapse of order, and the handing over of power to the American troops, are hard to imagine. In the initial period nobody, neither the management nor the workers, was allowed to even enter the works. However, in only a few days the military guards on the gates had left and the first machines started up for work. This achievement was due to the efforts of one man — Henri Dumur — the Managing Director who, together with the younger partner Ernst Leitz III, represented the company. These two men carried the burden of responsibility for conducting the business.

It was at this time, at the end of June 1945, when Leitz was already employing 1500 workers, that the visit of a group of uniformed allied officers was announced. During this time, only three months after the end of the war, the occupying forces were systematically visiting industrial plants and despite their obvious entitlement so to do, they asked most politely and formally whether it would be convenient to come and study the works and production methods at Leitz.

Dr. Dumur discovered amongst his visitors several faces that he knew quite well from his attendance at congresses and trade fairs, and he knew them as members of one of Leitz' most influential competitors. However, these gentlemen belonged to the "victorious forces" and in his capacity as Direktor of the Leitz works, and as a Swiss citizen, he welcomed the group and thanked them formally for their visit. "Gentlemen, the German Reich has surrendered unconditionally. You are therefore at liberty to do as you wish. You can take the machines as well as all our designs but you can not take away our experience of many years and you also cannot propagate our century of a growing tradition."

CHAPTER 7

The Siren Lure of the Perfect Viewpoint

In the spring of 1939 we received some shattering news from E. Leitz Inc., New York. The well-known and popular Leica specialist Anton Baumann, a former draughtsman and now extremely successful Leica lecturer in the USA, had been killed during a photo assignment when he fell from a water tower.

We learnt the precise details of this shocking accident as more news came in. It appeared that Anton Baumann was working on an assignment photographing livestock on a farm in Lexington, Texas. He was standing on a narrow ledge of a water tower for a better view of the scene and he must have taken a careless step back, lost his balance, and fallen down the spiral stairs breaking his neck — he was killed instantly.

This was quite unlike Anton Baumann because, on the contrary, he was known as a very careful and circumspect person. However I can imagine how it could have happened — the deep concentration on the subject, the eagerness to capture a fleeting moment, the quick and sure reaction to the photographic subject seen in the viewfinder, may cause the photographer to forget his own safety.

His preoccupation with the task may have been the reason for Baumann's accident and his tragic death. I can well imagine how he — an enthusiastic photographer — was completely fascinated by the unusual sight, for a European, of wild horses galloping across the wide Texan plane kicking up a dust-storm in their wake.

In my sixty years experience with the Leica, I can look back on many occasions when caution went out the window because I was too absorbed in my task. Luckily, the consequences were never as disastrous as in poor Mr. Baumann's case but sometimes I or my equipment suffered some damage. I have included some anecdotes of such events in this book.

MY LIFE WITH THE LEICA

In the autumn of 1939 I travelled to central Norway, after completing a lecture tour in Oslo. On a sunny but rather breezy October day I chanced upon a wonderful, furious waterfall, its waters rushing down into a wild gorge.

The air glistened with water droplets in the bright sunlight and a beautiful rainbow framed the scene which I just had to capture. However, there was no bridge or path from where I could look down into the deep gorge. I tried to slide down a small incline on my bottom. This steep slope was overgrown with low bushes that overhung the gorge. With my Leica and 35mm Elmar around my neck I picked my way carefully towards the edge.

The angle of view that I gained from this overhanging vantage point seemed to be sufficient. I needed just a few extra centimetres of height to be able to accommodate the entire waterfall in an upright format shot. At my feet was a small rock, which I tested with a hefty kick to check whether it was secure, as I wanted to use it as a support so that I could lean forward and out to get the right framing. If it held, I would be able to move from a sitting to a crouching position which would shift my angle sufficiently.

The rock was really solid. However, when I put all my weight on my right foot, pushing against the rock and lifting myself up to a crouching position, I found to my horror that the rock was as smooth as a mirror. The spray from the water had frozen on the rock to an invisible polished film − it was covered in a black, icy shell.

I lost my balance, let go of my Leica, desperately and instinctively trying to grasp for some sort of support. With my right hand I grabbed a thin branch, not much more than a twig, then I managed to find another with my left hand. And there I hung, both legs over the abyss, suspended by only these two thin branches.

Time seemed to stand still. It seems unbelievable now that those two thin and weak branches managed to support my weight for such a long time − it must have been 20 seconds at least. I had time to reflect on a lot of things; not least on how Anton Baumann met his death. Memories flashed through my mind and also the realisation that no one would find my body if I fell into the river as it would be swept out to sea. Then slowly I succeeded in pulling myself up onto firmer ground.

I was a lot more cautious after that.

CHAPTER 8

My Italian Concerto

About the middle of June 1940 I returned to Wetzlar from an extensive lecture tour in Hungary, Rumania and Bulgaria. On my arrival I was called to the Directorate. Dr. Freund, the director responsible for my engagements abroad, received me; his manner was very serious. So far he had been able to hold off the date of my being called-up for active service, mainly through the recommendations put forward to the Foreign Office in Berlin. He had to admit that now, apart from Germany itself, there were no other countries left which might be interested in one of my lectures delivered in German. Holland was already involved in the war, as was Denmark and Norway, and Switzerland had the benefit of one of my exhaustive tours only two years before. I interrupted his arguments with my comment. "Yes I think at the moment there isn't a neutral country anywhere that would invite a German, even if he came along quite peacefully, armed only with a Leica camera! Hungary and Rumania are the only exceptions." Dr. Freund pondered a while and then said hesitantly. "Well, as it happens, our Italian agents in Genoa remember your lectures with some fondness – you had some successes two years ago when you toured the German-speaking part of South Tyrol, Bozen and Meran and they would like to continue our Leica promotions. It has been suggested that the Leica agents organise more lectures together with Agfa (Italia); they will show your slides with an Italian translation of your texts spoken by an Italian expert. Naturally you will receive a fee for allowing your material to be used in this way."

I understood this short explanation from my embarrassed-looking superior as an indirect admission that he had exhausted all possibilities as far as this matter was concerned. It came as no surprise to me as I had seen the inevitable approach of this fact for some time now.

Even so, I had suppressed the unpleasant prospects in view of the recent developments in France and clung to a secret hope that perhaps the war would be all over soon. I acted quickly and retorted. "No, I cannot agree to lend my pictures in this way, I'd prefer to conduct the Leica lectures in Italy myself."

Dr. Freund regarded me with disbelief and replied. "With all due respect to the excellence of your lectures and your experience in this field, I have to point something out to you – Italian is a foreign language! You could, no doubt, if pressed muster up a few words to make yourself understood but there is a world of difference between a lecture of some 90 minutes and a short conversation. After all, you will be addressing some very intelligent people. How do you imagine will you explain, with convincing arguments, the advantages of an expensive and sophisticated system? Knowledge like this is not attained in a matter of a few weeks, it takes years!"

To this I answered with one complete sentence in Italian which I had learnt by heart from the first page of an Italian language textbook. "E assolutamente giusto se Lei sostiene che l'Italiano non soltanto bisogna parlarlo correttamente, ma ugualmente che il suono de questa lingua si nota chiaramente, questo è quello che conta!"

The Direktor stared at me in utter astonishment as if he had seen a ghost from another dimension before saying. "If I heard right, that sounded like perfect Italian to me but I did not understand what you said."

"Well, what I said just now was that to be correct, Italian does not only have to be properly pronounced it also is most important to convey the sound of the language; that is what really counts"

"So why did you not tell me that you can speak Italian?"

"Well, to be quite honest." I confessed. "I don't! I hardly know any vocabulary, only the few words you heard just now, but I have learnt to pronounce and read Italian almost like a native. Italians understand me very well and they are usually quite amused when they hear a foreigner speak fluent Italian. I have a suggestion. I could read my own text, properly translated into Italian, without any pauses or errors with just a little training from a good teacher so that I could learn the whole thing by heart, perhaps with the aid of a manuscript that is hidden from public view."

To cut a long story short that is what was agreed. It was nearly July and the lecture tour was scheduled for October; taking until December to complete the 30 shows, so I had three months for intensive training. All that was left was to inform the sympathetic Foreign Office that Mr. Benser would go to Italy to deliver his lecture

in Italian.

It did not take long before I found Signorina Tina G., a language teacher from Florence who also had some experience in teaching actors. She was hired to study the Italian version of my manuscript with me. Sound tapes which I have since used with some success were not known in those days.

I worked every day with her for three to four hours. She read every sentence to me and then I had to repeat it and in that way I learnt the text, more by the sounds of the language than by remembering words. As I still did not understand the individual words and sentences, I had to practise the stresses and intonations, which were marked up in red pencil on my manuscript. I had had some previous piano practise and I still remembered the symbols for *crescendo* and *decrescendo* i.e. for increasing and decreasing volume. I intended to deliver the text at a certain distance away from the speaker's rostrum so as to be able to accompany my delivery with the appropriate gestures that are so typical of the Italian temperament.

Signorina Tina had never had a student like me before — sometimes she was greatly amused but sometimes she would shake her head in disbelief after I had delivered a particularly emphatic sentence and then, still frozen in my last posture with arms spread wide, ask the sober question. "And what does this mean in German?" When dealing with my "eccentricity" she consoled herself with the thought that the opera singers at La Scala, in Milan, employed a similar method in trying to understand the text before delivering it at full volume.

Long before the commencement of my lecture tour, I spent some time designing a customised lectern which was collapsible, similar to an old-fashioned school desk. The top could not be seen by the audience as it was shielded on three sides by panels which also incorporated the lighting, hidden behind a shade, so that the speaker was neither blinded nor directly illuminated but just diffusely lit by the reflection of the light from the white pages. I did not have to turn the pages as the width of the top allowed me to slide them across. This clever arrangement served me very well later on when I delivered lectures in French and in English, conveying the impression to my audience that I had mastered their language perfectly.

When I stepped onto the rostrum in the lecture hall in Milan on 16th October 1940 I felt the same excitement as on that evening long-ago in Wetzlar when I had given my very first lecture. The hall was filled to the last seat and I had butterflies in my stomach.

The chairman of the Milanese Photo Club introduced me and

reminded everyone to be patient with me. "Signor Benser is going to recount his experiences in our own language!" This was greeted with a round of applause by my indulgent audience.

The Leica lectures in Italy met with a lot of success and as early as November the total number was increased to sixty. My daily contact with Italians who spoke no German helped me to improve my actual understanding of their language so I needed less help from interpreters. My resolve to actually study this melodic language was further strengthened by a rather embarrassing event during one of my first lectures.

One evening in Verona I was without the assistance of either a Leica or Agfa representative who normally operated the projector. The slides were still glass-mounted in those days and had to be taken individually from the slide box and placed in the slide changer of the VIIIs projector. Instead of an experienced assistant, who would be familiar with my projection programme, I was helped by an assistant from one of the local photo shops. As I stood with my back to the screen I had to rely entirely on his competence to keep the slides in the right order.

It was in the early days and I was still worried about getting the delivery of my lecture right. Like a very young pupil, I followed the words on the manuscript with my finger, as their meaning was still a mystery to me — it would have been a total give away to miss a line! My audience would have known immediately that my "perfect" Italian was just a sham. For this reason it was particularly difficult for me to check the proper sequence of slides without loosing my place in the text.

I suppose impending disaster was inevitable.

I was in full swing, extolling the virtues of the delicate colours of a mountain landscape in the glow of the late afternoon sun, when I was surprised to hear spontaneous laughter from the audience. A quick glance behind me at the screen explained the reason: my assistant had picked up the wrong slide and instead of a landscape the weather-beaten face of a drayman stared at me, his large red nose the prominent feature. This picture was supposed to have been used as the counterpart of the above-mentioned delicate colours of the landscape. In desperation I ran to the centre of the hall, to where the projector was standing, mumbling. "Scusate." (sorry) To try and find the correct slide.

Of course this very same evening I was also without the usual back-up interpreter. After the show I was bombarded by questions that I could not even begin to understand and my usually excellent

"disguise" of a perfect command of the Italian language, together with the appropriate gesticulations, was revealed for what it really was − a sham.

CHAPTER 9

Evicted by Herbert von Karajan

Having completed a rather successful lecture tour around Italy, in 1940, stopping at over sixty different cities and towns between Milan and Palermo, I decided to allow myself a few days rest in Florence, tempted by the "Maggio Musicale Florentine" (May Music Festival) and the wonderful spring weather of 1941.

Thanks to the lectures I had given previously I had established a good contact with the German Consul General. He had submitted a report to the Foreign Office in Berlin, entirely without prompting on my part, praising the five lectures I had given, and expressing his opinion that cultural events of this nature would be of great value in furthering international understanding. It was the Consul who arranged the hiring of Herbert von Karajan, the new star on the musical scene, to act as guest-conductor at the Festival.

The reception staged for the conductor, attended by about 80 renowned personalities from Florence and other Tuscan cities, took place in the gardens of the Consulate. It was a festive occasion. I asked the Consul to introduce me to Herbert von Karajan as I hoped to obtain his permission to take some pictures at general rehearsal the next day. The Consul thought it might be better if he approached Karajan about photographs as he knew that the conductor was rather shy and might not wish to be photographed. After some considerable time the Consul came back, his serious expression indicating that Karajan had rejected my request. He, the Consul, had pleaded most insistently and had assured Karajan of the serious nature of my work, pointing out that I used these pictures for my Leica lectures. All to no avail as Karajan refused and declined even to meet me.

The Consul was obviously embarrassed about Karajan's unrelenting attitude. In an attempt to conclude the matter in a reasonably amicable manner he smiled and pointing to my Leica, hanging

conspicuously round my neck, said. "I know from your own tips, explained in your lectures, how easy it is for you to take candid shots of well-known personalities but I would be grateful if you resisted taking any pictures of our compatriot. It would be best to forget our reluctant Mr. Karajan altogether."

I was not very willing to do this. On the evening of the concert my plans were ready. For the first part of the concert I sat in a box at the side of the auditorium and surveyed the situation. The entire stage was occupied by the orchestra. The large instruments, such as timpani and tuba, were in the back row just in front of the giant organ pipes that filled the entire width of the stage. I was glad to see that no curtain was drawn across them.

You can probably guess what I had in mind. The closely packed organ pipes were narrower at their lower ends. I was sure that I would be able to see between the pipes and gain a view of the centre of the stage. I judged the distance from the back of the pipes to the conductor as about 7m; too far for my 50mm Xenon lens. On the other hand, this lens was ideal for interior photography because of its fast speed of f/1.5 and I had hoped to use it if I had been allowed to get close enough.

The slightly longer 73mm Hektor with its maximum aperture of f/1.9 was more suitable. All my focal lengths were too slow, except the 90mm,f/2.2 Thambar, but this was a soft-focus lens and quite unsuitable for showing the distinguished lines of Mr. Karajan's face to full effect.

I slid the bulky 73mm Hektor, without caps, into my trouser pocket. My Leica IIIc, also without case, I accommodated in my other trouser pocket. The important accessory for this lens; the fold away, Albada-type viewfinder – SAIOO – I stowed in the top pocket of my jacket. My Leica was loaded with Agfacolor 15/10deg tungsten film. This was a well-tried emulsion for artificial light which Paul Wolff had given me.

A young Italian pianist – I had made her acquaintance at the reception in the Consulate – sat with me in the box. She now observed these preparations with some interest. She knew that I had been refused by Karajan from taking any pictures so she must have understood my intentions. However, she conspired with me by agreeing to keep an eye on my large leather bag containing the rest of my equipment.

Beethoven's 7th Symphony was scheduled for the second part of the concert. In the interval I joined the crowds wandering about and made my way towards the stage entrance. My dark jacket hung open

over my bulging trousers in an attempt to hide my ungainly shape. A dimly-lit corridor led in a semi-circle round the back of the stage with several doors in it. I quickly opened a door and found myself in a room behind the organ which contained stage props. A weak light from the concert hall filtered through the narrow gaps between the pipes. I soon found the best position from where I could see the hall in front of me so I knelt down and tried to remember where the members of the orchestra would be sitting.

Long before I had set everything up to take the first picture, I was thinking how I would show four or five slides at one of my lectures, the expressive face of Herbert von Karajan shown to full effect, whilst extolling the Leica for its handiness and ease of use in difficult situations − leaving my audience to form their own conclusions as to how clever I had been.

The bell sounded, the interval was over, the audience and the orchestra returned to take their seats. It was obvious to me that I would not be able to take a reliable exposure reading for the conductor alone. From my viewpoint the surroundings were the large, now darkened, concert hall. In those days we did not have such a thing as spot-metering so I had to avail myself of a trick that I used to describe in my lectures as "substitute metering of a similarly-lit object". Instead of the distant conductor I chose the light-grey, round shape of a timpano.

In this book I have intentionally chosen episodes from my *Life with the Leica* in which I have been prevented from getting my pictures either by unforeseeable circumstances or by my own impetuousness, or lack of foresight. Being familiar with Beethoven's 7th, which starts quietly but finishes with a dramatic final movement, I should have sat quietly and patiently in my little corner behind the organ pipes. I should have waited for the right moment when the conductor was completely absorbed in the music and exercised constraint in this first quiet movement. Instead I checked the scene through my viewfinder, trying to assess what pictures I would be able to get into the frame. I wanted to preset my camera and focus accurately. I hoped to get his head, together with the baton, exactly into the frame, excluding any irrelevant details from fore- and background. These theoretical preparations occupied the first movement. In the short break before the second movement, Karajan stepped off the dais and spoke to a person in the stalls.

A little later, after the start of the second movement, I was poised for success with the camera to my eye, the lens opened up to f/1.9, the shutter speed set at 1/100 sec., and the conductor in the

viewfinder, waiting for the right moment to press the release button when I felt a tug on my sleeve. I found myself being pulled back by the usher. I understand Italian and there was no mistaking what he told me; apparently the Maestro was "molto rabbiato" (very angry) as he had noticed me right at the beginning of the first movement.

For the next quarter of an hour the good man helped me to remove the traces of my failed attempt with a clothes brush. I was covered in dust on the outside and fuming with rage inside at having thrown away such an opportunity.

CHAPTER 10

Reluctant Conscript

It was November 1941. I had just returned from a very successful lecture tour in Rumania and Hungary to find that my call up papers were awaiting me at the military recruitment offices in Wetzlar. Thanks to the diplomatic dexterity of Dr. Freund, and his direct connection to the authorities in Berlin, I had escaped my fate so far but the slim list of "indispensable employees" (known as the "U.K. List") was continuously being reduced. Following the pressure of recent events, and the extension of the Eastern Front because of the severe winter in Russia, a higher authority in Berlin now examined this U.K. list and had a good clear out. It is not often that a person's name befits his job but in this case it was most appropriate; a certain General Unruh (unrest) being in charge!

To what extent aggravation felt by the recruitment offices in Wetzlar contributed to their decision to dispatch me to the (unpopular) multiple rocket launcher unit, I cannot say. I would not have put it past them to have done it in retribution because this assignment was on the secret list and photography or any photographic equipment was strictly forbidden.

From a professional point of view this was a pity because those weapons in use would have produced some spectacular pictures. The launchers could fire 12 rockets all at once, or one after the other in quick succession. The fire-belching missiles, seeking out their targets, would have made very interesting subjects. In any case I had the doubtful pleasure of reliving and capturing this experience about a year later when I was in Russia as a war correspondent. In 1943 the Russians had a similar weapon, called "Stalin's Organ", which was even more powerful. It launched 50 rockets, their trajectory being accompanied by the most terrifying noise, raining down in tight formation obliterating everything in their path. To explain the

They got me into the army at last.

photographic effect imagine a long exposure in the twilight with the impressive bright trajectories traced across the darkened sky. Today you can see a similar sight by observing the launch of space rockets – the big difference being that you can do so from the comfort and safety of your home on T.V.

I shall keep the remarks of an enthusiastic photographer sent to a camera hostile unit as brief as possible. I was transferred to barracks in a North German town, I shall not name the place or names as I have included some anecdotes that concern colleagues and superiors, some of whom may still be alive.

A number of books have been written in recent times about the drilling of young recruits. I could add to them with some stories of my own as I had to endure three months of weapon drills but I shall refrain from this unpleasant subject. As far as I know, these methods are supposed to have changed but one still hears, now and again, of bullying and other unpleasant practices in training camps. My ideas regarding respect for human dignity were the same then as today so I shall recall this time by only one example.

I was then nearly 30-years old, the father of two children, with a responsible and interesting position which had been interrupted by the events of the time. It was routine, after morning roll-call, to

receive our mail. The procedure was for the sergeant to call out the names of the recipients from the bundle of letters in his hand. This occasion was during the early part of our training and the names of the new recruits were not well known to the sergeant. If you heard your name you had to run at the double to the sergeant from your platoon to be handed your letter before the next name was called. I once had the bad luck to respond only after the second, angry bark of my name as it had been mispronounced the first time as "Beuser" instead of "Benser". My failure to respond was punished by making me run round the parade ground. I ran off, angry at the unfair treatment fully intent on justifying myself when I did receive the letter — I should have kept quiet because I was not even listened to, instead I was ordered to run round a second time and to instruct my family not to misspell my name!

A Lucky Encounter

February 1942 was bitterly cold. The small ponds and lakes in the city park were frozen over, the trees and lawns were covered with thick snow. We recruits, equipped with shovels and brooms, had been detailed to clear the paths because an army ice-skating event was scheduled for the following Sunday.

We were busy by a particularly pretty lake which had some spectator stands erected on its banks, probably used in summer for swimming galas. At this time of year the sun was already quite low in the sky, although it was only 4 p.m., nearly disappearing behind the high trees that surrounded the lake, casting long, deep shadows over the ice. I looked at the scene with some regret as I imagined the very pretty picture I could have captured if only I had been allowed to carry a camera.

I was surprised to see a man standing on a bench in the top row of the stand. He was obviously shooting just the subject that I had previously imagined. I noticed, however, that he was not doing it quite right as, from his position, it would have been much better to turn the camera into the upright format so that the long shadows could have been brought fully into the frame.

My natural curiosity got the better of me and I took advantage of my snow-sweeping job to get closer to the photographer. As I did so I realised that he was in uniform and a quick glance at his epaulettes told me he was a captain. I also noticed that he was using a Leica, whether it was a IIIa or IIIc I could not tell, but I was alarmed to see that he had forgotten to take the lens cap off. As he proceeded to

It was while sweeping snow that I had my lucky encounter which eventually led to my becoming a war photographer.

take a picture and then another, all to no avail, his error pushed all thought of caution from my mind and I shouted. "Captain, you must take the lens cover off first!!" In an attempt to excuse my behaviour for not having addressed him in the prescribed manner I saluted, holding my broom at the "Present Arms" position.

The captain looked at his Leica, then at me, before climbing down from the bench. He addressed me with a few friendly words in a typically nasal Saxon dialect, explaining that he had forgotten his lens hood otherwise he would never have made such a mistake, before remarking. "You must know a little about photography yourself — are you also an enthusiast?"

I concurred, and seeing the chance of a chat about photography when I could vent my outrage at having to be without my camera, I continued eagerly while pointing at his Leica. "I have the same model as you, together with the entire lens system, up to the mirror reflex box with the 200mm Telyt lens, but I am not allowed to have any of my equipment at the rocket ranges." The captain obviously had a lot of sympathy for me.

I looked back to observe that the deep red sun was now behind the trees, taking the opportunity for pictures with it, but I reassured the captain that a similar opportunity would soon come again although I kept the advice about holding the camera in upright format to myself.

This prompted him to ask. "You seem to be a professional photographer, how did you end up with the rocket launchers?" His question gave me the opportunity to explain that I had been employed by Leitz to conduct lectures and slide shows to advertise the cameras. I added that my last engagement had been in Hungary, just a few months before, when I had shown colour slides. He interrupted me with a friendly grin. "Ah, so it was you who gave the Leica lecture in Dresden about 3 years ago, was it?" To which I replied. "Yes, it was in the large hall of the Hygiene Museum and that evening is particularly vivid in my memory because a funny thing happened during the slide show. The audience was very amused when a large spider crawled across the slide and appeared as a monster on the screen ..." "Yes." Interrupted the captain. "You were just showing a rather good portrait of a pretty girl ..." "That's right." I continued. "And my projectionist was quick enough to focus on the spider which made a woman scream in fright and I capitalised on the situation by remarking that it was the most lively portrait that I had ever shown!" Captain Sch. then became quite sentimental reminiscing about his leave during which this event had occurred.

Meanwhile my fellow recruits were being ordered to start marching back to barracks so I had to leave but he assured me that now he knew where to find me I would hear from him.

I spent the following days in happy anticipation that something decisive would occur. I did not breathe a word to my comrades and when they asked me what I had talked about with the captain, I replied, quite truthfully, photography. This was accepted without further question as they knew it was my favourite subject.

During the fifth day of my patient wait I was called to the office. The sergeant informed me that I was to be transferred to a different company and that I should pack my belongings. This was not difficult as the sum total of my possessions fitted easily into the narrow space of the tin locker next to my bunk in the room I shared with five others.

I marched across the parade ground, kit-bag on my shoulder, towards the neighbouring unit. On arrival at my new company I had to follow the usual military drill: stand to attention, heels together, right arm raised up at an oblique angle, barking. "Heil Hitler." Which usually sounded more like. "Hay-tler." Followed by name, rank and number, the company I had come from, and finally the reason for my appearance, in this case my transfer. The officer in charge had been informed and I was instructed to leave my things in a corner and report straight to the captain.

I entered the captain's office, stood to attention, and finished the recital of my formal greeting with. "Gunner Benser reporting for duty, Sir." And waited for the captain to speak. He left his desk and told me to. "Stand easy."" He then continued in a friendly manner, no longer the military man. "I spoke to the C.O. and he has agreed to allow you to undertake certain special missions for the regiment. We have cancelled certain earlier orders that had obviously been given without proper assessment of your case, as it is more advantageous to the army to use you in a capacity that matches your abilities."

The duties laid down for my future engagement went beyond straightforward photographic tasks and lay outside the scope of the rocket launcher regiment. To my great delight I was even to be free from the normal routines of the barracks. I was to have the use of the darkroom of a local newspaper in town where I would be able to work, even in the evenings, and as the barracks were situated on the edge of town I would have to rent lodgings in the centre.

I was granted a special short leave to fetch my photographic equipment, which I had stored in an air-raid shelter in Düsseldorf. At the same time I also brought back my VALOY enlarger because the one I had been issued with would not be suitable for the printing of Leica negatives.

Lieutenant P., an officer from the captain's company, found a very satisfactory solution to the problem of my lodgings. I was introduced to the elderly widow of an officer — she had asked the garrison to find her a lodger as she lived alone and felt very vulnerable. As it turned out, my presence was a considerable comfort to the old lady, particularly in view of the ever-increasing nightly bombing that the town had to suffer.

My assignment had also come about because of this nightly occurrence. I was told to document the area. I therefore proceeded to systematically photograph the apartments of the officers who lived locally. At first I just took the pictures without making enlargements from my negatives. My readers may find the reason for this assignment difficult to understand. As I mentioned previously, aerial bombardment was increasing and my film was to be used for later compensation claims against the authorities for the damage caused to civilian property. My carefully-taken negatives of entire interiors and close-ups of particularly precious pieces of furniture, paintings, silver and china, were to be kept and printed up only if the worst happened and the objects in question were destroyed in an air raid.

As this assignment brought me into contact with the occupants,

usually the wives and children of the officers, it was only natural that I was asked to take pictures of them too. Of course, I then had to provide enlargements. This was a most welcome change from the sterile job of shooting the evidence of real or impending bomb damage. For portraits I favoured my magnificent Thambar 90mm,f/ 2.2 that I had used many times for this purpose since 1937. It was a variable soft-focus lens, of which less than 3000 were ever produced. The advantage of a soft-focus lens is that the subject appears slightly blurred, even though it is in sharp focus, thus softening angles and skin imperfections. I suppose a lens that "suppresses sharpness" does not really fit into the Leica emphasis on utmost sharpness and this might have been a factor as to why production was restricted. In any case, my clients considered it to be a magical lens.

You may ask yourself whether this full-time job, which I performed as a soldier in civvies, could be considered a deviation into black market activity — however much condoned from above? In my defence I would like to point out that the necessary chemicals and quantities of film that I needed were administered by Lieutenant P. He then passed on the developed film, and any enlargements that I had made, at cost-price to his comrades. The prices were calculated according to the actual materials used.

How I Became a War Reporter

I am sure my quite valuable service for the regiment and the pleasant activity it entailed could have continued well beyond the autumn of 1942. I enjoyed a privileged position, similar to that of hairdressers, pianists, etc., who were often stationed much longer than others in the home garrisons. However, I found my privileged status more and more embarrassing. Here I was in relative safety while my colleagues had to face action at the front. This was one reason why I thought of trying to get to the front, another was that my work had become anything but creative. After the many years of interesting assignments with Paul Wolff, and the opportunities of showing my own slides, I started to envy those photographers assigned to the Propaganda Kompanie (known as the "P.K.") who were in the midst of the action. My attitude was probably a little naive but I saw it as more of an adventure than a dangerous undertaking.

I discussed the matter with the sympathetic Lieutenant P., who was a reasonable man like Captain Sch., neither of them being a hard-line Nazi. Times were difficult, the war effort was beginning to turn sour and voices of discontent could be heard. However, we were

Thirty years of poster art. Top left; 1934, Top right; 1952, Bottom; 1966.

most careful not to discuss politics or the war in any derisory manner as this could have had serious consequences. During a further confidential discussion with Captain Sch., he managed to convey his political ideas in a circumspect manner. As far as he could see, the future was grim. He feared that the war would go on for a long time yet and that neither he or I would be spared from having to serve at the front eventually. He was responsive to my view that if I had to be a soldier then I might as well serve in a way that suited me best − as a photographic reporter.

I received his support and in the middle of November 1942 I was transferred to Berlin to the Propaganda Kompanie. On the 10th December I boarded a train that took me to the Caucasus.

THE
BENSER
GALLERY

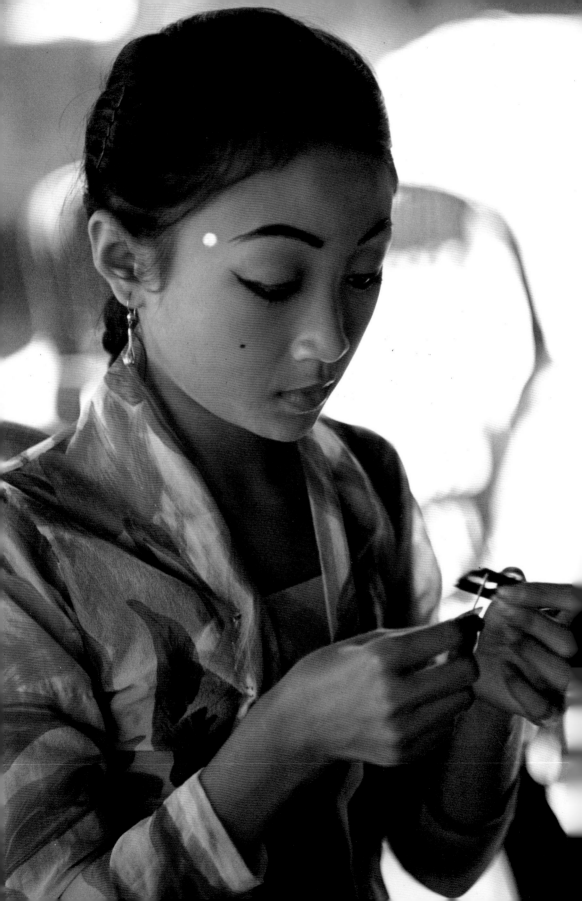

Close-up portraits like these two from Bali should best be photographed "detached from the background". This is the case with the young Balinese dancers. One wears the typical, flower-decked, dance costume while the other is still busy with her make-up. In both cases I photographed with open aperture as this fades the background into haziness, making the heads stand

out sharply, clearly and vividly. The extremely different lighting in both pictures necessitated close-up metering of the one dancer's blossom crown and the other's half-shadowed face. I had to make do with the available light and surroundings for although neither picture was taken candidly, they still did not allow for lengthy preparations.

Of course I used a longer lens. These pictures were taken on the lecture tour of Australia (1964) during a sojourn on Bali. Opportunities arose to use both the Leica M2 with the very fast Summarex 85mm,f/1.5, in spite of its weight, or the first reflex camera from Wetzlar − the Leicaflex − with the also-new Elmarit 90mm,f/2.8. These heads may have been photographed with either equipment − after more than 25 years I cannot recall those details!

One factor in favour of the M2 equipment played an important role with "Uncle Tom". The old man with the expansive straw hat over a "facial canvas", which practically cried out for a landscape-format picture, did not want to be photographed under any circumstances. He sold hand-woven baskets and hats in the local market. As he had no objections to me taking pictures of other people with his hats on, in the end I managed to catch him as well. After a few futile attempts which he foiled by ducking, this picture happened thanks to the quiet mechanism of the Leica M's shutter. I was able to take exact aim at him in a brief moment, when he was intent on his customers, through the M viewfinder and I covered up the faint click of the shutter by clearing my throat.

(Overleaf) This dramatic sunset, with the silhouette of the fisherman throwing his net, was for many years one of the highlights of my Leica slide shows.

Contrary to what you may think, this was no snapshot but a deliberately arranged picture. The fisherman was asked to come to pose for me on this beach in western Bali. Originally I had asked him to wade into the water up to his thighs. I followed and took up position about five to six metres behind. However, the first trial shots proved that I would have to crouch low, even if I used a 35mm lens, otherwise the horizon would have described a rather unsuitable line across the centre of the frame. To place the horizon low enough I would have had to sit in the water!

The framing worked better from a position further up the beach. Now I was able to capture the whole figure effectively outlined against the sky, sea and sun without getting wet myself.

Luckily I was never challenged about the facts that this fisherman seemed to be a perfect photographic model and that, considering the calmness of the water, he would never have caught anything.

The memory of a stroll through the old town of Athens has become unforgettable because of this snapshot of a cat lying in wait on the head of a life-size bronze statue. The way this odd picture came about, in which the raised arms of the statue seem to be about to grasp the animal, needs some explanation. My first visit to Greece in 1952 was mainly dedicated to new pictures for my lectures. To be honest, I had ancient architecture in mind, particularly the many examples around the Acropolis. I certainly had no plans to be surreptitious otherwise I would not have had the Leica in front of me for all to see.

 When we entered the antiques shop a draught must have set the chains in motion and the cat was mesmerized by them. There was no chance of a careful spot metering of the lighter fun in the darker surrounding; the only shot possible before the cat pounced on the chains was placed exactly in the quickly measured distance. I have no idea which aperture and speed I used, merely that the Agfacolor film was certainly no faster than DIN 12/10 (ASA 12).

(Left) Here I present not only an introspective old Italian peasant woman but also a picture which exudes quietness and serenity through the little cat at her feet. The evening light not only supports the restrained colouring it also shows, in a literary sense, the end of a life as well as the end of a day. The closed form, her wonderfully expressive face and hands intensify the peace and harmony of the whole image. In spite of her southern dialect we managed to converse and I learnt the simple story of her life while I took my pictures with the camera on a tripod. During the 1950's I went through a phase when I tried to find the ideal exposure as well as the perfect moment to create exemplary genre pictures with my Leica M3 plus Visoflex and 135mm lens.

This subject, taken on the Cyclades isle of Mikonos in the late 1950's, is already one of a series of nostalgic pictures as horse-drawn cabs are rarely found these days. Now the pale wall can only reproduce the graceless outlines of taxis, which would not make an attentive amateur photographer eagerly reach for his camera.

Little can be said about the technical aspects of the photo. Even a complete beginner would soon realize how to set the aperture and speed. However, it is important to take the scene from the side so that the photographer's own shadow remains outside the frame.

A Bantu street-trader sitting on the pavement in Johannesburg, South Africa, with her wares spread out beside her. She has to leave the city area before sunset and return to her district.

The contrast between this poor native woman and the twenty-four-hour bank fascinated me so much that I wanted to photograph the scene. It also had journalistic value in the context of the apartheid issue. A shot taken from the other side of the road with a telefoto lens would have been easier, because I could have worked unnoticed by the woman. But there was scarcely a break in the constant stream of pedestrians, bicycles and other vehicles. If there was a brief moment of unobstructed vision, the Bantu woman was invariably not in the ideal position for the shot.

The only possible solution to this difficult problem remained the direct approach, with quick and constant attention, fast reaction and exposure. Not to forget that the rangefinder Leica allows observation of the subject even at the moment of exposure.

CASH
AROUND
CLOC

(Left) The famous Copacabana beach in Rio de Janeiro. At first sight the curve dominates as a diagonal — in the lower right the empty beach, in the upper left the deep blue of the Atlantic. A light/dark contrast equally weighed, even if the picture is turned upside down.

This picture was taken from the roof garden of one of the modern hotels at the edge of the beach. Again, the bird's eye view proved to be a particularly convenient way of photographing a concentrated part of the total by means of a sufficiently long lens. With today's Leica technology, a zoom like the 35-70mm Vario-Elmar is the most convenient lens to achieve the ideal composition, faced with the impossibility of varying the standpoint even by a few metres.

(Above) This little scene does not show that it was taken in a remote village, 500 kilometres from the nearest human settlement, in the deepest South American jungle of Surinam, former Dutch Guyana.

My reason for being there was a recommendation from the management for such "adventure trips". My only equipment was the Leica M6 with three lenses. My kit was small, and waterproof, because of the long distances to be covered in open boats on jungle streams where heavy rainfalls and other sources of dampness are a constant danger. (This is also true, of course, for "adventure trips" in other countries and continents, where the risks range from the spray from waterfalls to killer whales spewing sea-water over the side of their aquarium pools.)

The M6 has the advantage of being the least vulnerable to failure of the professional high-quality cameras. A failure of its electronics merely means having to do without the light metering. This can be done with a separate meter if necessary.

This little chap in the washing bowl wailed terribly. In spite of the selective metering through the 90mm Elmarit I had got a bit too close for his comfort. The fact remains that a white child in a black bowl would present much less of a lighting problem — of course only in the photographic sense!

How could I dare to photograph this Arab with his two veiled wives, at close range in a bazaar crowded with Muslims, without causing violent protest?

A mere three steps from the scene, I stood in a shady corner of the souk of Marrakesh and realised with increasing astonishment that none of the people walking towards me seemed to notice me. Occasionally I held the Leica up to my eye, ready to shoot, almost provocatively. How could this be?

The explanation was simple. The passing pedestrians were briefly blinded by a sunbeam coming through a skylight. The bright outlines on both women's robes show that the light beam came in from behind. A white wall to my left reflected the light so intensely on the passers-by that I could take pictures of them without inhibition, as if under the protection of an invisible cloak.

I discovered this lime quarry on Haiti on a day trip from Port-au-Prince. The four workers silhouetted against the bright, almost monochrome but not monotonous background seemed to be worth a photograph. Unfortunately they were all working on the left-hand side of the picture. I would have liked to have "rearranged" them but knew from experience that attempts to manipulate amateurs like film extras generally did not succeed because of unnaturalness. Thus patience was the better way to a good image.

I sat in the back of my hired car, the Leica with Elmarit 90mm on my lap. Pretending to study a road map of the island, I kept one eye on "my picture". It took quite a while before the two men in the lower pair moved towards the right side. All the time the four communicated in short calls and shouts and remained in the relaxed attitude typical of a break. Now was the time for the photograph.

If the picture is turned upside down, thus getting away from the concrete objects, colour and form can be evaluated separately from the content. This is an old painters' trick to help control the balance of a piece of work.

(Left) Dusk, with its blend of fading daylight and already-bright sources of artificial light, offers a brief but promising time for interesting images to every experienced photographer.

A high speed colour film, for example, ASA 400, should be used in order to reproduce scenes of quick movement sharply — unless you want to achieve intentionally-blurred contours through longer exposures, which can sometimes produce very attractive results.

The merry-go-round shown here was photographed at early dusk and the $\frac{1}{500}$ sec shutter speed took me to the border of underexposure. This becomes the picture very well as the brief exposure creates a night mood not yet actually in existence, emphasising the contrast between the dark blue of the sky and the luminous red and yellow of the carousel's roof.

(Overleaf) Visiting Bali, I wanted to photograph the popular performance of the "Ketjak" (Dance of the Monkeys) in a manner more appropriate to its mysterious character — it is usually held in daylight for the tourists. At night, by the light of only a few torches, the "Balinese saga of the Gods" accompanied by ritual chants, appeared much more impressive.

The much-maligned flash seemed to be the most convenient light source as there was no high-speed colour films in the late sixties. With the aid of the main flash, which lit the 120 native dancers in the huge Elephant Caves, I triggered a follow-up flash, also known as a slave or servo unit, via a photo cell. This unit was hidden behind an idol in the dancers' midst, to light separately a small group in the background. The performance contained several exciting sequences which I would have liked to photograph repeatedly but unfortunately this was not feasible. These simple inhabitants of a small Balinese village were not able to interrupt their dance ritual let alone repeat individual sections — throughout the whole performance they seemed to be in a trance-like state. The hire fee for all these men amounted to exactly US$20!

This picture is probably more instructive if I explain how it was taken. I was in the Peloponnes when I overtook the peasant woman on her ride home with her tightly-packed flock. Looking ahead on the country road I could see that an attractive backlit picture could be taken. With the camera at normal eye-level, however, the sheep, peasant woman and extensive landscape background would be rendered too compressed, not as you see it in the photograph. The solution was to drive ahead for a few hundred metres, stop the car in the middle of the road and prepare myself at leisure.

Turning thought into action, the Volkswagon's sliding roof enabled me to climb through and perch on the roof. The bleating flock slowly caught up from behind and surrounded me. I took several pictures with the 35mm lens from my elevated viewpoint of 2.50m, with the Leica held at a slight downward angle. The bright-line viewfinder made it easy to watch the moving animals. I retained the distant Mediterranean as a narrow strip at the top of the frame. Everything worked out well. This gave me an appetite for repeating the exercise, as each picture of such moving subjects is a little different so I drove another 200 metres further up the road and in a flash I was back on the roof again!

The comparatively narrow angle of view was of course achieved from a high viewpoint — I took this picture from the fourth-floor window of a hotel in Colombo on the Indian ocean. The strong surf, that made swimming dangerous and the fisherman retreat from each wave, brought constant motion to the scene.

However, as I was able to determine the composition at leisure from above, I selected the diagonal as a special factor; compared to vertical or horizontal image elements, it gives the photograph a dramatic impact.

A little trick: the nimble-footed fisherman really held his rod with his right hand on the right-facing ocean shore. I had the enlargement printed in reverse. This is definitely feasible as it helps to increase the effect of the breakers rolling in from the left.

This photograph came about quite by accident on the way to the hotel. I was in a taxi, making its way through the multi-coloured groups of Hindus. The driver explained that they were the guests at an Indian wedding being celebrated in the' slum quarter. A longer halt was not possible at this spot, especially as I would have been surrounded by children the moment I showed myself with the camera. When the driver wanted to move on after a brief stop, I noticed a bridge, directly above us, leading across the area. I asked him to take me to the bridge as quickly as possible. Even on the way there I fitted the 50mm Summicron into the bayonet of the M3 and set the largest aperture of f/2, with a worried glance at the evening sky. At the same time I paid the driver the amount shown on the meter, plus a US dollar as a tip.

The railings on the bridge were a welcome support for the 1/15 sec exposure. Soon after the first few shots, some of the people squatting in the separate groups of men and women became aware of me and looked up. The onset of dusk by now required 1/2 sec exposure. Thus I had to content myself with just one series of pictures.

Every Indian travel guide cites the central Crawford Market of Bombay as especially worth seeing. From dawn to the early afternoon a turbulent and colourful spectacle is on display – mounds of fruit and vegetables interspersed with meat and fish stalls – typical market life with all its scents and smells plus the noise of the sellers haggling over prices.

In this picturesque market quick and inconspicuous action with the camera is recommended if the naturalness of the people is to be preserved. There is hardly any protest, most people even try to strike special photographic poses so you are well advised to refrain from advertising your intentions! If possible, do not hang the camera in front of you by the shoulder strap – try to hide it but at the same time keep it within reach. I hold my Leica as Paul Wolff used to; with one hand behind my back. Thus, I bided my time, standing behind the lemon seller and was able to record the moment totally unnoticed.

The real Africa begins just one step away from the tourist path — anyone who wants to experience it can do so.

Thus, in Medina, the old town of Marrakesh, with its confusion of narrow alleyways and courtyards, I only found this corner in the cereal dealer's souk by accident. When I tried to return later hoping to photograph similar scenes I searched in vain.

The brightly-lit centre of the dark framing was almost a vision from biblical times. Initially I stood behind a human wall of natives, through which I then pushed forward, hiding the Leica with the 35mm wide-angle lens behind my back. To avoid attracting attention by making elaborate preparations, I had to estimate shutter speed and aperture for the DIN 15/10 (ASA 25), taking the brightest parts into consideration. It was essential to work quickly — even the single second needed to focus on the old man caused loud protests — but by then I had my picture and they couldn't see me for — abundant — dust!

Occasioned by the November 1964 lectures held in India, I arrived at a small, quiet hotel in Delhi. It was quite hot for the season. Opening the rear-facing window of my room, I discovered a humble, but photogenic, narrow alley. Soon I was posted at the window with the Leica and 50mm lens. The reflective light metering, taken from above onto the dark pavement and brightly dressed passers-by was far too vague. A sensible reading had to be obtained – from the scene of the action into the sky! I quickly slipped through dark corridors, not intended to be used by the hotel's guests, down into the alley. There I took a reading of 1/250 sec at f/2.8 to f/4 for 50 ASA using incident-light metering.

Back at my window, I awaited the photographic opportunity. A short while later is was "red alert"! I was just about to photograph the black animals crowding into the narrow alley on their own, when I noticed the woman with the light-coloured cloak coming from the right into the frame of the viewfinder. I managed to wait until she had stepped almost into the centre of the composition. The way in which the bright-line viewfinder gives warning of the unexpected is also evident in the girl with the water bucket approaching from the left. At the decisive instant, before the two figures overlapped, I pressed the release.

(Left) In spite of the contrasting contents of these two images — the dancer making her veils come alive (during a visit to a Shanghai theatre in 1985) and the groom using a lunge-rein to control an unruly racehorse (New Delhi, 1987) — they share an essential feature. In both instances the essence of the picture stands out sharply from a blurred or invisible background. I would have liked to show such a comparison in a double projection at the time of my lectures, including a reference to the different countries of origin, but unfortunately neither existed then.

(Overleaf) A cloud-burst poured water onto the motorway as if from a waterfall. I was finally forced to parked under a bridge where I intended to await the end of the downpour. In the meantime I marvelled at the courage — or foolishness — of the other drivers racing past, heedless of lurking dangers of aquaplaning. Most of them zoomed past at high speed on the streaming wet road.

When the rain eased off, it occurred to me to photograph the situation. It was still daylight but all the headlights were on of course. I climbed up the steep embankment next to the bridge with my Leica bag and beheld a fantastic view from the top. Long lines of cars in chains of light reached back to the horizon with the shining plumes of water adding to the drama.

The rain had almost stopped. Behind my back the low sun emerged from dark rain clouds! My light meter showed only 1/60 at f/5.6 for 100 ASA. I needed a shorter exposure for the fast cars and the jets of water spraying up right and left. I deliberately underexposed, firstly at 1/125, then 1/250, and finally I even closed the aperture down to f/8! To my great fortune, it worked. Here you see the "best underexposed image": bright day turned into dark night!

The picture of an almost biblical scene, taken in 1964, in one of those surprise moments of which one has no inkling before taking the next turn in the road. The pleasurable shock almost takes one's breath away. Every photographer secretly dreams of instants like this. It need not be India but that country is a photographer's paradise.

I discovered this scene near Benares — now better known as Varanasi — in the province of Uttar Pradesh. The photograph was taken with the Visoflex II and 135mm Elmarit on the Leica M3. The 50 ASA of the Agfacolor film only permitted 1/125 sec at f/5.6 — f/8.

I could have been a little quicker with the Leicaflex, which came out two years later. Instinct told me not to set up the tripod, however useful it might have been. Without hesitation, I started to shoot with the camera hand-held. After the first few shots the peasant noticed me and absolutely refused to continue ploughing, in spite of all persuasion and offers of baksheesh. Nevertheless, four frames were in the can.

The elevated viewpoint, from a small hill, and the backlighting, from the low afternoon sun, demonstrate the compression of perspective typical of long focal lengths.

These two shots, of a shy Indian shepherd boy and his rather scared looking little sister, I owe to a strange situation that − at least originally − had nothing to do with the use of a Leica camera. These two children were herding their goats in the temple district of Mahabali Puram near Madras, where my wife and I were sight-seeing, when a sudden thunderstorm forced the four of us to take shelter under an overhanging section of rock. The children were nearly naked and the sudden drop in temperature made them shiver but this was not the only reason for the frightened look on their faces. They had been forced into close proximity with a strange man who held in his hand a threatening-looking object that he pointed at them, looking down a sinister pipe at his feet. I must have looked very menacing as I handed my Visoflex I, together with vertical focusing lens, and the bulky Elmârit f/2.8 (with adapter on the mirror attachment) protruding in front. The little girl's anxiety is clearly written in her face, her fingers pressed to her mouth. Her bigger brother's attitude is slightly different, he is not quite so frightened, averting his eyes to avoid looking straight into the camera.

(Above & Right) A ZEFA crew at work, photographing holiday scenes of sun, sea and beaches for clients such as travel agents.

The "genuine" snapshot shows a happy laughing group of young people on a catamaran but the reality is somewhat different – this shot was the result of many hours intensive work, Klaus standing knee-deep in water with his motorized R3. An assistant stands ready to change lens or film.

Despite the ideal lighting conditions between 7 and 10 a.m. and again between 4 and 6 p.m., it is still necessary to use a screen to reflect the sun from the opposite side onto the scene. This screen is neutral white or silvered to fill-in dark shadows. If a particularly warm light is required, a gold-coated umbrella is suitable.

(Left) A chip off the old block! My son Klaus, loaded down with a pair of R3's and a 400mm Telyt in a TELEVIT focusing mount on the Leicaflex.

CHAPTER 11

Photographer on the Russian Front

The railway journey from Berlin to the Caucasus took nine days and nights. Most of the 25 soldiers who had shared the freight wagon with me for the journey got off at Rostov. From conversations I had with them, although I did not get precise details, I gathered they were going to Stalingrad.

I finally arrived in Piatigorsk, a dilapidated health resort situated in the northern foothills of the Caucasus, too late in the day to look for my unit; the P.K. However, nearby there was a "straggler collecting point" where a "bed" was still vacant. I put the latter in quotes because it was merely a bedstead; I had to lay a tarpaulin and the wool blanket they gave me on the bare springs, but my sleeping bag, which I had used in a more comfortable way during the past nine days, guaranteed me a pleasant night.

Early next morning on icy, slippery and bumpy roads I tried to find my unit. The totally false information I received about the correct route was probably due to language difficulties with the otherwise quite friendly inhabitants. For this reason I had the unexpected opportunity of getting to know the town. Finally, in the Oktoberstrasse, I found my unit in a large building and reported to the company commander. Luckily for me he was a young, sympathetic lieutenant, as after all my travelling of recent months I had completely forgotten I was supposed to stand to attention and salute smartly when addressing an officer!

My billet was in a room with eleven other men. I introduced myself to each of them. The P.K., more than a hundred men strong, consisted mainly of drivers, technicians and other military personnel with only about twenty being reporters. I was part of the film, photo and radio reporter group; some of whom were very talented artists.

At this small place on the southern section of the front, 3800 km

from Berlin, the P.K. had a relatively quiet time with only a few men detailed to cover the defensive operations in the Caucasus, or visiting a barracks or a field hospital where one was not allowed to take photographs.

I heard that my predecessor, who had been killed in October, was supposed to have been an incredible daredevil. He was always trying to distinguish himself from others by saying. "I'll show you how to do it!" Therefore, it was seen as his own doing when he finally bought it.

I was advised by Werner, a film reporter, to take "acceptable" pictures, otherwise I could get a warning from Berlin to the effect that I was not a member of a camera club! They wanted to have pictures which described the positive side of life as a soldier with lots of happy, contented faces in favourable situations. These were the type of subjects he had to film. He said the falseness of the stories he sent back made him want to spit. I realised to my relief that we were apparently in agreement concerning our opinions, but some time was to pass before we had an opportunity to talk freely. We both had enough experience to weigh each word carefully when discussing politics.

The other reporters also had reservations and everyone grimaced at what they had to do but they were in a minority in the company. There were many drivers for the numerous vehicles: cars, motor cycles, with and without side-cars, and a special van fitted with a PA system which was used to encourage the troops going to the front. A mobile cinema shuttled between the sections of the front and showed peaceful feature films, with crooners such as Zarah Leander and other celluloid stars of the time. One vehicle was a mobile darkroom, another stored propaganda posters, leaflets and photos of Hitler in different sizes to suit the varying amount of wall-space in the soldiers' billets and canteens. Compared to these activities, mostly behind the front line, we reporters had more creative tasks, often at the front itself, but we didn't enjoy any higher status because of it − only military rank counted.

It was relatively peaceful at the front around the Christmas period. We had little to do except routine military chores such as guard duty. While others tinkered with their cars or motor cycles, we from the photographic section busied ourselves in the darkroom or cleaned the cameras. One always had to appear "busy"! Otherwise the ever-watchful sergeant major would sarcastically comment that we were obviously idle and find even more pointless tasks for us. Compared with my recent time in the garrison in north Germany, I felt my

presence in this unit to be completely nonsensical. The N.C.O.s played the demigod and looked down upon the newly-arrived reporter. I remained unperturbed and replied to questions such as. "Can you take pictures at all?" With a laconic. "I think so." Not a single word about my former life which belonged to the photography I could be proud of compared with the average level I saw here. The daily repetition of routine, from morning till night, stifled all intellectual intercourse under the dull pressure to be obedient and respectful.

The mess was prepared for the festivities. A blood-red swastika flag hung on the wall. The diabolical face of the Führer stared out from a colour print − from his position beside the Christmas tree he was supposed to hold us spellbound. Christmas presents were to be given from Dr. Goebbels for "his" PK men: a piece of soap of medium quality, a bar of chocolate made in France, writing materials, a boring book, 200 cigarettes of an unknown brand, a whole bottle of oude genever which I could exchange on the black market for butter, brilliantine (what for, for Heaven's sake?) and razor blades.

My Christmas Eve was spent on guard duty for which I had inadvertently "volunteered". I missed the Christmas celebrations but felt my absence was not a penalty. I only thought that the endless patrols around the P.K. quarters were particularly silly. I wore a lambskin coat and thick felt boots regardless of temperature. Despite the apparent nonsense of such a guard at this peaceful place I knew better than to skive off. A young soldier of the company had been court martialled because he had crept into a parked car and slept during his guard. He was sentenced to "only" 21 days bread and water in the guard-house in the company of rats and mice! Guards who slept on duty at the front were shot after a summary trial.

The remaining days of December passed in no time. There was nothing worthwhile to photograph. Moreover, we were always tired by about 9 o'clock in the evening due to the daily labour of collecting, sawing and chopping of wood in which everybody had to take part. There was no coal and our small iron stove needed more wood than was allocated to keep us warm.

Our daily routine was suddenly broken on the afternoon of New Year's Eve. The company was paraded at this unusual time and the C.O. ordered us to pack quickly, load the vehicles, and be ready to march off the following morning at a time still to be determined. Furthermore, with immediate effect, all incoming and outgoing mail would be stopped. The special drink allowance for New Year's Eve was cancelled, but one bottle of wine to four men would be issued

at dinner.

Of course this caused a great stir and rumours were rife. What we had already suspected soon became clear — an inevitable disaster at Stalingrad, meaning that our position would be threatened. In this pensive mood we passed the last night of 1942.

Understandably, the young men in the company had only one thought and that was to get drunk to forget their worries. I lay on my bed and stared at the ceiling. I recalled that during the previous spring, in the middle sector of the Russian front there had been a sudden breakthrough and men going on leave had to return. They had been taken off trains, quickly mustered and ordered back to the front. There had been a high rate of casualties among those with very little infantry training. No one was safe in such circumstances, not even P.K. men.

Werner came in, the Russian veteran, quite imperturbed. He guessed what I was thinking. He told me not to be depressed. It was possible that the move was to deceive Russian spies who lurked everywhere. He did not think that we would go north as hastily as it appeared. We had been ordered to put our cameras safely in with the main baggage and only carry a small kit-bag and a sleeping bag.

I would have preferred to have gone in the dark for a special personal reason. On this New Year's Eve a sudden drop in temperature to well below freezing had followed a thick fog and under the clear sky and the nearly-full moon frost was forming rapidly. You can guess what I saw in my imagination — frozen twigs, boughs, and fences, phone lines sheathed in brilliant crystals, roofs glistening in the morning light — the purest poetry for my Leica. But now I was without my camera because of the emergency I didn't want to take part any more!

In the town we passed long lines of people, weeping, bewildered, or even grinning. One could read their thoughts. On the one hand they were afraid of the Bolsheviks, but on the other they were glad to see our withdrawal. What would happen to those who had fraternised with the Germans during the last few months? No doubt is was because of those fears that we overtook fully loaded carts, undoubtedly refugees from the region. Our own column became separated as other vehicles pushed in between ours. We passed our canteen truck stranded with a puncture; thank God we had already been issued with cold rations. As we passed through the hilly hinterland we could see the high white mountains of the Caucasus in the setting sun.

Soon it became dark. We arrived on the outskirts of a town. Four

of us went to look for quarters for the night; a new experience for me. We could forcibly billet ourselves in any house, an action I would have found very unpleasant, so I was glad when a friendly farmer took us in. There was father, mother, three little children and granny at a spinning wheel in the corner. At first we appreciated the warm room but with all of us crowded together a nasty fug soon enveloped us. An old soldiers' saying came to mind. "Nobody has ever been suffocated by a stink but many have frozen."

Normally I would have held my breath and run out of such a room to take a deep breath outside. In the same way I would have preferred to starve rather than eat bread that had been fried in sunflower oil and turned in the pan by the countrywoman's dirty hands. But the darker it got in the room, the more indifferent I became to the horrors of the oily offering. That first night our sleeping quarters was the floor and I lay fully-dressed on top of my indispensable sleeping bag to reduce the hardness of the earth. I was surrounded by snoring bodies and mice scurrying about searching for bread-crumbs before I finally fell asleep but it was not so dreadful.

Excerpts from a Letter Home — February 1943

Almost three weeks have passed since my last entry in my diary. However, since our rapid retreat from the Caucasus this letter should have a good chance of reaching you even before my previous mail to you. The reason: a trusted friend is being dispatched back home with an urgent mission and he will post this letter when back in Germany. This is also the reason why I can write freely, as this letter won't have to be passed by the official censor. As you know we are not allowed to mention any names or actual events that take place here at the front. Now I can throw caution aside and report truly what is happening here — we are, and have been for the past six weeks, routed by an intensive Russian counter-offensive. The Russian troops, who are pursuing us so hard, are being amassed in the Kalmucken-Stepps from where they are pushing westwards. The much criticised order that we received last New Year's Eve in Piatigorsk, on the edge of the Caucasus, to pack our kit and get out, had not come one minute too soon otherwise a similar tragedy to the one in Stalingrad would have been unavoidable. It is rumoured that around quarter of a million German soldiers were either killed or taken prisoner in Stalingrad.

We have now travelled 800km on foot, all the way from the Caucasus to Rostov. As our P.K. unit is always near the army

headquarters, never in direct contact with the front, we had not seriously considered the possibility of actually being surround within enemy territory. The poor boys in the infantry are much worse off − their seriously depleted numbers have to bring up the rear.

In the middle of January someone came up with the daft idea that a P.K. detachment should be sent to one of the infantry divisions in order to report on the "flexible defensive battles" being fought at the front. Werner, the nice chap from the *Wochenschau* (Newsreel), and I were sure that we would travel together in one car. This mission − travelling in an ordinary car through the infantry lines engaged in heavy fighting in freezing temperatures and driving snow was a complete nonsense. We were caught up in the general retreat and in the prevailing chaos bumped into some fleeing soldiers, who had lost their kit and were trying to find the same regiment as us.

Our task, to report on "flexible defensive action", was hardly feasible under the circumstances. Instead, we joined the retreating troops in the hope of rejoining our own unit as soon as possible. At the edge of the totally snowed-in road we noticed dead horses and prisoners. Having endured several hundred kilometres of marching through the bitter cold, through snow storms, and with little food, those who could not continue were shot in cold blood and left by the roadside. We dared not abandon our car, we would have been as badly off as the infantry, relying on the strength of our own legs. Whatever vehicles there were could not take anyone else. Each was fully laden, sometimes we even saw men perched on the mudguards. Everyone was desperately trying to get as far away as possible. Later we heard how close we really came to contact with the rapidly advancing Russians when we crossed the Delta at Asow − it was a miracle that we got away. But despite these experiences, I never ceased to think of taking pictures whenever this was even remotely possible.

Werner, with whom I had often spoken about my doubts as to our position, did not understand my endeavours to take pictures. Particularly as our "mission towards positive reporting" − as he called it in his cynical manner − had no chance of success. He suddenly smiled maliciously and said. "I have a great idea for the two of us − we will use "Kaiserfilm"! Tomorrow we will go somewhere where we will not only get something good to eat but also something to drink." I looked at him nonplussed, I did not understand what he was on about nor what he meant by Kaiserfilm.

I soon found out what he meant. In our capacity as film and photo reporters we would visit a nearby food distribution centre. He had

noticed a board to this effect when we had entered the town. These places were usually administrated by older SA personnel in brown uniforms. "We'll tell them a tale." He decided. "I have to make a film of their distribution centre for the *Wochenschau* and you have to take pictures of them which will be published in the papers back home." He also explained to me what was meant by Kaiserfilm. It goes back to an anecdote told about Kaiser Wilhelm II. Apparently Wilhelm always insisted on being filmed at his public appearances but he was never interested in watching it afterwards. Therefore the film crew would save film by using the same piece of celluloid several times to keep the publicity-hungry monarch happy. Since then such tricks were always referred to as Kaiserfilm in the film industry.

We arrived in the yard of the warehouse. We saw several lorries being loaded but no uniforms to be seen anywhere. One elderly man assisted some others in loading the vehicles. He seemed to be in charge. We greeted him and he excused himself saying that he had no time to spare. "Surely you know we have to evacuate the site before the whole damned place is blown up!" We recognized from his accent that he came from Berlin. Luckily Werner changed his mind about the filming idea and instead told the truth, that we were looking for our regiment and had noticed, quite by chance, the sign-post indicating this centre and had assumed that he might perhaps know where it was. Fortunately he did and was even able to show us on the map how to get there. He also knew a lot more about the general situation than we did. The preparations for evacuation were well founded as the Russian stood "in front of the door". He divulged this snippet to us over a cup of real coffee − a very special treat, which, together with his Berliner accent brought on an intense feeling of home-sickness in me. We soon realised that he was not a "brown shirt" although he was in charge of this distribution centre. At this close proximity to the front and in the face of reality we were able to speak more easily of how we really felt. Our friend, and this he became in those few minutes, made a quick gesture across his neck indicating that he had had enough of the whole thing. Our mutual agreement was understood without having to say too much.

When we departed he offered us, without having to be asked, some provisions to take back to our regiment. he gave us such priceless treasures as smoked sausage, butter, and several tins of assorted foodstuffs. Finally arriving at our regiment with all these delicacies earned me the reputation of having certain "organisational talents".

A Normal Day on the Russian Front

In one of my letters from the front I told of an advance on a Soviet village on the Donez when events had turned against us and we were routed: the advance turning into a retreat. This mad rush to get away with our lives gave me food for thought. The shout. "The Russians are coming!" Aroused fear in all of us which smothered the ability to think rationally. Those who had been at the front since the invasion of Russia were less prone to succumb to such mad panic but the newcomers, the young recruits, many barely nineteen years old, were the most vulnerable to the terrible stories that went around. Stories telling of how the Russians would massacre any German soldiers they captured, or how they would drive their prisoners into houses that had been set alight by our troops and leave them to be burnt alive. These young men had not been part of the German invasion of Russia which had driven a desperate peasant population deeper into Russian territory.

A few days after this debacle I learnt that a counter-attack was planned on this particular village – as a reporter in the P.K. I was able to receive confidential reports.

The attack was started by about 30 Stukas, which dived low and bombed the Russian positions. Although we were about 10km from the action, we could hear the terrifying howl as they dived, which was the notorious feature of these aircraft. It was caused by a siren that the pilot switched on as he dived to attack. Tanks and heavy guns moved to a ridge that night, supported by artillery fire from positions further back.

The first forward move and decisive action would be over before I could get involved, because the poor light in the early morning would make it impossible to obtain useful pictures – films available in those days were not fast enough. On a previous occasion I had had to convince a commander, who had ordered me to join an advance party to take pictures, that my refusal had nothing to do with cowardice. "Sir, I must respectfully ask you to accept responsibility for the risk as I should have to use flash when making contact with the enemy at night!"

As dawn broke I was driven the 10 km to the front by a young soldier in a radio car. My companion was very proud of his equipment and handed me rubber-cushioned headphones which emitted sounds of dance music transmitted from some unknown station oblivious to the happenings at the front. We drove in the radio car on the frozen earth up some incline, from where we could see no-

man's-land sloping down towards the river Donez. I got out and ran into a bunker where a heater spread some comforting warmth amongst the sleeping and resting men who were closely huddled together, obviously cold and exhausted, glad of the short respite. Dawn was still barely visible on the horizon. I walked back towards the artillery line which was to start the bombardment as soon as the infantry met with any resistance in its move towards the village.

I had to abandon my original idea of taking colour photographs of the explosions against the grey-blue of the frosty dawn sky because it was already broad daylight when the first rounds fell. I had already lain quite a long time on the hard snow, Leica at the ready, waiting for the opening salvo. I had no tripod but a few heavy stones, suitably arranged, helped to provide the necessary support. I had reckoned on slow shutter speeds but this was unnecessary as time passed and nothing happened.

Then I heard from the artillery, who were in radio contact with the forward troops, that the advance was proceeding very well. I had to move swiftly up front to get some good pictures and as it was now full light I would be able to move much faster. I ran in the tracks left by the tanks as it was not only easier but I could also be sure that no mines would be in my path!

Soon after I had passed the former front line I saw the first dead Russian soldiers. The bodies must have been lying there for some time — I supposed they belonged to one of the patrols who had been rather active in the past few nights. The sight of these lifeless figures, half-hidden between the bare corn stalks, presented a sobering contrast to the pleasant early morning air and the uncanny stillness of no-man's-land.

The noise from the village ahead increased with the intensity of the firing. I hastened along, overtaking a group of soldiers from a signals unit who did not notice me as they were busy laying a cable. I stepped into an empty house which they would soon have to pass, with the idea that I would have a good view from the upper storey to take a picture as they worked. I thought of Dr. Wolff. He used to remind me that I should always look for the unusual shooting position; a view from the top — the bird's eye view — often produced good results. I then took another picture from street level to conclude my observations on the topic "signals unit". I then entered the village and it was a strange feeling to move through the streets where we had been routed only a few days before. I felt very uneasy. The streets seemed deserted with not a soul in sight, only one dead body lying in the middle of a road, face down and arms spread wide. A

few chickens scratched about in the dirt. That was it.

The soldiers from the signals unit appeared at last. They greeted me cheerfully and much too slowly for my liking we all walked towards the noise of the firing.

I was still in time. First I came across an anti-tank unit, the men resting against a brick wall. As soon as one of them noticed my two Leicas around my neck he called out. "Ha, I see the P.K. managed to get here too!" His tone was friendly rather than cynical but even so I felt rather ashamed because I had joined them so late. I asked a sergeant to brief me on the current position and enquired where the action was. This was not too difficult to locate, all I needed to do was to follow the noise and the ammunition bearers who turned into a street where some houses were burning furiously.

I found my way was barred by some high barricades which had been erected by the Russians. I climbed to the top. The scene presented me with plenty of suitable subjects for my camera. I managed to get a sufficient depth of field with the 35mm lens and a medium aperture to bring the river in the background and the machine guns with their gunners in the foreground, sharply into focus. My supply of colour film was limited and I had to use it sparingly. I managed to get some good colour shots, as well as a large number of black-and-white pictures.

I soon found more subjects. Behind the barricade a group of infantry soldiers rested eating their rations. I captured them too from my elevated position. Reality was not far away however. From the opposite bank of the river Donez we heard another bombardment start and I had to quickly run for shelter.

Excerpts from my War Diary — September 1943

Two years war in Russia has turned into a full retreat; which has been inevitable since the disaster at Stalingrad. The second front in Italy is also putting us under pressure.

In my "service" as a war reporter I cannot glorify the scenes I have witnessed during our withdrawal in this foreign land — they will always be lodged in my memory. Our "scorched earth policy" means that all the countryside on the other side of the Dnieper is being cleared. The inhabitants are not informed until the last minute that they have to leave and there are no exceptions. The orders are to raze the entire region, houses, crops, everything, so that it will be impossible for the advancing Russians to find shelter, food, or assistance. I feel ashamed and I can hardly look these tormented

people in the eye as they go past with anguished expressions. They are just as innocent of this war as the women and children back home. I find I cannot lift my camera to my eye, in spite of my overpowering instinct for photographic documentation. Anyone who still has cattle or a vehicle is fortunate, until they are requisitioned by the army, but anyone who has to walk carrying their children and worldly possessions is in a really desperate state.

The main harvest has been gathered in and the bulk of the grain, together with all the cattle, has already been carted off but the evacuation of the population started very late. Male inhabitants between 15 and 60 are taken alive for our industries which are so short of labour. Squads reminiscent of the press-gangs of old have been going through the villages and towns hauling men out of their homes at the dead of night to the anguish of their womenfolk − I'm glad I didn't have to be a witness to these dreadful scenes.

A few days ago I was attached to a sapper battalion, at that time situated south of Charkov, between the burning town of Losavaja and the Dnieper River a few miles away. They had the task of laying waste everything we passed including roads and bridges. I had been issued with a new motorbike and side-car, plus Robert, a nice Lance-Corporal driver. We loaded the side-car with our kit-bags, sleeping bags and the Leica bags. The pillion seat was hard but it provided me with freedom of movement. We headed into the stream of retreating German soldiers, on the way passing a village with every house engulfed in flame. Although I can hardly believe that the strict censors in Berlin will accept a single one of these hellish scenes from me, I tried using colour film under the overcast grey sky and the billowing smoke. It is a pity that it can only offer a paltry DIN 12/10 (ASA 12) sensitivity. I started off with the camera hand-held, but this was not suitable because of the slow shutter speeds, so I improvised and used the motorbike handlebars as a support! I chose speeds of $\frac{1}{2}$, $\frac{1}{4}$, $\frac{1}{10}$ and $\frac{1}{15}$ sec with corresponding large apertures on the 50mm, f/2 Summitar. I had a grey Leica IIIc with "WH" (Wehrmacht) engraved on its top-plate. I even exposed a few frames at 1, 2 and even 5 sec, holding my breath in the belching smoke. I wanted to blur the silhouettes of the soldiers to indicate motion as they dashed around the burning houses, but I was never sure whether these pictures ended up in a Berlin waste-paper bin with the ignorant judgement "incompetent blurs".

After a dry period a storm broke, heralded by muffled rumblings, and it rained heavily. Robert, a veteran of Russian campaigns, swore and predicted the worst. "If it keeps on like this the ground will

become a quagmire!" With the help of some sappers who had that morning blown up the heavy railway bridge at Losavaja I found their C.O., an extremely open-minded Lieutenant, who had already been warned of my arrival by Company H.Q. He understood the difficulties caused by the rain and the fact that I could not just dump the bike but even so there was no extra space on his squad's truck. In the end he advised us to drive behind one of the trucks.

The road was very good to start with. A relatively long stretch of 40km was to be covered during the night ahead whilst the sappers, bringing up the rear behind the infantry, blew up all the bridges, even the smallest ones. However it wasn't long before the bike got bogged-down in mud. Finally, the Lieutenant told us to attach the bike to the truck by a rope with plenty of slack so that Robert could steer the bike himself but if we became stuck we would be towed out.

Then began a journey through hell! So much mud became stuck between the mudguards and wheels that it locked them solid causing the bike to slip and slide all over the road before finally catching in the railings of a wooden bridge. The rope went taut and we were sure it would break − instead of that the truck came to a halt and its wheels started spinning! With a lot of swearing the sappers helped us back into the middle of the road and off we went again on our slippery nightmare through hell behind the sooty exhaust from Russian fuel billowing in our faces. I don't know how long it lasted but we no longer had a dry stitch of clothing on our bodies.

The lead truck then got stuck on a steep incline and blocked the way as its wheels spun. Everyone had to go and help − 25 of us lifted that rattling and thundering beast back onto the road. When the column resumed its journey we discovered that the rope had come adrift, leaving us stranded. To catch up we quickly had to grab all our kit and run after it feeling very angry and abandoned. We finally managed to scramble aboard a truck completely out of breath when red signal flares appeared in the sky not far behind us. Someone shouted. "That's the Russians!" The column sped on for several kilometres as if hounded by the devil so it looked as if we would never see the bike again.

As dawn broke the first Russian shell whistled overhead and landed quite a way ahead of us. The thought that we would soon have to pass that spot made me go completely numb. The column stopped again, the Lieutenant's voice rang out. "Everybody dis-mount and report to the lead truck, machine gun stand by!" This vehicle was again stuck deep in the mud but abject terror gave us all great strength! It was imperative that we keep moving otherwise we

would either have to shoot it out with the Russians on exposed ground or make a 10km run for it on foot. As another volley went overhead the truck was manoeuvred back onto the road amid cries of exultation. We would never have managed it so quickly without the open fear of death.

An inner voice was telling me that time was running out for any more such manoeuvres. Robert felt the same so we fetched all our things from the truck. I hung my two Leica pouches diagonally across my shoulders to stop them constantly bumping about. As we passed along the column the Lieutenant spotted us and asked what had happened to the bike. I could only point behind without being able to utter a word.

Our premonition proved accurate as shortly afterwards the Lieutenant ordered everyone to dismount to lighten the vehicles and to be on the spot if another one became stuck. We finally reached our forward base without further mishap, lucky not to have been shot at by our own side as they had given us up as lost to the Russians because the infantry rearguard had arrived long ago.

When I eventually found a billet I took my wet boots off but I was soon to learn that that is a big mistake unless you can rest for at least 48 hours! After a quick meal I flaked out on my rubber mattress which I hadn't even bothered to blow up because I was so tired and slept like a log into the evening. The events of the past few hours had been like a nightmare.

I was woken suddenly by the sound of firing and I jumped up, yelling out loud at the pain in my feet. Someone shouted. "The Russians have broken through – they're right outside the village!" I shall never forget the terror in his voice. My billet was at the edge of the village and it was pitch black outside. Apart from my sore feet, the abject fear which went straight to my stomach made me anything but a hero.

Nobody knew whether the enemy was even now creeping round the corner ready to throw a grenade through the window. All I knew was that I had to get back into my boots but because of my fear I felt no pain! I picked up my gun, one finger on the safety catch. Both Leicas were slung around my shoulders; there was no way anyone was going to steal them if it come down to hand-to-hand fighting. I opened the door and I bumped straight into someone who, in their terror, yelled. "Scheisse!" That swear-word probably saved his life because otherwise in my panic I would have shot him – instead we hugged each other with relief!

The immediate danger of a breakthrough had been averted. Next

morning orders were given to clear out a ration store before the sappers blew it up. Everyone could take what he wanted — what an opportunity of enhancing my reputation in the Company as a "magician" for producing things that were in short supply! Unfortunately I had neither the strength nor the means of transport to move the 50kg of sugar and the 100kg of butter that I was offered. I did accept a large carton of cigarettes which were exceptionally good "currency" for bartering. At 22.00 the whole building was blown to smithereens in a mighty column of fire and smoke. The eerie atmosphere of burning buildings at night is virtually indescribable.

I watched infantry units pass by, looming out of the darkness to be bathed in golden light from the burning store for a few seconds before being engulfed by the darkness once more. Hardly anyone stumbling past turned their heads, they all looked tired, pale and hollow-cheeked, with blank expressions. Some held onto the sides of the horse-drawn carts and were towed along. I don't think they were really aware any more of what was happening.

The next morning the Lieutenant gave me a proper certificate stating the reasons for the loss of the motor bike and side-car which I forwarded to my own C.O. Three days later he telephoned the Lieutenant and was very understanding about the loss, saying better that than the men who drove it!

We moved on to Crivoj-Rog where new billets had been found. The Lieutenant informed us that we were to go urgently to Dnepropetrovsk on a matter that would be important to me as a photo-reporter; the blowing up of the huge bridge across the wide Dnieper river. This was to happen at midnight, not the best time for such a difficult shot. The Lieutenant drove along the bank with me until we found a suitable spot about 1 km from the bridge. A Russian prisoner, promoted to "volunteer", was ordered to dig us a foxhole — what this boy managed to do in record time was absolutely amazing. I was glad I had a full pack of the recently acquired cigarettes to give him as a tip. He was also there when the explosion happened. The ball of fire which flashed for a few seconds in the middle of the bridge like a giant firework only allowed time for a single shot to cover the ignition of 26 tonnes of explosive. I was standing at the edge of our foxhole and the pressure wave sent me reeling, but the Russian boy caught me before I fell over completely. Immediately we dived for cover as debris rained down.

I would have needed different equipment to capture the whole sequence of the explosion. With the MOOLY motor drive, introduced for the Leica just before the war, I would have been able to make a

series of four or five exposures but that would have only been possible from a tripod. For us photographers in the ranks the MOOLY was out of reach — only a few reporters of officer rank had access to such special Leica equipment.

These particular diary entries ended on a light-hearted note when I was able to cash-in my loot from the ration store.

It was gone 2 a.m. before I was driven back to my billet after photographing the bridge demolition. We went through the town of Dnepropetrovsk which had been completely obliterated by heavy artillery bombardment. Because of the fast-approaching deadline for withdrawal my unit had arranged to send me by truck next morning to another store being cleared. On a previous visit I had "booked" a large barrel of honey. As a sample I had been given 5kg in a tin bucket! In return I had taken a whole colour film of the store, its Quartermaster and his men, which then I gave to him exposed but not developed as I obviously could not have it processed by the Sapper Corps.

I was waiting in front of my billet, an abandoned house, when I saw five privates dragging along a tired, morose but dignified cow. They stopped by me as I jokingly called out. "Where did you get that one from then?" They said they had heard it lowing in a deserted barn but it needed to be milked and they had no bucket. I told them they would find one in the kitchen. I then asked whether they really intended to keep the cow because she would soon have the Russians hard on their heels. I tried to bargain with them for her but had little to offer with my small bucket of honey. Like an bid in a card game I offered. "500 cigarettes." Whereupon one of them shouted. "Add another nought to that!" There was a brief argument but they were obviously interested. (My C.O. sprang to mind who had, more in jest, once expressed the wish for a cow.) I said. "Boys, I have exactly 1000 cigarettes in my kit. That is my last offer, otherwise get lost with your obstinate beast."

They shook hands on it and divided up the cigarettes. I fetched a pail from the kitchen. The boys knew how to milk a cow and got several litres. I called the animal Lotte because as a six-year-old I had watched and tried to help a farmer milking his cow who had been called Lotte. I watched my cow-trades closely while they were milking her so that I would also be able to do it, unlike the clumsy attempt of my childhood.

Now I was all alone with Lotte and led her across the street of the completely deserted town into a small garden. No sooner had Lotte smelt the grass than she dragged me along behind her so that I had

trouble in keeping myself from stumbling. She charged through a dilapidated old fence and nearly uprooted a tree before stopping suddenly at the sight of a huge marrow which fascinated her — unfortunately she was also standing on my foot! I managed to push her off as she happily munched away. I then enticed her back to my billet with a smaller marrow as bait where I installed her in the kitchen — she didn't like these alien surroundings and showed it by lifting her tail and leaving her "calling card" on the floor. Then she found an open window, stuck her head out, and began to moo loudly. Thank goodness the unit's truck arrived at that point. Fortunately it had a tarpaulin so that Lotte, plus the barrel of honey yet to be collected, could be hidden from prying eyes.

CHAPTER 12

Posted to Italy

It was November 1943 and more than six months since I had had a terrible experience on the Russian front. I had been engaged on front-line reporting, assisted by two comrades. We were just leaving a soldier's canteen by way of a revolving door when I realized I had left my Leica behind on a chair. I returned for it while they carried on through the door. Suddenly there was a terrific explosion immediately outside caused by a bomb that had been dropped from a small fighter plane and my comrades were killed instantly. I was trapped by the mangled mechanism of the revolving door and had to wait to be released. This incident left me dirty and scared but otherwise unharmed.

This occurrence brought a question sharply back into my mind that I had pondered for some years. Was I merely lucky or was my destiny guided in some way? I felt more inclined to take the latter view now.

Another event, a chance encounter, although totally different from the first terrible incident, reinforced my view. I am talking of a meeting that was to alter the whole course of my life.

In the middle of November 1943 my special home leave came to an end. I had been granted this leave because my home in Düsseldorf had been completely destroyed in an air raid. Even my journey to the Black Forest, to join my family who had been evacuated there, was not quite as straightforward as I would have liked it. Our German generals were trying to beat back a intense attack by the Russians on our retreating forces. They were gathering together whatever men they could find but my luck held out and I escaped being recalled to the front by a hair's breadth.

Now my leave had nearly come to an end, in three days I would have to return. I would need my transport orders which I had to collect from the army post responsible for the areas where I now

lived. This involved a one and a half hour train journey to a charming little town in the middle of the Black Forest.

It was not difficult to find my way to the army post. As a soldier on leave from the front I was treated very politely. I received my orders with the comment. "Have a good journey." Thanking them I could not suppress the question. "Where to?" Naturally, they could not tell me where I was being sent. This decision was made by some higher authority – the P.K. 691 – in fact.

Inwardly I felt worried. These marching orders did not specify anything in particular. The only thing they meant for certain was that I would be leaving soon for some unknown destination. Most probably I would be sent back to the harsh Russian winter. I still remembered vividly the hardship and uncertainty of the past year and I was afraid of having to say good-bye again to my wife and children. It would be hard to console them with any real conviction.

The last few days seemed to melt away. I had to get back to my family as quickly as possible. The direct way to the station led me over a busy main road; my progress was slow because of the throng of people. Moreover, I had to make sure I would not forget that I was now back in uniform. I had quite got out of the habit of offering the military salute to every uniformed soldier having spent the past few weeks in civvies.

As I threaded my way through the crowd I noticed an officer coming towards me. He was tall, his head and shoulders well above the rest of the crowd. I started the routine of military greeting: head erect, eyes left, my right arm angled to the corner of my cap, barking my salute whilst looking straight into his face. He was carrying something in his right hand so he responded to my salute by nodding as he glanced at me. For a fraction of a second I thought that there was a glimmer in his expression that I could not read properly. At the same time the thought struck me – didn't I know this face? I stopped, involuntarily it seemed, and turned round but how could I recognize him better from the back, it was absurd. Not so – he had also turned round and was walking back towards me. The whole scene happened as if in slow motion, partly because there was a certain intensity and partly because our actions were hindered by the throng of people around us.

The short time that it took for us to approach each other was not sufficient to jolt my memory. He must have noticed that uncertainty in my expression. As he stood in front of me he held out his hand and spoke. His deep voice immediately reminded me of an encounter before the war. "Dr. S... from F... We last met in 1937 at the Leica

School. Good morning Mr. Benser. You are still taking pictures?"

Now I remembered. He was a great Leica enthusiast from a neighbouring town and a physician by profession. I could see from his uniform he was now serving in the medical corps. We knew each other from my first Leica lecture in 1935 which I had delivered in his home town and I had immediately taken to the nice gentleman. He was nearly 60 then but we soon were talking freely and frankly about politics and other topics. His experiences in the First World War had made him a convinced opponent of war and he had declared himself an enemy of "those ghastly Nazis in their brown uniforms". When I met him again, two years later in 1937, the occasion being a photography course at the Wetzlar Leica School, we continued our conversations. This time we uttered our political opinions with a little more caution but we were still agreed on the same things.

Naturally I was aware that I had to be very careful. Now we were in the middle of a war — a war that he had foretold a long time ago — and any careless remark might be dangerous. I therefore told him quite factually of my career as a soldier; how I had escaped service with the photographically-hostile secret weapon company and became a photo reporter. I did not have to tell him anything about the Eastern Front, he saw enough in the hospitals where he treated the wounded to understand the hardship and danger endured there.

The prevailing political position demanded that no one spoke openly about their political feelings and Dr. S. did not refer at all to our previous discussions. He did not even respond to my careful comment about the precarious situation at the Eastern Front. I then glanced at my watch and remarked that I had to go because my leave was nearly over and I wanted to get back to my family as fast as possible. At this he looked me straight in the eye and said, his voice assuming more the tone of an order than a friendly suggestion. "I want you to accompany me back to the hospital before you return home. I need to examine you thoroughly and this time we will not talk about the Leica, but about you." He put his hand under my chin, lifted my head and, with a serious expression, continued. "I cannot let you go until I am absolutely sure that you are totally fit and I must say I have grave doubts about that."

With these words he ushered me towards a restaurant nearby. He was obviously well known to the owner who served me a most delicious lunch, moreover, he refused any food coupons and any payment. I was treated to this lunch as the guest of Dr. S.

Before leaving I was given clear instructions on how to find the military hospital where I was to ask for Dr. S., who would expect me

at 2 p.m. I was still rather taken aback at what was happening and asked, rather naively, what I should do with my marching orders and could I still get a train back home after he had examined me. His reply was. "You can take my suggestion for a thorough examination as a military order."

At 2 p.m. precisely I arrived at the military hospital where Dr. S. examined me from head to foot. His manner towards me was now purely that of the professional physician in contrast to the almost paternal and friendly attitude he had previously assumed. The result of the examination shocked me somewhat. "You will have to stay here in the hospital for further examinations and results. My findings indicate that you will have to wait for a final diagnosis. Please hand me your marching orders, I shall arrange for their suspension until a further decision can be reached. Ask my orderly to phone your wife, you must tell her that you have to stay here a few days. Tell her not to worry, she can come to visit you if you have to stay any longer. It should not be difficult to find accommodation around here as it is not yet the high season."

I need not explain myself any further if I say that, despite the entirely different prevailing attitudes of the present time, I will not divulge the real name of Dr. S, or the name of the town in the Black Forest which was also his home. This is a pity as I would have liked dearly to dedicate a memorial to this good man. I recently checked the telephone directories of the area and found several physicians of the same name who are practising there today. Obviously the family tradition has been carried on and some of his grand-children are continuing in this kind man's footsteps. The silent stubbornness with which this great man tried to keep me from having to return to the Russian front could be interpreted quite negatively by some people even today and held against his family.

To conclude this episode — Dr. S. knew about my love for Italy and in the middle of February 1944 I was finally released from the military hospital after "an intensive treatment for the initial stages of tuberculosis". My marching orders now sent me to Italy where I was to continue my "recovery" and service as a military reporter for the southern regions. I was posted to the Nettuno front which was just outside Rome, but my quarters were in Rome itself, which had been declared an open city.

A Secret Darkroom in Vatican City

Shortly after my arrival in Rome I found a tiny darkroom for rent

Our darkroom in Vatican City!

right in Vatican City, near St. Peter's. The simple room contained a real VALOY enlarger and two CORREX tanks with spirals which made the processing of Leica films comparatively reliable. This included using a converted chamber-pot as the fixing bath! With the aid of a comrade I was at leisure to develop and print the photos for my proposed documentary "Rome – open city – to the front line by tram!" At first we worked secretly because my C.O. wanted to employ me only for individual assignments but the series had already been agreed with a well-meaning P.K. editor in Berlin. In the subsequent weeks I succeeded in photographing extreme instances of the macabre co-existence of war and peace, for example:-

On a restaurant terrace in the via Veneto, an elegant head waiter serves *haut cuisine* from silver salvers. In a trench near the front, soup is ladled into tin containers from a bucket. The soldiers drink it hastily, crouching to stay out of sight of the enemy.

Sitting on a park bench in the sun, a pretty young Roman girl wearing elegant leather gloves leafs through a magazine. Her face is

hardly visible, it is partially concealed behind a veil of a *chic* little hat. Between the remaining walls of a ruined house, a single soldier hides as look-out. Strands of green fabric hang thickly over his face from the front of his steel helmet; hands camouflaged in dark gloves hold binoculars. Thus he can watch the nearby front without being seen by snipers.

A German officer in a box at the Rome opera house. Standing up, he applauds the singers who bow on the stage, brightly illuminated by the spot-lights. At the nearby Nettuno front, immediately outside Room, tracer shells − taken with a long exposure on the tripod − curve into the western evening sky. In the foreground of my picture the silhouettes of artillerymen reloading their guns are clearly visible.

Eight such contrasting subject pairs appeared on a double page spread in the *Berliner Illustrirte* shortly before the retreat from Rome. This publication by "war correspondent Benser" reconciled me briefly to my somewhat strange craft.

The Nettuno Front − Spring 1944

I had just left my peaceful quarters in Rome. A short distance away the war was raging all round, right up to the edge of the city. I lay the whole evening until midnight in a small bunker close to the front. I waited for the amazing display of enemy fire when they bombarded the whole front line in an irregular pattern which was difficult to assess.

That evening I had time to contemplate how the kind of war being fought here was in no way comparable to the fighting I had experienced at the Russian front.

However cruel the fighting was, regardless of which side and what means were used to destroy each other, explosives, phosphorous shells or grenades, every time there was a heavy engagement involving a lot of wounded an extraordinary thing happened without fail. Even in the middle of an exchange of fire, a Red Cross flag would be raised and firing would cease on both sides within a short time. This enabled both sides to move about freely with not a shot being fired.

I was told how the side who had suffered casualties would then dispatch their stretcher bearers to rush across the field, where only a minute ago heavy fighting had raged, to collect their wounded comrades without so much as ducking. When they had finished their task the ritualized killing would recommence. All this sounds quite absurd but at least it followed the laws of warfare.

At night the withdrawal was under way, with convoys of supply trucks driving fast over the dark roads. Their routes were within range of enemy fire, but they were relatively safe, hidden under the cover of darkness.

In my first few days at the Nettuno front I had not been exposed to any really dangerous situations. I had been able to develop my films in a make-shift darkroom in the mountainous area behind the front lines. When I examined my shots I found that the series on the subject of "Nettuno and Cassino" needed further pictures taken of the same regiment that I had visited a few days earlier. I telephoned the commander who had been very helpful before. He understood my problems and sent a car, which arrived shortly before dusk. Visibility was very poor and the trip took a considerable time. I sat in the open car with the box that contained my two Leicas, my lenses and kit-bag. Naturally we had to drive without headlights. We could not make out the road in front of us, the driver had to feel for it rather than see it. Suddenly I saw a car coming in the opposite direction. It was too late to avoid each other and we collided. I was propelled over the man in the front seat and landed headlong in a ditch. My impact was quite soft, I only received a rather hard bang on the nose which made me see stars. My comrades in our car and those in the other vehicle all suffered minor injuries, but none too serious. By the time we were towed away it was 10 o'clock in the evening. I had to continue on foot through the dark night to get to the regiment but I was cordially received when I did finally arrive. I had brought a few photographs for the colonel which I had taken earlier. He was interested in what I was doing and I used them to explain what shots I still needed. The accident was not even mentioned as occurrences of this nature happened quite regularly.

The bunker containing the colonel's quarters was situated directly at the Mussolini canal, the guest bunker was about 300 paces away on the other side, accessible by a little bridge. It was midnight when I was escorted to my quarters by one of the officers.

I carried my camera bag and my kit-bag, the lieutenant helped by carrying my sheepskin sleeping bag with which I had been issued after my arrival in Rome. It was so dark that you literally could not see your hand in front of your face.

Sporadic firing could be heard in the far distance. I could hear the frogs in the canal and the lieutenant drew my attention to a nightingale that was singing nearby. It was a peaceful night and the war seemed so far away. My companion was in good spirits. He told me of his girl, to whom he had sent greetings over the forces network;

I was touched by his tale. We finally reached the canal. We could not see it but we knew we had arrived by the sound of water close to our feet.

A moment later I lost consciousness. I have no recollection of hearing anything at all or of having any premonition whatsoever. The only thing I remember was that I still stood upright even after the first impact hit the ground nearby. The lieutenant was obviously lying somewhere close to my feet as I heard his cry of pain. I dropped to the ground by instinct and rolled sideways into the canal which fortunately was quite shallow at this point. I held onto the flat bank and it was possible to lean against the side with my feet in the water.

I went through the most terrible time in my life during those next five minutes — I experienced the purest, starkest fear imaginable. The human brain seems to function very efficiently when under extreme stress. First I looked around for the lieutenant and helped him as he came crawling down towards me, groaning that he had a splinter in his backside. One shell after another came down all around us in a tight pattern. We had no cover; we were completely exposed to a direct hit or to lethal splinters.

We lay huddled together wrapped in my sleeping bag to afford us at least some sort of protection. The lieutenant's groans were faintly audible in the absolute silence in between the individual hits. Each salvo was announced by a bright flash of light above the hills, followed by about five seconds silence before the next one.

After a two minute break in the firing the lieutenant whispered that we should try to get back as he was losing a lot of blood. Although the firing continued the shots seemed to be aimed a little to our right. During the next break in the firing we picked up our courage to make a dash for the colonel's bunker. I had to exercise a lot of self-control not to run on ahead but the badly wounded lieutenant needed my help.

I had left my Leicas and equipment behind and returned the next morning to collect them. When I examined the spot where we had lain the previous night I was horrified — it was pitted with craters and strewn with splinters. We were both incredibly lucky to be still alive.

CHAPTER 13

The Last Weeks of the War

The retreat from all fronts happened on the same date the German army left the area around Rome – 6th June 1944. The last nine months had been adventurous but not productive photographically. However, my own chapter of war ended with a surprising turn of events in April 1945 as my guardian angel decided I should be posted to a little village near Frieburg where I could billet on my own family!

Stationed with my own Family!

Planning, even for the immediate future, was very uncertain. The French were still fighting on their own territory at Belfort but it would not be long before they crossed the Rhine and as soon as this happened I would have to get away. Not out of fear of the enemy, the danger actually came from our own German rearguards, as the retreating flood contained groups of marauding SS soldiers, known as the "SS Werewolfs", who picked up anyone they suspected of being a deserter and strung him up from the nearest tree.

They could easily have requisitioned my cameras so it was high time to find a suitable hiding place for any valuables and camera equipment. I packed my equipment and some jewellery into tin boxes, dug a hole in the vegetable garden, under a cold-frame, and buried the lot.

Two days later the time came for me to leave. I put my kit-bag (which was padded out with newspapers and stones) in the car and made my farewells. Their pain at my leaving was quite real, my wife being the only one who was party to my plan, while the neighbours waved and witnessed my departure to join my allotted regiment. My wife, Ursula, knew that I planned to return the same night, throw stones at her window to announce my arrival, and then hide in the

already prepared loft which she would guard for the next few dangerous days. This was so that if the worst came to the worst and our house was searched, the other members of the household could not give me away because they would be unaware of my presence.

I drove until I reached a wood about 8 km higher up the valley where I left the car. Under cover of darkness and with the aid of the moon I managed to walk back home with little difficulty. As agreed, I announced myself by throwing a stone at the window. Ursula crept downstairs and opened the door for me. If we had not been so worried about the uncertainty of the next few days and the likelihood of a fatal outcome, we would have enjoyed this little escapade.

Luckily no difficulties arose with any German troops and two days later on 28th April 1945, the first French troops, together with a Moroccan unit, arrived in the village. I was able to leave my hiding place and my appearance at the meal table was a great surprise to everyone!

Our household had now expanded to nine persons. This arrangement was no different to thousands of other German families, offering accommodation to relatives and friends who had lost their homes in the heavy bombing of the cities.

The most pressing worry was to find enough food. This had been rationed for some years but was now becoming less and less every month. Circumstances were usually not quite so bad in the countryside as something could always be found. As money had no value bartering was the accepted form of trading but the poor evacuees from the cities had nothing of any value to trade because they had lost all their possessions in the air raids.

Safeguarding the Future

In this situation my conversations with Oskar Barnack came back very clearly. He had told me how scarce food was at the end of the First World War in 1918. He also told me how he found a solution for himself and his family. Money was worthless then too, but he was able to barter his skills with the farmers in the area round Wetzlar by trading photographs, taken with his original Leica, in exchange for eggs, bacon and flour.

I was now in a similar situation to Oskar Barnack's nearly thirty years before, so I would try to do the same — barter pictures for food. I used my "scheduled photographic operations in the area between the Rhein and the Black Forest" to organise a provisional darkroom. I had to try and find supplies of photographic paper of various

grades, dishes for developing, and all the other things that were necessary, just as I had done once already as a young recruit in 1942. I had already managed to bring south several CORREX developing tanks and a VALOY enlarger which had been stored in Berlin before the city was totally destroyed. Negative materials were more difficult to obtain. Films, like many other things, could only be acquired through the black market. My connections with the photographic trade did help in this respect; many remembered me from my Leica lectures and were quite happy to help out with one or two films.

End of the War in Wetzlar

While I was preparing for the end of the war in the Black Forest, back in Wetzlar two brave women prevented the destruction of the town. Despite the very real danger of falling into the hands of the Gestapo they had stayed true to their convictions and retained their integrity. One was Dr. Elsie Kühn-Leitz, the daughter of Dr. Ernst Leitz II.

When the American troops approached Wetzlar and the Nazi district administrator ordered the execution of a citizen because he had hung out a white cloth as a sign of surrender, Elsie Kühn-Leitz decided to act. She took her bicycle and courageously rode toward the American tanks. This was a very dangerous undertaking, her intentions could quite easily have been misunderstood. However, she managed to persuade the American commander that his troops would not meet up with any resistance in Wetzlar. She managed also to extract a promise to treat the inhabitants with consideration.

In 1943 she had been involved in an unsuccessful attempt to help some Jewish people escape across the border to Switzerland. This humanitarian deed cost her several months imprisonment in Frankfurt. There she was not only exposed to the usual hardships but also to the danger of constant aerial attack as the prisoners were never allowed to use air-raid shelters.

This was not the first time that Elsie Kühn-Leitz had come to the notice of the Nazis. She had expressed her strongly-felt opinions against the authorities' inhumanities in an open letter, denouncing the plight of women from the eastern regions who were serving in labour camps, describing them as "Staging Posts to Hell".

The other Wetzlar heroine was the forceful and determined Frau Beutemüller, commonly referred to as Mama Beutemüller, the cook at the Leitz Canteen. She managed to persuade the Wehrmacht officers stationed in her house not to blow up the bridges across the Lahn before the American troops arrived.

CHAPTER 14

The Egg is Hard Currency

My enthusiasm regarding my plan to take my camera into the Black Forest, visiting its most productive farms, was rather dampened after a talk with a professional photographer from Freiburg. He knew the conservative character of his fellow countrymen and advised me that Oskar Barnack's method of bartering with photographs, which were quite rare in 1917/18, would no longer be relevant in 1945 as conditions had changed. He did not think much of my idea of visiting farmers and offering to take pictures of their families as most people now went to a photographic studio on special occasions, such as a wedding, and so had family photographs.

"However." He confided in me. "I can see a continuous and lucrative business in a different, though perhaps rather morbid, direction. I am often asked to copy or retouch poor or faded amateur photos of sons and husbands who have died in the war. With a little skill one can do wonders."

My hopes of starting a business as a travelling photographer were suddenly revived through an unforeseen set of circumstances. The French occupation forces issued a regulation in late April 1945, stipulating that every adult had to carry an identity card with a photograph, called a "Laissez Passer", which had to be carried at all times and would be checked if the bearer moved outside his immediate place of domicile.

I was overwhelmed with requests and every day travelled many kilometres on my bike into the nearby Munster valley. I used to return the results of my first sittings during my second visit. Usually these were in the form of 4.5x6cm passport photos which I used to cut from 9x12cm bromide paper and my aim was to sell them in units of two, four or six.

The farmers offered me cash for my work but as I preferred to be

paid in kind I used to plead that I had ten people to feed at home and that my photographic equipment could only be got by barter. We therefore had to agree a currency for my services and to start with this was the egg, a well-known and generally accepted means of payment! The "price" quoted was 1 egg for 1 passport photo; the smallest order being 2 photographs. My first day's takings were 32 eggs which I wrapped in newspaper and carefully transported home in my knapsack. Although my success was well received, I wanted to trade in all kinds of food otherwise our diet would have been very monotonous.

Naturally, I also received enquiries for more interesting portraits than the quick, dull passport photo. Among the peasants in this area I discovered many lovely, fresh faces of children together with a wealth of weather-beaten ones belonging to their grandparents. For this work I used a 90mm lens, the ideal tool for portrait studies (I thought of Oskar Barnack and how happy he would have been if he had had one of these lenses).

Often I simply snapped away, particularly if children were involved. Although initially I had no order for these portraits, I used to take a chance and print them up on 9x12 paper and more often than not I was able to sell them without any trouble and as a result received even more orders. This earned me small, but sufficient, supplies of bacon, dripping, sausages, butter and, most welcome, plenty of eggs! And, after I had rediscovered the wonderful taste of home-baked farmhouse bread, I added that to my tariff.

Ursula contributed to the household income in her own way. She was a professional artist and used to paint portraits of the children in the area. The paintings were not only honoured by being displayed in a prominent position in the front parlour but they were also very well paid for as they took far longer to finish than a photograph. One farmer, who was really pleased with her portrait of his child, recommended her services to the miller in the next village who paid her a fee of 50kg of flour for painting his son. To make proper use of the flour the miller helped us to make a simple wooden baking trough so we could then bake our own bread. I was allowed the use of a baking oven that was provided for the common use of the neighbourhood once a fortnight to bake 6 loaves, each weighing 2kg, which was just sufficient for our family. I used to knead the dough from 12kg flour, some yeast and some sour dough. I shall spare you the exact details, except for a tip from the farmer's wife. "...knead the dough until it doesn't stick to your fingers but your shirt sticks to your back!"

After only a short time my supply of photographic materials had

dwindled. In all the years I had taken pictures I never had to worry about how many films I used and, like other Leica photographers able to load 36 frames into their cameras, I had the habit of taking more than one shot in a given situation – particularly with portraits.

Luckily I was able to obtain films and other important items for the darkroom, such as printing paper and chemicals, with the popular egg "currency" but going "shopping" meant a time-consuming journey into Freiburg. In those days the only possibility of getting there was by bike which meant I had to part pedal, part push it the 12km over hilly terrain so the journey usually took me at least four hours there and back. It would have been possible to cycle to the railway station about 6km away but the trains were very unreliable and there was always the danger that my bike would be stolen.

A steam wagon made the journey into town regularly to make deliveries from the lime works in our village that had already restarted its operations. This always left very early in the morning and it only had one comfortable seat next to the driver. At the back there was more space but it was totally exposed to the cold and wind. A further disadvantage was that it did not return until the evening or even later, as it was prone to break-downs. But petrol was scarce and most cars had been confiscated for official use anyway so this wagon was a cheap way of getting about, even if it was not exactly fast or reliable.

It was necessary to economise and I devised several methods of making each film last longer, particularly when taking the popular but undemanding passport photos. For a while I used the effective, but primitive, method of shooting two heads next to each other against a neutral background. In this way it was possible to obtain two portraits on one frame in horizontal format; the heads could then be enlarged individually. I dismissed the idea of extending this method to three heads by using a wide-angle lens as this would have exceeded my personal "threshold of shame" of what was qualitatively admissible.

A very interesting, if unconventional, method of capturing a large number of subjects with as little film as possible presented itself to me one sunny Sunday in the middle of May. In a village, close to where I lived, there was a picturesque church where over a hundred children were being confirmed that particular Sunday and it gave me the excellent opportunity of taking a large number of subjects with very few frames.

One of the farmers who lived in this village, for whom I had already made some passport photos, told me how the ceremony

would be conducted as he had a grandchild who was being confirmed. At about 10.00 a.m., after the religious ceremony in the church, the members of the congregation – friends and relatives – would come out of church and descend the ten wide stone steps, forming a line on both sides of the road that led to the centre of the village.

I went and surveyed the scene and decided to borrow a step-ladder which I would erect opposite the steps providing me with an unobstructed view of the church porch. I was going to use my 50mm lens and I checked my set-up through the universal VIDOM viewfinder, an accessory I always carried with me. Another inhabitant of the village observed me in my preparations and offered me the window of his house, opposite the church. I had to decline his kind offer though, with the explanation that I would not be able to change my shooting position quickly enough. The real reason will be revealed shortly.

After the adults had come out of the church the girls would follow, all dressed in their pretty white confirmation dresses with white garlands in their hair. Behind them would be the boys, all dressed in dark suits. All the children would be carrying burning candles in their right hands, held in a prettily arranged paper frill which, apart from looking nice, also protected the child's hand from hot wax.

I envisaged the scene and realized that most of the hundred or so little faces, that I hoped to accommodate on as few frames as possible, would most likely be turned towards their feet while looking where they were walking at the crucial moment of shooting.

The friendly farmer understood what I was getting at and suggested that he instruct his granddaughter to tell her friends that they were to be photographed as they walked down the steps but they would have to look at the camera to be in the picture. Now you can see why I had to refuse the offer of the unobtrusive place at a window; the steps would be far more noticeable.

Everything went according to plan. I was overjoyed to see how even the adults turned their faces towards me high up on the steps while the children gazed intently at me and I was able to get the scene into eight frames. I only regretted that I had not brought my other Leica, complete with 35mm lens, as then I would have been able to capture almost the entire group, from the very front to the back, all in sharp focus.

Little more than an hour later I was in my make-shift darkroom, installed in our bathroom. After development I washed the film in clear water and poured the fixing solution into the tank. Working on

the premise of the news reporter. "I need my pictures quickly and only today will do!" The final washing process had to be cut short and any chemical residues had to be accepted. With the help of some members of the household the whole process of developing and printing was performed at high speed. The film was dried with a hair dryer, the five best negatives selected and enlarged in the VALOY. To avoid mixing up the thirty prints that I was going to make of each negative, the exposed bromide papers were marked on the back in pencil before developing, which was then done in a large dish, fifteen at a time. From there they were immersed briefly in a stop-bath and then put into the hypo while the next lot of fifteen prints followed into the developer. Two pairs of helping hands removed the prints from the dishes: as we had no tongs this had to be done carefully with bare hands. At last 150 pictures floated for the final rinse in the one and only dish that was large enough to hold them all — the bath tub!

A drying press would have been ideal at this point. Instead we carefully had to dab the prints dry with clean cotton towels, finally pressing them between layers of towels to accelerate the process. If I had had to print up only a few pictures I would have used the iron.

The use of the bathroom as a darkroom presented an additional difficulty to the household as our only toilet was there too. The carefully blacked-out room was out of action for any use other than photographic from the late morning until about 4 p.m. Our four-year-old son was rather perplexed by this but the situation was not impossible, although the elderly members of the household found the solution much more difficult to accept, because we did have a large, unkempt garden!

About 5 p.m. I took my bike into the village and displayed my handiwork on the church steps with five sample pictures, numbered 1 to 5, stuck on a box. Soon my "stall" was surrounded by a swarm of children like bees round a honey pot. "One picture for one egg" was my friendly offer — they were off like greased lightening, probably to raid their mothers' larders or even the chicken coop, to return with the necessary "currency".

My turnover would have been even greater if I had taken my stall into the surrounding villages where many of the children had come from. Even so it was difficult enough to carry my day's takings — 123 eggs — safely home where my reception was enthusiastic.

CHAPTER 15

The German News Service

Our reasonably well-ordered existence in the French zone of occupation came to an abrupt end in the late summer of 1946. The supply of the most essential food-stuffs had been deteriorating daily, with bread and other important things strictly rationed. To improve the situation, the authorities decided to relocate those evacuees who had come from other parts of Germany. This decision was taken irrespective of the fact that the majority would not find a roof to put over their heads. In our case this meant back to Düsseldorf.

The railways were still totally disorganised with overcrowded trains and long delays, making a journey a very stressful event. A journey that used to take, say, eight hours would now take over twenty-four with many stops and nights spent in draughty waiting rooms. Therefore, instead of using a passenger train we decided to take advantage of the officially-organised "repatriation transport" in a relatively roomy goods train.

Strange as it may sound, transport in a goods train was much better although it took a long time but at least you could settle down comfortably on some straw and it was free. We knew we would have to accept being confined in the trucks for long periods at a time, that light and air could only enter through tiny cracks in the boards or the large sliding doors, and that it was rather undignified but despite these things we applied for this special transport home.

Only six of our immediate family started the return trip as my mother, who had so bravely lived through those hard times, had died in April 1946 at the age of 65.

I had known that my photographic career as a wandering photographer was at an end as the prospects of making a living taking passport photos and snapshots of childrens' birthday parties were non-existent. I had to look for some other employment and on

the advice of a friend and colleague from a group of war reporters I wrote to the Director of the Press Agency in Hamburg – the German News Service (GNS) – instigated by the British Occupational Forces.

I applied for the post of photo reporter, submitting a detailed reference from Leitz. The offices of the GNS were under the direction of Mr. Hans Berman, the former German Newscaster of the BBC in London, and I remembered listening to his news reports on the radio in the final, terrible months of the war. The BBC's call sign, a distinct. "da da da daaa..." Introduced the enemy broadcasts which were, of course, strictly forbidden. As we did not possess headphones we had hidden our radio under the quilt and listened there; safe but hot. Utmost secrecy was essential because a "patriotic" neighbour could easily have reported you to the Gestapo for such prohibited activities.

I can't remember what decided Mr. Berman to invite me to Hamburg, offering me the job as director of the picture agency, but I imagine I owe my being short-listed to the references provided by Dr. Hugo Freund, a director of Leitz. These references must have convinced Mr. Berman of the quality of my work at Leitz since 1933 as well as my political soundness, which had made the provision of the so-called "Persil certificate" unnecessary. This was the then necessary assurance by the authorities that the person in question had never been a member of the Nazi Party nor had been known to be actively involved in the activities of the Party.

It was agreed that I would start work with the Service on 15th August. Mr. Berman welcomed me and explained my duties. He hoped that I would be able to improve and speed up the output of the print department with its fifteen employees. The administration of the agency had not been properly organised and was in chaos.

Due to the enormous administrative task before me, and my own incorrigible habit of trying to do everything myself instead of delegating, I soon found myself totally desk-bound. There I was, the boss, trying to tell our photographers what they should or should not do.

It was the time of the War Crime Trials in Nürnberg: August and September 1946. The demand for up-to-date pictures, expected to be supplied daily to the newspapers in our British zone, kept us exceedingly busy. The technology for transmitting visual images was not available in those days so they had to be sent by our own vehicles or by special messengers from Frankfurt where the official Press Agency "DENA", installed by the Americans, was based. They used to supply us with pictures from Nürnberg and we could, in return, supply pictorial reports from the relatively close reception camp

Friedland, on the border with the Russian zone. We covered heart-rendering scenes of soldiers, perhaps given up for lost, being welcomed and embraced by their families and friends. Moving pictures of wives, children and parents waiting for news of their menfolk and holding out portraits of them in the hope that one of the returning soldiers might recognize the missing man and be able to tell of their whereabouts. These scenes represented a unique documentation of a heartbreaking time.

All of us worked long hours as it was impossible to conduct a nine-to-five office routine. The reproduction of newly arrived pictures and the printing up of negatives often kept us busy until the late evening, a messenger stand-by service being on call day and night. Our five photographic reporters who worked in the field, one of whom was a woman, worked with different cameras and the quality of the pictures varied accordingly. It must be said, though, that a good photographic talent should be able to overcome the limitations of poor tools.

If I ever had to prove to myself that I belonged behind a camera and not behind a desk then it was in Hamburg during my spell as the responsible Picture Editor. I am not complaining, I had a good job and should have been satisfied. However, I knew the right place for me was out in the field, taking pictures. Every experience has its good side though. I never dreamt that my work in Hamburg would come in useful later on when I established my own picture agency.

My job demanded that I had to suppress my leaning towards practical photography but I still kept an eye on Wetzlar and any developments there. I was able, within the limits of our budget, to buy some Leica cameras as well as other equipment for our processing lab. Getting these items so quickly at times of such shortages had nothing to do with my connections at Leitz, but was attributable to the weight and importance that our Allied occupiers could bring to bear. The letter-head read most impressively. "German News Service (BOAR) British Zone"

I was congratulated in Wetzlar for having landed such a dream job. I must admit I was fortunate, not many people could enjoy the privileges I commanded: a car with driver, open invitations to all cultural and sports events — the word "Press" was the magic key that opened almost any door.

We were entitled to an extra lunch allowance of 400 calories in the canteen at the GNS agency and in view of the very meagre food rations, the smallest special allowance was a precious and most welcome addition to the diet.

Black market activities flourished, particularly in St. Pauli, a district of Hamburg. Every luxury was available here – at a price. The following price comparison could be made about 6 months before the currency reform. On our ration allowance we received 62.5g butter per week so if you wanted to buy a little extra you had to pay 100 Marks for 500g. 100g of real coffee, a luxury which could not be bought anywhere else, was available here for 100 Marks. The main currency, equally accepted in all the four occupation zones, was the cigarette which cost between 6 and 7 Marks each: my comparatively high monthly salary was 700 Marks. Even so, this second German inflation of the 20th century could not be compared with the first, in November 1923, when half a loaf of bread used to cost more than a thousand million Marks!!

It was not only the scarcity of basic foods that was the problem in the post-war period. The supply of coal was another difficulty in winter as there simply were not enough goods wagons to transport it. I shall never forget that hard winter of 1947 – one night in Hamburg the thermometer fell to minus 20°C. Over 50 dead were brought out of the many temporary, corrugated iron huts in which the homeless found shelter. "Victims of the Cold" was the caption beneath our pictures.

Even we, who enjoyed the relative protection of the British forces, were not entirely shielded from this bitter cold. As the coal stored in the cellar of our offices in the Rotenbaumschaussee dwindled, so did the temperature in our offices, down to 10°C. We persevered, however, wrapped in our coats and hats as we sat at our desks.

The only real problem was in the processing laboratory as the prescribed 18°C could not be maintained in those conditions. I remember how we managed to turn out a few prints one day that were urgently needed for dispatch.

In the Wetzlar Leica school we had learnt how we could treat prints where certain structures or details were supposed to be developed more strongly than other parts of the picture – we used to breathe over the wet prints that came out of the developer or rub them between our hands. Our laboratory assistant in Hamburg smiled indulgently at my tips; she had managed to raise the temperature of the developer simply by stirring the Metol-Hydroquinone solution with her bare hands! Well, it was logical, our body temperature being 36°C.

There is one more event in connection with my work in Hamburg that I wish to include here. A colleague at the picture agency was a certain Renate Sch., a talented photographer and conscientious

worker, who preferred using a 13x18cm format camera plus tripod; I tried to persuade her to use the much handier Leica format but it was to no avail.

She had taken some rather charming pictures of scenes around a farm yard in Holstein, cows being milked and farm workers going about their daily routine. Although our agency was really more interested in topical pictures we took the photographically-excellent pictures into our library. She asked us to print a series of pictures from her negatives, which she wished to present to the farmers as a thank-you for allowing her to photograph on their farm. These good people were so surprised when their received the pictures that they sent Renate "and her friends at the picture agency" eight tins of syrup from their sugar beet production. It was agreed that this delicious and precious addition to our diet would be collected on a Saturday evening as our cars were always busy during the week. The driver, who also had a stake in this "sugar blessing", had been instructed to leave the tins in my small apartment as they weighed 5kg each and would have been quite heavy to carry upstairs to the agency which occupied the upper floors of the same building. Another considera-tion was that the transaction would then be kept within the relatively small circle of the picture agency as we did not want to make the other reporters jealous of our good fortune.

I had to work quite late on that Saturday night and I noticed that the whole building was in darkness when I arrived home. The light in the entrance hall did not work and neither did the light in my apartment, but I thought no more about it because power cuts were quite usual and I was well prepared for such eventualities. I always kept a candle and matches ready in my wardrobe on the other side of the room. I knew my way around in the dark but as I walked quickly over to fetch the candle I tripped and fell over something — the driver who had delivered the tins earlier that day could not have foreseen the power cut and had left them in the middle of the room!

As I flung my arms out in an automatic reflex to save myself my left hand went through the top of one of the tins and became totally immersed in syrup, even my wrist watch was covered in the stuff. With my right hand I knocked over another tin, which promptly burst its lid and spread its sticky contents across the parquet floor. I picked myself up, dripping with syrup, and managed to get to the bathroom without further mishap, but it took a long time to clear up the mess.

When I told my colleagues about my accident they all laughed heartily and even I saw the funny side of it after a while.

My First Picture Agency

The British handed over the GNS press agency to the German authorities as early as 1947. The DPD (Deutscher Presse Dienst) was now established on the same basis. It operated, as before, in friendly competition with the DENA agency, which was still under American control and had its offices in Frankfurt. I was retained in my previous position and the best thing about that was my title: Picture Director! It was my job to decide what the others would actually photograph.

In the period before the currency reform we mainly supplied newspapers with picture material and they generally wanted a record of current events. The scarcity of newsprint meant that editions were thin and sold out quickly. A single copy of a newspaper would be passed from hand to hand. People used to queue in all weathers in front of newspaper offices where the daily editions were hung out for everyone to read.

In this unusual situation I, together with Dr. Ulrich Mohr, one of our photo reporters, hit on a remarkable and quite profitable idea — at least for a while. We — that is Dr. Mohr, myself, and a third person who had a particular talent for supplying punchy captions for the pictures — established a picture display service. We called ourselves "Drei Mohren Verlag" (Three Moores Publishers).

Every week we selected ten pictures from the DPD archives, had them printed up in 18x24 horizontal format and sent them to several hundred subscribers throughout Western Germany. These pictures were displayed in windows of book shops, newspaper stands (which were short of anything else to display) and many other shops who wanted to attract their customers with a lively sequence of interesting pictures. This idea worked particularly well immediately after the currency reform as the shelves started to fill up and people were actually able to buy things. This continued until the early 50's when more and more newspapers started being published including *Stern*, *Spiegel*, and the particularly successful *Bild*.

CHAPTER 16

The "Etsi Picture and Film Service" and my African Adventures

The clever Drei Mohren did not go under in the face of all this competition from the new picture magazines - on the contrary! After all we were well equipped to supply pictures and films. The official press agencies were not quite so well off in this respect. The DPD had meantime been amalgamated with DENA of Frankfurt, forming the DPA (Deutsche Presse Agentur). However, pictures for advertising were not at all their métier. Towards the end of 1950 the Drei Mohren acquired a further member; a businessman from Hamburg who provided his yacht *Etsi* for excursions and travels in search of stories, reports and pictures. The company was henceforth called "Etsi Picture and Film Service".

Sometime during 1950 I began to realize that my time with DPA was drawing to an end. I had suppressed my desire to return to the life of an active photographer for long enough and now seemed a good time to resume my own professional career. A short visit to Wetzlar provided the opportunity of rekindling old friendships. Dr. Freund at Leitz who had been so successful in keeping call-up day at bay for me was still there. He assured me that Leitz would be interested in continuing the Leica promotions in the form of my illustrated lecture tours. He was also in favour of this idea as well as agreeing to the condition that I would only work for Leitz on a freelance basis from now on.

The demand for Leica cameras and all sorts of accessories was still much greater than the factory was capable of producing, but this would improve in the foreseeable future. The economic situation was still quite tight and Leitz could not be counted on at this point to make a down payment towards the cost of producing a new series of Leica slides. In any case the management would have to meet

officially to approve the venture. In the meantime I had to rely on the rather limited capital reserves of our small enterprise.

Our idea to arrange a journey by yacht to the south to find suitable subjects for reportage took shape. The trip was planned to take four months. We intended to visit Italy and the North African coasts of Libya, Tunisia, Algeria and Morocco to shoot film for the *Wochenschau* (Weekly News-reel) and to take colour pictures for some of the magazines that we supplied. The V-Dia Verlag of Heidelberg were interested in a range of pictures from the Mediterranean for a school project and this too fitted nicely into our plans. A number of these locations would also provide an excellent opportunity of shooting pictures for new Leica lecture slides. However, at this stage of the preparations this particular project had to be kept in the background.

When I put forward my wish to leave my desk and take up active photography again the management at DPA were quite accommodating, so I left after training a successor.

Two NSU Fox motorbikes with 98cc, 4-stroke engines from the then well-known Motor Bike Works in Neckarsulm had been put on board our yacht in Hamburg. These bikes had been provided by the company as a practical means of transport for our photographic excursions in return for the advertising value of including them in our pictures. This idea was the brain-child of Arthur Westrup, head of NSU advertising department, who ran quite forward-thinking, public-relations exercises even in those days.

Off to Africa

In the middle of March the 40ton, ocean-going yacht *Elsi*, 66ft long with a 75ft mast and carrying 1800sq.ft of sail, set to sea.

We three — the film reporter, his camera man, and I — preferred to let Dr. Mohr and his crew of four sail the boat through the Bay of Biscay on their own. The journey took longer than anticipated, a total of six weeks, because of an engine break-down which meant they had to rely on sail alone for most of the way through the Mediterranean.

Meanwhile we waited for the yacht in Naples. Film coverage of her eventual arrival on the 1st May ("with Mount Vesuvius in the background and a colourful bunch of Neapolitans waving on the quayside if possible" being the request from *Wochenschau*) was literally washed-out as it rained cats and dogs. Not a single person stood on the quayside and Mount Vesuvius was hidden by cloud. We unloaded the two bikes. They showed a few signs of their long

voyage but we soon managed to restore them to their former glory. It then transpired that the yacht would have to remain in Naples for several weeks to await the delivery of spare parts. However, we wasted no time and commenced filming and shooting. Thanks to my previous experiences during my lecture tour of Italy in 1940/41 I was able to perform the duties of a second assistant for the film crew. They knew no Italian and this made filming difficult as it is usually impossible without the help of local people. It was often the case that a ladder was needed or the power supply developed a fault and a local electrician had to be called. As I spoke Italian I was called in to assist, to the detriment of my taking pictures! We filmed and took pictures at the most diverse places: from the 2,000-year-old stone bath tubs in Tiberius' villa on Ischia to climbing Mount Etna in Sicily before sunrise in a freezing wind.

The delay in Naples upset my plans. Further delay was caused by shortage of funds and we did not land in Tripoli until the end of June. At these latitudes in high summer, between 11 a.m. and 4 p.m., the sun is in the worst position for taking pictures because it is too high and produces very harsh shadows. Also the prevailing temperatures − 40°C in the shade − make it advisable to stay indoors.

There were nine of us on board and the combination of the tremendous heat, the close quarters, the jumble of equipment, and the small kitchen where it was impossible to cook resulted in a very tense atmosphere and the most trivial incidents led to arguments. I was worried that my plans would fail completely because the others had decided to leave the intense heat of Africa and sail instead to Turkey via Greece and I realised that unless I went on my own I would never be able to produce the pictures for my Leica tours. Moreover I had no desire to spend yet more days in those cramped quarters and by now I was quite convinced that I was no great sailor!

I Travel on Alone − The Hard Choice

I now had to transfer my luggage from the much too small storage areas in the cabin into small bags and containers that in turn had to be accommodated on the small luggage rack of the motor bike. Although I reduced my personal kit to the bare essentials, the camera equipment too had to be reduced to the very minimum. I was particularly worried about the 50 or so colour slide films that I carried with me. I kept exposed and unexposed films in a rubber pouch which I stored in as cool a place as I could find every night. A very difficult decision was what to leave behind of my camera equipment.

The small capacity of the case and the long journey ahead meant that I had to do without my special gadget bag which held my Visoflex-1 together with the 135mm and the 200mm lenses. The decision to leave the 135mm,f/4.5 Hektor behind was particularly difficult as I had used this lens for a long time; either with the short focusing mount, ZOOAN, on the Visoflex or directly on the Leica with its normal focusing mount. I had thought the latter to be superfluous and had left it at home – now that I had to re-organise myself I was desperate that I had not brought it. The Hektor would have been ideal, but not with the bulky and heavy Visoflex. I was thus reduced to the following lenses: Elmar 35mm,f/3.5, Summitar 50mm,f/2 and Elmar 90mm,f/4. The latter being always attached to my Leica IIIf as its constant companion. In my despair at having to leave behind the Visoflex lenses I tried to console myself with the thought that Henri Cartier-Bresson would have made such a journey with even fewer lenses.

I was soon quite glad about my decision to take only the bare minimum of equipment. The heat and dust of the African summer was quite oppressive. However, I did take a second camera body as a back-up and insurance against accidents or other misfortunes. This was my Leica IIIa, which I normally carried ready assembled with a Visoflex. In the past I had had occasion to use this camera whenever my main camera broke down or could not be used for some reason.

I was not at all sorry to leave my electronic multiflash unit behind. I would not have used it in this part of the world very often anyway as I had found out that Muslims were not particularly keen to be "shot" with a flash. I sold it to a Libyan colleague who was very happy with his unexpected purchase while I welcomed this boost to my finances as I would able to live off the proceeds for the next two or three weeks. I bought some light clothing as well as a sleeping bag, which would be essential against the very cold African nights.

I was now quite free and totally at liberty to do as I saw fit. With the help of my Libyan colleague I studied Libyan and Tunisian maps. He knew his way round and advised me on my route: I should go from Tripoli via Ben Garden, Gabes, Kebili and then through the now very dry Schott El Djerid, a giant salt lake, to get to the famous Oases of Tozeur and Nefta. From there I could ride another 700km north via Sheitla and Kairouan to Tunis.

I sent an account of my adventures together with pictures, as if from my faithful NSU Fox bike, back to the NSU factory which they published in their magazine. I will reproduce some extracts here:

Companion's Situational Report from a "Low Angle"
Sender: NSU Fox AW 87-1270
15.7.51
somewhere in the interior of Tunisia

To:
NSU Works
Neckarsulm
(Wurttemberg)

Dear Paternal Delivery Works!
My lovable but quite crazy driver is laid-up in bed, nursing his leg after a fall which the two of us suffered yesterday afternoon in a sand drift. Under the circumstances neither one of us can blame the other, it was just one of those unfortunate incidents − in any case he suffered more than me; the worst moment came when the carefully guarded bottle of drinking water broke and the precious liquid trickled away into the hot sand. I really don't know why we had to come here in the middle of summer; October would have been much better.
You never know how to handle the roads here. Everything is fine until you suddenly come upon a sand drift. The most treacherous are the shallow ones, only 10-15cm deep, because you can't see them in the brilliant sunshine. If I am cruising along and hit one of these shallow drifts at about 40 km/h, my wheels − being rather narrow − lose their grip and we start to slide around in the slippery mess. And that is exactly what happened yesterday. Benser tried gamely to get into a lower gear but this proved impossible as he needed his legs to balance and could not use the foot pedal at the same time. We therefore described a nice arc through the air before landing most inelegantly in a heap on the road.
The really high drifts are much easier to negotiate as you can see them from a good distance. Benser knows what to do − he switches back to first gear, jumps off and runs alongside, pushing me with the throttle fully open up these miniature dunes. If any Arabs are nearby they always help to push.
Recently the road was completely impassable due to a drifting dune and Benser had to hire some camels with their drivers. There is a picture of me packed on the back of one of them.
Benser talks to me a lot. I don't think it's the heat, he says it's because I am the only thing around here that understands German! In Tunisia he managed to get by with poor French and Italian, as well as a few phrases in Arabic.
Yesterday was the most strenuous and exciting so far. To reach the interior of Tunisia we had to pass through the infamous Schott El Djerid. This is one of the largest salt lakes in Africa covering an area of 400 square kilometres.

After a sand-storm the desert roads were impassable on a bike. This was the solution!

In the summer it is dry with an 80 km crossing at its narrowest point. Every 100m or so there was a large drum or rock to mark the "road". The salty surface either side of the road is terribly dangerous despite its harmless appearance. If a wheel should sink in only as far as the rim it is almost impossible to get it out again. Just imagine 80 km through the burning heat with not a scrap of shade anywhere. Directly ahead of us one mirage after another enticed us on: cool oases with upside-down palm trees in a "lake" of mosques and minarets. It was a very strange experience.

This is when Benser started to talk to me. "Don't you dare let me down here in this inferno!" Suddenly, when we were right in the middle of the Schott with nothing but salt for 40 km in each direction and the sun overhead I could not get any petrol to my engine, all I could do was gasp, my heart literally missed several beats — so did Benser's! "Oh God, Oh God, Oh God!" He moaned as he stood or rather jumped desperately from one foot to the other as the hot surface burned straight through the thin soles of his shoes. Then he did something which would have been quite clever had he known what he was doing but it seemed quite illogical at the time as he had only filled me up with petrol in Kebeli; he took the tank cap off to check the fuel level inside. This action relieved the air-lock and allowed petrol to flow back into the carburettor and we were off again.

We should really have notified the French Gendarmerie at both sides of the crossing before we set out. The consequences if we had not been able to get going again are too terrible to contemplate. Only a few minutes stationary in that heat was unbearable.

The oasis was so beautifully cool!

There was one incident when my gasping for petrol was no false alarm. We had underestimated the distance between two points where we could get more petrol and were still two kilometres short of our destination when my engine begun to splutter. Benser laid me gently on my side to allow the last quarter of a litre to flow into the carburettor. When we finally arrived at the next

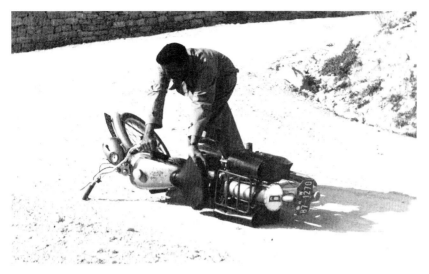

Coaxing the last drop of fuel out of the tank.

"petrol station" we had to buy it out of a barrel. The system was to pump the petrol into a see-through check-glass and then into the tank. Not only petrol but a lot of dirt as well was pumped out of the barrel and we had to kick up a lot of fuss before the system pumped reasonably cleanly. All this was observed by a crowd of youngsters who in the end fought over the last drops for their lighters.

Thankfully I am not at all dependant on water. However, travelling through these arid parts I became fully aware what it means to most creatures around me. Everything depends on the availability of water. It is hard to imagine how profusely the vegetation flourishes in an oasis in contrast to the barren desert. An oasis is a veritable paradise: bananas, oranges, figs, pomegranates, melons and grapes grow there while all around is miles and miles of sand. Every time we arrive at one of these havens we make straight for the watering hole as quickly as possible.

Benser found out that he could utilise me on occasions to take secret shots of forbidden subjects. He pretended that he had to repair something, touching this part and that, moving around me. Any bystanders soon grew bored and turned their attention elsewhere. This was his opportunity to shoot away with his 90mm, either from the saddle or even between saddle and tool box. This method was the only way to get natural shots of these camera-shy people.

All that remains to say for today is that we will soon send some very interesting pictures back to you. They will further illustrate what we have experienced so far.

From your trusty NSU Fox

Arrested Again – A Lesson on Candid Photography

Shortly after I arrived in Tunis I had the distinction of being arrested by two officers of the SST (Service Securité Tunisienne). They identified themselves by discreetly letting me have a look at their badges on the reverse of their lapels before asking me to accompany them to the local office of the Securité. It was 8 a.m. on 4th August – a time and date imprinted on my memory.

A little later they arranged for all my belongings to be brought from the hotel: my Leica equipment, my films and my correspondence. Two interpreters started straightaway to read all my notes and the short stories I had written by way of a diary. They worked methodically, reading every sentence and making lots of notes, which were then placed in separate folders to be forwarded to their superiors in Paris. To my questions about why was I being held I received inconclusive replies. I was also carefully guarded at all times, even when going to the toilet. When I protested about the lack of privacy I was told. "We do not appreciate it if our guests commit suicide in the washroom when our backs are turned."

When I challenged them as to why they were holding me, reminding them of my legal rights and *habeas corpus*, which also applied to French territories in those days, I was put in my place with the remark that I had not been arrested, only provisionally arrested. (The difference between being arrested and provisionally arrested eludes me even now!) However, they said I was free to insist of being properly arrested but then I would have to reckon on a prolonged stay in a remand prison; this did not seem much of a choice to me so I declined. My treatment in police custody was generally very polite and correct, I was even invited to eat at the same table as my guards and the interpreters. The food was brought in from a restaurant. As to sleeping quarters, I had a very uncomfortable and rough straw mat on the floor in one of the offices with only a thin blanket for warmth. However, this was the season of the Sirocco, a wind from the Mediterranean which brings with it a very close atmosphere so the thinness was not a problem. That said, in the early morning I would have appreciated a thicker one because this was the time of day when the mosquitos were most bothersome and I was regularly attacked by a hungry swarm.

When I was interviewed for the first time the next morning I became aware that they were not only interested in me but also in the yacht *Etsi*, in the Drei Mohren Verlag and also in the activities of the Deutche Presse Agentur (German Press Agency).

I shall spare you all the details of the many interrogations I was submitted to and report only the basic facts. The actual reasons for my arrest were due to an unfortunate set of circumstances: a German photo reporter had been arrested on board the yacht *Ingeborg* which was based in Bremerhaven. This person was supposed to be guilty of espionage and was threatened with a five year prison sentence. As the French consulate in Hamburg had issued visas in March to all the passengers of the *Etsi*, for the French Mediterranean territories, we automatically became suspects too. When crossing into Tunisia I had told the border guards at Ben Gardan – quite correctly as it happened – that I was travelling ahead of my party who would catch me up later. Since reporting entirely voluntarily to the French Controlleur Civil to explain my photographic project I suppose they must have kept a constant eye on my activities. My attempts at photographing from all sorts of unusual positions must have further strengthened their suspicion that I was indeed up to no good. Now that the *Etsi* had also failed to turn up this seemed to provide further proof that the whole thing had been carefully planned.

Judging by the instructions that the department in Tunis received, the imaginations of the Securité people in Paris must have been further fired by what they gleaned from my papers. This was made obvious by the curious questions that were put to me, some of which I shall recount here.

In a letter from H.U. Wieselmann, the editor of *Auto* magazine, Stuttgart, the following words gave rise to some intensive questioning. "By the way, I am sure you will be interested to learn that the people at NSU have got a new director. Mr. von Heydekamp, whom I am sure you know, has been appointed to the post. This is quite funny as he used to be in charge of building tanks – now he builds little Foxes!" I was interrogated along the lines. "Can you tell us more of this man? What did he do? What is his age? What else do you know about him?" I could not tell them anything as I only knew him by name.

Mr. Rumpf from DPA wrote a letter containing the words. "What you tell me of Africa is really most interesting. We must get together when you return and you can tell me more." That prompted the question. "What exactly did you tell Mr. Rumpf?" My reply. "This man is my successor at work. I told him of my photographic experiences, what kind of film I found suitable and what filters I used."

An old friend to whom I had sent a postcard of a nude as a joke had written back to me. "Your card was really good. I can just

imagine what you will see and experience once you reach the French territories!" More questions. "What did the writer mean and what did you say in your card?"

A letter from the Drei Mohren Verlag office stated. "Unfortunately Mr. Nannen is presently abroad, he will be away for some time in the USA. Therefore at the moment we are unable to show your most recent pictures from Tripoli and from the Beiram festival." Questions. "What did you photograph in Beiram and who is Mr. Nannen?"

I was not under any illusion that my answers would cause a great stir in Paris. After all I was really telling the truth and my experiences had absolutely nothing to do with politics.

Finally I was confronted with the deeds I was suspected of having committed. So far these were only alluded to in passing. For this purpose I was surrounded not only by interpreters but also by some more cool and serious interrogating officers.

I often pretended to be attending to the bike when trying to take pictures surreptitiously. This behaviour was to lead me into trouble with the French authorities.

A report was read to me in passable German by an interpreter. This had been composed by a secret agent who had tailed me in the Oasis of Tozeur. This read as follows. "The suspect tried several times to

place his motor bike in such a way to disguise the fact that he was taking candid shots with his camera. He took his pictures with a very large lens which was attached to a very small camera. He pretended to be attending to the bike but he was really hiding behind it, taking pictures from behind the saddle. He also walked about, seemingly without any particularly aim, in front of the Post Office. He stopped several times, his camera hanging on a strap around his neck, the leather case open. He finally took a picture of the display of fruits and vegetables in front of the building. Then he stopped again and looked at a group of children who were sitting on the Post Office steps. I thought he would take a picture of them as he was observing them for such a long time but he did not." As this report was read out I could hardly suppress my mirth. When I was asked what I thought was so funny I decided it would be diplomatic to give some explanation. As I did not wish to use my poor school French I asked the interpreter to help me out. I said very slowly in German. "I have to congratulate your agent for being so observant. However, he does not seem to know a lot about photography. The small camera that he refers to is called a Leica." I stood up, went over to the other table and took out the Leica IIIc and the 35mm Summaron lens. "Now watch closely and I will show you how I, the suspect spy, prepared to take my candid shots. This lens is a wide-angle lens. As the name implies, with this lens you can take a small group of people from close range; for example the children of the steps from whom I was no more than three to four metres away. I was very interested in this charming picture of native children in an African oasis."

"And before you ask me how I took that picture without your agent realizing I will let you into a secret. In situation like this we photographers try not to raise the camera to our eyes, otherwise everybody would know what we were doing. Especially in this country, with its large Muslim population, my activities can be most unpopular and even risky but you know that yourselves. To avoid raising the camera to my eye I work practically "blind". Even so, in most cases I am quite successful and get good pictures."

Whilst I was explaining and the interpreter translating everything I screwed the wide-angle lens onto the Leica and stood for a moment in front of my audience. The camera, hanging on my chest, had the scene in its frame. (With a little experience it is relatively easy to judge the framing and distance without looking through the viewfinder.) I had my left hand placed unobtrusively around the camera as I continued my explanations.

"I was not at all interested in the Post Office, gentlemen, only in

the scene on the steps; the mother with her brood of children." My obviously amused audience seemed to encourage me with their smiles to continue my lecture on photography. "If I had tried to take a picture of this scene the way normal tourists do." And at this moment I pulled the camera quickly to my eye and pressed the release. "The mother would definitely have protested. And this, gentlemen, is the reason for my subterfuge. In these countries where the Prophet forbids reproducing the image of people, it is not a good idea to try and photograph them in the normal way. This small camera is ideal for working "blind", particularly as the shutter is very quiet; I'm sure you could hardly hear it when I pressed the release just now."

At last I got the impression that my interrogators were more and more inclined to believe in the harmlessness of my activities. This turned out to be the case because soon after this interview my camera equipment and all my films were returned to me and, to my great relief, they let me go.

However, my enthusiasm to continue across the other French territories, through Algeria and Morocco, had waned. Moreover, I had also run out of funds, I had just about enough left to take a ship back to Palermo. I telegraphed back home to ask for some money to be transferred to await me there. The crossing was uneventful. The lower deck offered to me and my Fox was simple but reasonably comfortable accommodation. I spent almost the whole of September in Sicily which was, from a photographic point of view, most fruitful. the colour slides I took there were to be the most successful pictures on the lecture tours in the coming months.

The office! Outside it was 48°C in the shade.

CHAPTER 17

The Highlight of the Leica Slide Demonstrations

At first I only received a commission from a well-known travel bureau in Hamburg, who asked me to show my slides under the title *The World in Colour* but because of the great demand I had to repeat these lectures several times. After a while Wetzlar contacted me again with the invitation to give a lecture tour with the title *The Sunny South* which was scheduled for 1952.

Two-screen Projection – Necessity being the Mother of Invention

If, dear Reader, you attended any of my Leica tours in the fifties or sixties, you will remember that there were usually two screens erected next to each other on the stage. With this arrangement I could demonstrate photographic problems and how to overcome them. By projecting one slide on the left and one on the right, I could demonstrate correct and incorrect exposure, particularly if the two shots were of the same subject. The impressive effect of polarisation filters could be shown in this way: on the left the picture without filter, a beautiful landscape with meadows and villages in the foreground set against an imposing mountain range, but the whole picture obscured by haze despite the bright sunny weather. This is caused by the light being scattered by the haze and the colours losing their saturation. In contrast, on the right, I would show another picture taken of the same view but with a polarisation filter and the effect was quite startling. The meadows would now be luscious green and the red roof tiles glowing in warm tones, under a deep blue sky with the clouds sharply and clearly defined.

Before I hit on the idea of using two projectors, I used to show one view after the other, alternating them to fit in with the text of the

lecture, but the effect could never be so dramatic as projecting the two slides side-by-side. It was also very suitable for demonstrating the whole Leica system because I could compare the effects of different focal lengths. I was able to show not only how a distant subject could be brought in close, with a longer focal length, but also how it appeared more proximate compared with the wide-angle view, which embraces space and gives a totally different impression of perspective. This fact had never really been pointed out before but the use of comparable images gave me the ideal opportunity.

Today, multiple projection is a well-known technique but in 1953, when I discovered this new dimension for my lectures, it was quite revolutionary. I must admit, the idea came about entirely by accident. What happened was that I was scheduled to lecture in the largest hall that I had ever had to work in; the Deutsche Museum in Munich which could seat 2650 people! My 4x4m screen would look like a handkerchief on the 20 metre-side platform. Any viewer, sitting more than 30m back, would be unable to enjoy the full effect of the pictures.

Luckily, the manager overhead my comments and gave orders for the stage screen, which measured 10x12m, to be unrolled from its gantry. Wonderful! It would be ideal but I had to think quickly – to make use of this huge screen I had to get a second projector. I immediately phone Wetzlar and asked for another VIIIs projector. I would then be able to utilize this screen to its full potential by projecting slides side-by-side.

Knowledgeable people who were there at the time have assured me that my idea of multiple projection doubtless inspired, if not actually gave rise to, this system.

At its "première" the two powerful VIIIs projectors were positioned 35m from the stage. With 200mm lenses they projected a Leica slide to an enlargement across nearly 6m onto this huge screen. They happened to be working for the first time with 750w bulbs and had to be cooled with special fans.

Wetzlar arranged for a cinema projectionist, whose name was Walter Heun, to assist me in my endeavours. He stood between the projectors and, following my text, fetched the right slides from their boxes and loaded them quickly and deftly into the projectors. Sometimes he had to load both of them at the same time. Luckily, when I first adopted this technique there were not too many slides that were suitable for comparative showing. We observed that our viewers tended to look at the two pictures like a tennis match, their heads moving to and fro, and concluded that this stimulus should

prevent them "nodding-off" during the lecture!

In the early fifties we had neither slide magazines nor any electronic aids for automated projection. To overcome the difficulty of "darkening" the projector not in use Walter designed a "black-out" slide, made out of a 5x5cm glass plate covered with insulating tape.

I had taken a lot of multiple shots of the same subject, such as bracketed exposures, but most of them were never intended to be shown as they were incorrect, either from a technical or a composition point of view. Luckily, I had kept them and now I searched through my archives for suitable examples of "not quite perfect" shots of thematically similar scenes, to demonstrate how a particular situation could best be tackled. When showing both a good and a bad example, I used to jump around, gesticulating. "This is the way … not like that!" Leica fans in the audiences always acknowledged my self-critical remarks that accompanied these "demonstration failures" good-humouredly, recognizing their own mistakes.

That first lecture with two projectors on the giant screen in Munich, on the 16th September 1953, must have attracted a lot of attention. The word must have spread about it because when another show was advertised there, three weeks later, the doors had to be closed shortly after 7 p.m. because the vast hall was already full − more and more people kept arriving, forming a huge throng outside. When I arrived, completely unaware of what was going on, I saw mounted police trying to keep the crowd under control! Making an instant decision I borrowed a megaphone from the manager and announced that I would repeat the lecture at 9 p.m. Inside the auditorium I explained the situation and started the first show 40 minutes early. This experience taught me and Leitz always to book two successive evenings in the larger cities to accommodate the demand.

My Magic Lantern − The PRADO 150

A new 35mm slide projector had been developed and manufactured at Wetzlar and was ready for delivery. This relatively tiny instrument was immediately dubbed "magic lantern" by me − I had fallen in love with it on first sight. Leitz had named this little marvel quite simply PRADO 150. I decided to show it during a short interval in my lectures. Walter illuminated me by projecting a small beam through the black-out slide. I pointed out the fast Hektor f/2.5 lens and 150w bulb. Then I loaded a 35mm slide in each of the two slide carriers. The spotlight was extinguished and the hall was temporarily plunged into darkness. Then the first slide appeared; a very sharp and

brilliant, but slightly overexposed, portrait of a dog. First I showed the slide at the usual projection size of 1.5m, suitable for domestic viewing. So far, so good. But this was not enough to convince the packed hall of the excellence of this new little gadget. I then stepped off the platform, still carrying the PRADO and walked backwards, continuously readjusting the focus to keep the image sharp. Soon the projected image was six metres high – the same size as the previously shown Leica slides. As a finale I pointed the PRADO straight at the ceiling, producing a sort of "cloud projection", which was received with great enthusiasm by my audience. Still moving I suddenly projected the second slide – the focus having been set earlier – and the audience saw a bright, colourful reproduction of the well-known Wilhelm Busch cartoon *Max and Moritz*. In all my days delivering lectures I had never been rewarded with such thunderous applause!

When, a few days later, I received an urgent message from Wetzlar to cease the PRADO advertising I was very angry. However, I soon found out the reason for this strange request and was able to have a good laugh about it. The stock of PRADO projectors was totally depleted – every last one had been sold!

Demonstrating a "low angle shot" in front of my two large screens.

The "Max and Moritz" colour slide I projected onto the ceiling of an auditorium with the little PRADO 150.

First Lecture Tour in the USA

In the summer of 1955 it was clear that the Leica lectures should be given in the USA. Because of the experiences of the operation in West Germany, Austria, Switzerland and Sweden, it was decided to have two tall screens, up to 5x5m, on the stage in the future. The hall should accommodate not less than 800 persons, but preferably 2000. Bigger halls were not suitable because members of the audience sitting very far away from the screens would not get the overwhelming impression given by the big and sharp images. Only at theatres and opera houses, with balcony and boxes to accommodate more persons, could everyone have a relatively near viewing distance.

E. Leitz Inc. wanted to start my first lectures in October 1955. I arranged a much earlier arrival in New York to have enough time to prepare my text. As in 1953 and 1954 I had the same projectionist and assistant, Walter Heun, but with the big difference that the formerly very silent and detached Mr. Heun had become considerably more easy-going and talkative due to his mixing with the US troops of the occupation forces. So now I often stood silent beside Mr. Heun, who ebulliently made comments on my behalf! Instead of returning home at the end of the first US lecture tour, he was encouraged to stay longer by Leitz. After a very short time he became a course leader

and lecturer at the Leica School.

At the time I wrote some reports for the magazine *Leica Fotografie* about my impressions of the USA. These are so characteristic of the end of the fifties when air travel was so novel that I would like to reproduce an extract here:

Shortly before landing in the USA on board the huge KLM plane, we were served a drink called oude genever, which smells like wet wool but tastes delicious! The sun went slowly down and tinged the huge wings a reddish-yellow. Unfortunately it was definitely because of the oude genever that my picture of this dramatic sunset failed — I had put my finger in front of the wide-angle lens!

Selecting my programme.

After touch-down, an ant among ants, I followed my fellow passengers to the immigration hall. My knowledge of English was virtually zero. Everybody was checked very politely, very quickly, while pieces of luggage came off the conveyor belt. My familiar suitcase beckoned me so I didn't feel so vulnerable any more. Then it was off to customs where there were more conveyor belts. By mistake I put my large Leica bag on the inactive one. Suddenly all my Leicas tumbled out as I tried to put my big suitcase on as well. The customs officer saw what had happened and helpfully collected up all my property in front of him: two Leicas and my good old Leica IIIa, which was in another bag with the Visoflex. This last camera had worked very hard for many years and its range-finder was "in retirement" so to speak. There was also a bag

for the films, as well as another small bag and the tripod.
In the past I had experienced tiring explanations and arguments with narrow-minded border guards in such places as Jugoslavia, Greece and Egypt. They did not understand the rudiments of photography and the need for so much equipment.
But here in the USA you often see photographers loaded down with cameras and accessories looking like decorated Christmas trees. The understanding customs officer let me through, but not before glancing at the Leica with the Visoflex and 200mm Telyt with its elegant telescopic lens hood.
I felt quite relieved and thanked him gratefully. In my exuberance I nearly gave him the dollar note which was actually meant for the porter.

Photography played a greater part in the life of the average American in the fifties than it did in Europe. Just as owning a car was not considered a luxury in the States, it was same with photography.

None the less, up until then, no photographic organisation in the US had ventured beyond the well-attended club meetings, so Leitz, New York, were playing for high stakes when they began to rent mammoth halls, seating 1500 to 2000 people, without any previous indication of what to expect. I personally was not the attraction, it was the name "Leica" that drew the crowds. Photo-dealers, amazed but helpful, stood at the entrances of these halls to welcome customers and others while police and parking attendants had to cope with hundreds of cars. Newspapers reported that "for the first time in the history of photography the Leica has succeeded in convening purely photographic mass meetings".

"Don't Lose your Accent — You Slayed the Audience!"

As a foreigner in an English-speaking country you need many years of experience before you can give an interesting lecture for one-and-a-half hours without your audience falling asleep! I had only three weeks, not three years, so I applied the method which I had already employed in 1940, in Italy, to give the impression that I could speak the language fluently.

E. Leitz Inc. had already translated my text from German before I arrived. We then further cut and corrected it to fit with the slides before a professional speaker recorded it onto tape, which I then listened to and repeated, parrot-fashion, in my hotel room, every day for five to six hours. If it was late I would turn the volume down and let the words flow over me until I eventually fell asleep, but I can't say I literally learned it in my sleep.

The "gun" I bought in Chicago. This of course is not the very rare, prewar, Leitz RIFLE but the Sabre Stock, made and sold by the Sabre Photographic Supply Company of Illinois, in the late 1950's.

Of course, I had brought my portable lectern with me. This was another useful aid to deceive my audience because no one could see as I turned over my notes and carefully pushed them aside, page by page. Some slips of the tongue which I quickly tried to correct made everyone laugh.

The reason why they were so indulgent of my bad English was explained to me by a well-known contemporary film actor. One of my teenage idols, Harold Lloyd, whom I had admired for his dare devilry, now sat opposite me in the Coffee-Shop of the Sheraton

Hotel in Boston. Ironically, after 30 years, he recognized me first: he had been in the Leica lecture the evening before! After he had introduced himself and put on his glasses, he complimented me on my speech. I rejoined by telling him how I had shouted myself hoarse in the cinema in the scene where he climbs along the ledge on the skyscraper roof but because of my poor English, which he would have noticed already yesterday evening, it was not possible for me to convey my great enthusiasm for his films. Harold Lloyd replied. "Oh Walther, don't lose your accent, you slayed the audience!"

I looked taken aback and asked him what he meant by that. he remarked that the whole continent of America had been populated by immigrants in the past who couldn't speak one word of English on their arrival. Their poor English had been tolerated by the older-established population because their own parents and grandparents still spoke with an accent.

Return to the USA

My third lecture tour of the USA was planned for 1960. E. Leitz Inc. were asked by many towns which we had not visited in the two earlier very successful tours to be included. I had known the dates of our third tour, January to May 1960, for a long time. Fifty eight lectures were booked on a circular tour from coast to coast and back again. Anyone familiar with the vast distances to be covered will appreciate how tight the schedule was. Only four days respite between Forth Worth, Texas and Tucson, Arizona, with all our baggage crammed on the top of our VW bus.

I remember that I found the word "Sanatorium!" scribbled at the end of the tour itinerary which had come from the senior clerk at Leitz in New York.

The publishing house, which had published my book *Color Magic* in 1955 during the first US tour, planned to publish another one to coincide with this third tour. As the first book was out of print and its contents needed to be enlarged they didn't want to rack their brains thinking up another title so it was simply called *More Color Magic*.

The advance publicity for this tour was very thorough and the headline read:

BENSER IS BACK!
Europe's "professional amateur" to make third US tour
In the fall of 1955 a deceptively ascetic-looking German arrived in the United

States to begin his round of lectures for American amateurs on behalf of better color photography.

Some three months and 46 one-night stands later, Walther Benser returned leaving audiences totalling 100,000 asking for more.

Early in 1956, complete with dazzling slides and "gemutlich" (pleasant) accent, Benser returned for a second tour. This time he visited 58 cities drawing even larger crowds. One group arrived by plane from 600 miles away!

So the announcement of a third Benser tour, starting in January, should be welcome news to American camera enthusiasts.

Walther Benser has lectured and taught in Europe for more than 20 years and was one of the first instructors in the famous Leica School in Wetzlar, Germany. He is known abroad as "The Professional Amateur" — an unofficial title both intended and accepted as a compliment. For while Benser has all the skills of a professional, he has never lost the amateur's enthusiasm and approach to his material. His speciality is color and his subjects are those that interest every amateur. At the same time, he has plenty of tips that can teach professionals something about 35mm technique.

Laughter is permitted.

"Fun" and "enthusiasm" are key words in Benser's photographic vocabulary. His lectures, while rich in information, are also full of asides that hit 100 on the laugh meter. Photography, he feels, can be serious without being dull. By taking photography, rather than himself, seriously Benser makes his audiences better photographers painlessly, in a way that has put the "Standing Room Only" sign in the lobbies of lecture halls everywhere he appears.

He uses two screens instead of one to illustrate the photographic points he is making. On one is the 12-foot-high, heroic image of the not-so-good approach to a given picture situation. On the other is the same subject photographed with all the little knowledgeable tricks that Benser has at his command.

And there are plenty. For instance, the "before" picture might look like a prize-winner to 95 percent of the audience. But the "after" shot draws surprised and delighted "Ahhs".

The difference between the two? It might be the addition of delicately handled fill-in-flash, or a three foot change in camera position to include foreground framing. The two-screen technique drives home the lesson constantly.

From Icy New York to the Warm South

After the overture lecture in New York, I sent my new assistant, Rolf, with all our baggage in the VW bus on to Richmond, Virginia, which was our next stop. I then allowed myself the luxury of following more

peacefully by train because I had never travelled by this mode in the USA and I was curious about the experience.

Late in the evening, shortly before midnight, I stood with my suitcase in the large hall of Pennsylvania Station. It was as large as a cathedral but not nearly so quiet or solemn. After purchasing my ticket I rode slowly down on the escalator to the trains below. On the neighbouring escalator crowds of people moved slowly upwards, temporarily checked in their hectic life, and passed me with stoic equanimity. Nearly everyone was coloured and their skins seemed to glimmer olive-green in the cold, pale light. Here and there would be a bright flash of colour — a hat decorated all over with artificial flowers and jet-black eyes underneath — and then it was gone.

Rolf operating the PRADO 500 projectors with their 300mm, f/2.8 Hektor lenses.

Oh God! What wonderful pictures they could be! I thought seriously for a moment of catching a later train and staying here looking for picture opportunities. With the 35mm and high speed film a hunt for Cartier-Bresson-type subjects in colour would be well worth the delay. But I was about to drop with tiredness, a state I would often experience in the next few months, so reason prevailed.

According to the time-table my train would take about 6 hours to reach North Virginia. In contrast to the wintery temperatures of New York, the air-conditioning on the train was stifling. All the windows were hermetically sealed, as in American hotels, so there was to be no respite from the heat. At the end of the journey my shoes, which I had taken off, seemed two sizes too small as I struggled to put them on again.

I felt the symptoms of the enormous change in temperature during the day before the lecture. I could not afford to get flu. The local photo dealer recommended a physician who was also a keen photographer. By way of thanks for a very prompt injection of penicillin plus additional pills and advice I demonstrated to him how a Leica with two lenses would be perfect for his photographic activities.

The next day Rolf and I set out in the VW bus from Norfolk on the approximately 1000 mile journey south to Florida. Day by day, and finally mile by mile, we felt the heat more and more under the deep blue sky as we passed palms, flowering Bougainvillea, sunshades, sand, and determined, beautiful girls on water-skies.

I should have been glad about the sudden summer but I was not one hundred percent. I was in a listless mood and it was only through an inner sense of duty that I carried my Leica equipment round with me, but without any real intention of taking good pictures. I knew already what I was going to hear when I got back home. "What, no slides from Florida? In that paradise! Impossible, how could it happen?"

It was then, in Florida, that what I had known for many years really became clear to me. To be successful in photography one not only needs attractive subjects and suitable lighting but also an inner readiness which can only come about if you feel relaxed. The Turks have a proverb which sums it up. "Haste is the friend of the Devil"

Ever Helpful America

Somewhere on the way, in a big hire-car with automatic transmission which was absolutely new to me, I came upon a photographic

adventure in Alabama. Many miles of swamp-land opens up there with Spanish Moss hanging from the trees in silver-grey fronds. The tree trunks were reflected here and there in the brackish water under a dull and overcast sky. The whole atmosphere was ghostly.

I saw the possibilities for pictures. The swampy district was reminiscent of the impenetrable rain forests in South-East Asia. I stopped the car and took my Leica equipment out of the boot. During overnight stops in motels I was often too tired to take all the photographic paraphernalia into my room, which in any case was right next to the parked car, so everything remained locked in the car boot out of sight, thereby saving time the next morning.

With my bag I went down a small slope in order to find a good viewpoint but in my haste I had left the boot lid open. Suddenly a big white luxury car stopped behind mine. At first I though it was the police who would ask for my identity card. I still trembled with memories of experience during the Nazi period in Germany, so I was all the more surprised when a kindly giant stood beside my car and asked me. "Can I help you?" I was very embarrassed when I learnt that an open boot lid means SOS on American highways. I thanked him profusely for this unexpected gesture of help. The further west we went, far from the big industrial towns in the east, the more helpful and hospitable we found the people.

Lectures in French too?

I could simply have refused the request by Agfa-Gevaert to hold slide lectures in France. But at the last Photokina I was informed by a German-speaking publicity consultant from Agfa-Gevaert that they were toying with the idea of inviting me to hold lectures in France. He had been given a brief to discuss it with me.

He could speak fluent German so, thank God, I was not compelled to negotiate with him in French; otherwise he would have noticed from the very first sentence that I am not at all talented in speaking foreign languages. When I tried to express my regret, with a characteristic movement of the hand, that he was unfortunately mistaken because I would only be able to lecture in German in the Alsatian area of Strasbourg and Mulhouse, he answered surprisingly. "But I was in Turin in 1940 and went to your lecture which you held in Italian. Of course, it was no secret that you were German, but I was astonished at how you had mastered Italian with such confidence and intensity. Then an Agfa colleague enlightened me to the fact that you more or less learnt how to "speak" your lectures and

Animated discussion after a lecture
in Hungary.

then read them off. At the time I did not notice this at all. If you could manage it then with such a routine, you will be successful in France too, with your twin projectors and two screens!"

He seemed to have recognized how he could soften me up, because there is nothing I like more than being complimented on my method, which I had achieved with a great deal of effort. It was good to talk in German with a Frenchman about details of a possible tour in France. Then I told him about my meeting with Harold Lloyd in Boston and how he had encouraged me to keep my German accent and cultivate it for my lectures in the US!

The Frenchman laughed and immediately recognized what I was on about but he had to admit that, although the animosity between the French and the Germans was dwindling, a German who spoke French would not be so indulged as a Frenchman who spoke broken German, which apparently is attractive to German ears. He mentioned though that the French would accept a German accent and find it pleasing when spoken by a beautiful and charming German woman, which he emphasised by snapping his fingers, rolling his eyes and exclaiming. "Ooh la la!"

Joking aside, we soon came to the same conclusion that in France they are very proud of the structure and sound of the classical French language. Therefore, I had to have a watertight text in order to make an excellent translation into French which, of course, could only be made by a German-speaking Frenchman. An announcer from Radio Geneva was recommended to me for the best French pronounciation.

LEICA SLIDE DEMONSTRATIONS

Two months later I had the manuscript together with a tape spoken by the lady from Geneva. I had less than a couple of months before the start of the tour in Paris, so when I went to give my lectures in the Netherlands I took the tape and a small recorder with me. From that time onwards I practised French in every free hour.

In Groningen, a little town in the north of the Netherlands, it so happened that my lecture did not finish until 10 o'clock so it was after eleven before I finally took the tape recorder and tape out of my suitcase. I put on my pyjamas and made myself comfortable. As always, I listened to the French text first while I marked the emphasis of the words in the manuscript. After each sentence I pressed the STOP button and read it aloud.

Suddenly somebody knocked at the door and I had to press the STOP button again. I opened the door a few inches. The Hotel Porter stood in the hall and pointed out on behalf of the management that as the occupier of a single room I was not allowed to have a lady visitor at such a late hour!

Doing my best not to laugh I requested that he tell the lady himself. He was embarrassed and said that he had just informed me about it. But I didn't relent; I opened the door and let him in even though he was reluctant. On the grounds that the lady would not listen to what I told her, I took him first to look in the bathroom and then through a curtain into the shadowy bed recess. Nothing! I felt sorry for him because by this time he was quite confused so I brought the little joke to an end by pressing the START button to let her mellow French tones ring out again. Thank God he had a sense of humour and laughed very loudly. This story is still told by my former Leitz colleagues at their pensioners' evenings.

In later lectures I increased my "battery" to four projectors, but they were still hand operated.

CHAPTER 18

Freelance Leicaman around the World

In the autumn of 1953 I was travelling by car south of Hannover. The sun was shining, most of the sky was a brilliant blue but low down in the west dark grey clouds threatened. The French describe the colour most aptly as "gris orage" (storm grey). I had to capture this moody sky. Photographers interested in landscape photography are aware that such a dramatic sky needs a suitable foreground and this is not always easy to find.

Luck was with me. I had stopped in a small car park where there was little opportunity to move around to select a suitable shooting position. The landscape was totally flat. However, in the far distance I could see a large factory complex, the high chimney stacks reaching into the clouds, spewing out thick, yellow smoke. The air was still, everything seemed to be waiting for the impending storm.

It did not take long to set up my tripod, which I always had with me, and my well-used Visoflex I. The choice of lens was quite easy. I selected my 135mm Hektor and checked the composition through the viewfinder. I was pleased, it was an effective picture. I changed over to the 200mm Telyt, to check that effect, but my original assessment was the correct one. The narrower angle of view of the longer lens was unsuitable, the narrow chimney stacks were too close to the top edge of the picture. I changed back to the 135mm lens: the framing was better and I managed to avoid too much uninteresting foreground by tilting the camera slightly upwards. The increased expanse of sky was no bad thing – threatening heavy clouds extending over the stark outline of the factory stacks with the buildings still brightly illuminated by the strong sunlight.

This slide was one of my favourites and I used to cite it as a typical example when slight underexposure was beneficial to increase the impact of scenes such as this. Considering how rare such an

opportunity was, I used to advise my audience always to take a series of pictures, bracketing the initial metering in half-stop intervals, to ensure at least one perfect result. Sometimes it is a good idea to make sure and duplicate a shot.

During one of my lectures in a town not far from the place where I had taken this dramatic picture, I was addressed by a member of the audience. He recognized the site and identified the factory. Someone else suggested that I should approach the company and sell them my picture. "They issue a company calendar every year and I am sure they will be happy to get such a good picture."

I noted down the address and sent them my slide. My suggestion that they use it for their next calendar was accepted with thanks. I soon received the amount that my picture was deemed to be worth – a whole DM 50. This is approximately equivalent to DM 150 these days, but I was not at all happy with the way the fee was determined. I had always found it difficult to haggle about prices and my experience with the Press Agency in Hamburg did not help either. My department had not dealt with financial matters and I had no idea how much we used to charge for our picture service. When I protested to the company I was rebuffed with the remark that pictures were always remunerated with the same sum and I had "only supplied a 35mm slide".

The way photographers used to be treated 40 years ago was quite shameful. In particular, the products of a 35mm camera were considered inferior, although this was partly due to printing reasons and does not apply any more today. However, disputes of this nature led to endeavours to find some sort of reasonable arrangement between photographers and potential customers.

I recall another difference of opinion some years later. This was an incident that contributed towards my resolve to put the sale of pictures on a sounder basis. As previously, I was approached after a lecture delivered in Stuttgart. An advertising agent was interested in my slide of the Golden Gate Bridge in San Francisco. He told me my picture was. "Amazing!" I was not surprised that he liked it. To obtain my shot I had sought special permission from the bridge superintendant to be taken up in a tiny one-man lift, in one of the two huge towers, to a narrow catwalk used for maintenance purposes. From there, equipped with my 35mm lens, I looked down at the vast emptiness beneath me with shaking knees. At least this customer had asked me what kind of fee I had in mind; my dizzy view of the famous bridge was intended to be used on the title page of a book. I suggested DM 200. The publishers protested politely and

said that DM 150 was their top price; they also argued that difficulties with printing from a 35mm slide made them reluctant to use this kind of photographic material. In this case it would have been possible to ask for my slide back. However, I did want to see one of my pictures in print and I therefore agreed to their price.

The above recollections should illustrate how the work of photographers was assessed generally and the difficulties experienced with 35mm materials. 35mm slides were disliked from a reproduction point of view and some publishers would refuse to deal with them altogether.

Soon after that I met an old colleague, who became my partner. I knew he had great technical expertise and the necessary laboratory experience to produce technically-good 9x12cm (4"x5") reproductions of my Leica slides. We called these copies of my originals "colour doubles". this ingenious man was called Willy Vogt and he was the owner of V-Dia Verlag in Heidelberg. In 1951 I had supplied him with slides of my adventurous journey through North Africa, which he used for an educational picture series. We had known each other for years, both on a personal and professional basis. Vogt was a hard-working man and an expert in his field. He was one of those unfortunate people who had had to leave their homes in 1945. He lost his photographic business, darkroom and shop in Stettin. Stettin is in Pomery and today belongs to Poland. He moved to Heidelberg and built up a new life in the hard post-war years. Diligence and persistence won through and he and his family could once again feel secure. His story was typical of many Germans of that period. their attitude to hard work was the decisive factor in producing the German economic revival. Today Willy Vogt's photographic lab is considered one of the leading businesses of its kind in Germany.

A Leading Picture Agency is Born

V-Dia Verlag used to receive requests for individual slides from their educational series, from other publishers wishing to use them in their own books. Even advertising agencies used to place orders occasionally. Mr. Vogt soon realized that there was an up and coming market for colour slides, but 35mm colour slides were still not a popular medium for this application. Most potential customers were looking for medium or large-format slides. In recognition of having discovered a gap in the market that we could successfully fill, in December 1959 we founded the "Zentrale Farbbild Agentur", which was subsequently known as "Z.F.A.". I knew from my lecture tours

in America that some well-known picture agencies had started to distribute colour slides. However, they were in a better position because they were already well-known to their customers through distributing millions of archived black-and-white prints.

We soon found an editor who was able to take charge of the initial phase of our fledgling business. For a start we had about 4000 colour slides, partially from my own stock of pictures and the rest from the private collections of other authors of V-Dia Verlag. Having invested a small sum of capital, we hoped that this business would eventually be successful. Right from the start we met a problem. Our potential customers wanted to choose amongst our offer of 9x12cm colour doubles, but we preferred to produce these from the original 35mm slides only after we had received a firm order. Our solution was to produce a representative selection of doubles, of subjects that we thought would be popular, so that our customers would have a reasonable choice. To establish an archive of about 30,000 colour slides took eight years and in this time we managed to build up the business. It was not all plain sailing — many a well-meaning "expert" recommended that we throw in the towel and not sling good money after bad. Willy Vogt, my faithful partner, had his own worries in building-up his photographic lab, resulting in my moving back to Düsseldorf after two years in Heidelberg.

This is how the Picture Agency in Düsseldorf was slowly develo- ped. After 1962 it took another six years, a period which — against all odds — I kept my faith in the future of colour photography. This firm belief was partly the result of my experiences in the early period after the war when I had worked for the German News Service. I was well aware of the dangers of incorrect filing and how this could lead to wasting a lot of time or even loss of business. For this reason I introduced a punch-card filing system to register new archive pictures. The use of a computer was my next step. This investment was greeted with a lot of negative response by many experienced business people who thought that "I had over-extended myself with this heavy investment,it would only serve to drag me down".

This period coincided with the start of the career of a remarkable young man. He was then a student of sociology and I employed him during the summer vacation on a casual basis to frame our new slides and attach captions. Right at our first personal contact I realized that Eckart Grob had a keen and lively mind. He understood our problems intuitively and he was not shy to voice his opinions. He was one of the very few people who agreed with me about taking the plunge into the computer age. After a relatively short period working for me

I asked him to interrupt his studies for another six months and help me in establishing this side of the business.

The rather difficult-to-pronounce Z.F.A. was changed to "ZEFA" in the 70's and our image spread across Europe. We established ourselves with offices in London, Milan, Paris, Zürich and Vienna.

Today many people think I deserve praise for my insistence on continuing with the picture agency. This may be so, but I do feel that the eventual success was due to a large extent to the young Eckart Grob. My decision to engage him not just for the initial six months, but to persuade him to stay on with the agency and to appoint him manager with full responsibility for the computerization of the cataloguing, was most fortunate. Without his help and effort, it would never have developed into its current success. Eckart, in close co-operation with my daughter Sabine, has led the ZEFA agency right into the present day.

Meanwhile, I was able to concentrate on what I loved doing most of all, and which, especially after my African trip, I knew I did best. This was taking a Leica and seeking out pictures for the agency. I have been to many countries throughout the world and had many adventures along the way.

Hong Kong – A Wealth of Interesting Subjects

It was 1964 and I had just completed an extensive lecture tour through Australia and New Zealand and flown from Sydney to Hong Kong. My slide lectures, organised by the foreign representatives of Leica and Agfa-Gevaert, had been scheduled for the early Australian spring. To make the very long journey economically more viable, two lecture evenings had been arranged for Hong Kong, after the Australian tour. After that I was to stop off in Bangkok and then visit India after the monsoon was over in November.

In Hong Kong the large lecture room of the university was equipped with its own enormous projection screens and was ideally suited for my double projection system. The response to my lectures was reminiscent of the enthusiasm when I first introduced projection on two adjacent screens in the fifties in Europe and America. In those days one did not have to battle against the magnetic force of TV that keeps most people at home these days.

I asked for the two Hong Kong lectures to be scheduled within a period of eight days. This gave me the opportunity of wandering round looking for photographic subjects. Hong Kong and Tokyo are the most densely populated cities in the world. In Hong Kong an

incredible number of skyscrapers are packed into the very small island but part of the city is also situated on the Kowloon peninsular, which is on the mainland, and is less densely populated with stretches of green landscape along the waterfront and the railway to Canton. On the island, near the airport, you will find the largest accumulation of the poorest people of the world in the smallest area imaginable which has become known as the Walled City. Compared with such poverty only a stone's throw away the beautiful, modern and very comfortable hotels, the numerous international banks, the elegant stores, and the villas of the rich, gives food for thought.

I had to plan my itinerary with care. The people at the Agfa and Leitz agencies in Hong Kong, who had lived there for many years, helped me and I was overwhelmed with offers to be shown around. I talked with experienced photographers who knew the city well and quickly learnt where I would find interesting scenes and subjects. My choice had to include suitable pictures for further Leica lectures as well as increasing the range of my expanding picture agency back home in Düsseldorf, which was not particularly well stocked on this subject.

I found two scenes that would be suitable for both purposes by looking at a number of travel brochures. One interesting topic would be the world-famous, densely-populated side streets of Nathan Road in Kowloon where numerous shops offered duty-free goods to tourists. A wide range of cameras and photographic accessories were offered here at much lower prices than back home, including whole Leica systems. I bought the then fastest available slide film, Anscochrome 200. I hoped that my friends back at Agfa in Leverkusen would be pleased if I could show them the results of my exposure tests on this film from a rival manufacturer. I set my exposure meter to ASA 200 and noted what amazingly short shutter speeds were possible with the faster film and the bright conditions in this tropical climate. At night, the number and variety of dancing, glittering, moving, circling advertisements displayed all around me were a subject typical of Hong Kong, and to my mind one that not even New York could compete with, and for which this film was ideal.

The ugly mass of pipes, scaffolding and shapeless projections clinging to the houses, which could never have been approved by any planning department and certainly defied any safety standards, however lax, were transformed in the dusky light of the early evening into a magical colour composition. I shot away enthusiastically, trying to capture this strange display, and successfully produced a series of

slides that would be useful both for my lectures and as illustrations for travel brochures.

This was the first time I had had the opportunity to visit this part of the world, and those few days in Hong Kong turned out to be a spectacular part of my tour. With the help of a local guide I found an excellent, high vantage point near Victoria Point on Hong Kong island which, in the evening light, would present a most interesting shot of the entire harbour with the giant skyscrapers outlined clearly against the surface of the water. The viewpoint was on a wooded slope accessible only by foot and I took up my position long before dusk, Leica on the tripod, accessories at the ready.

I only had my shorter focal length lenses with me. I knew I could find subjects for my long lenses too but the very short duration of dusk would not allow many lens changes and the search for different shooting positions.

The time within which the best dusk scenes can be taken near the Equator is as short as 5 or 8 minutes. The inexperienced photographer can easily make the mistake of waiting too long before he takes his first exposure reading. In my experience, you have to take this reading within the first phase of the falling dusk because slides of such moody scenes usually turn out much darker than our eyes lead us to suspect.

A modified base-plate with two bayonet sockets to carry spare lenses – a non-Leitz accessory especially designed and made to order.

The colour slides that I took that evening were very successful in my slide shows and they also sold quite well through my picture agency. Thanks to my exposure series, I was able to secure ten good shots that were useful for a variety of purposes. At that time, in 1964, it was not possible to produce absolutely perfect copies of slides.

A little less than three years later the ten Hong Kong slides found their way back onto my desk at home. A customer had complained that the skylines of Hong Kong and Kowloon were no longer the same as shown in my pictures as new skyscrapers had been built. I did not have to go back there myself just to take new shots, I could always rely on the ZEFA reporter who covered this part of the Far East to take more up-to-date pictures. I had to make a note though, that these pictures too would be out of date sometime soon, particularly the views towards the landward side of Kowloon where they are always building new hotel complexes.

Fascination of a Photographic High Spot

It was almost 20 years before I visited Hong Kong again. My stay in September 1983 was very short as I was on my way to Peking where I had been invited to give a series of lectures.

My plans for an immediate connecting flight to Peking had to be abandoned on my arrival in Hong Kong as the area was under a typhoon warning and all transit passengers had to be accommodated quickly in the nearby hotels in Kowloon to wait until the danger had passed. I was not at all sad about this enforced stay, after all I could enjoy the welcome break in the long journey and I was sure of being safely accommodated during the period the typhoon was expected. Moreover, I had never experienced this phenomenon before and I followed the progress of the storm on the television in my hotel room as it ravaged the neighbourhood and sank ships in the harbour; small boats were thrown about like pieces of kindling wood. The storm lasted all night and naturally I was keen to find out what had happened, especially in the street which I had photographed on my first visit in all its illuminated glory, so I set off next morning to see for myself. Fleets of rescue teams and fire engines were everywhere, trying to repair or make safe damaged buildings, while all sorts of rubble lay in the streets, bearing witness to the forces that had raged in the night. Most streets were still closed to all traffic. With all the devastation there was no chance at all of making a comparative and up-to-date series to match the scenes I had taken twenty years before. I could have made a most effective comparison series but declined

the temptation as I have little talent for newspaper reportage.

When I returned five weeks later from China I set out to explore Hong Kong again. One pre-requisite for a successful, independent search for suitable subjects in an unknown and strange country is that one can communicate with the local people. I have wondered since whether I would have found the ideal shooting position for the Hong Kong panorama that I did, if I had not had the help of a local resident.

I asked around just like any other tourist and was directed to the picturesque fishing harbour of Aberdeen, a place which is recommended to every tourist as worth a visit. It lies at the rear end of Hong Kong island and its special attractions included the culinary offerings served in floating restaurants – boats anchored in the middle of the bay that can be reached only by boat. I marvelled at the sight of hundreds of fishing boats, tied up closely next to each other, crowded into the bay. I moved about trying out various shooting positions but however hard I tried, the profusion of detail required a higher shooting position to show the scene to good effect.

All around were only high apartment blocks, no offices or public buildings where I might have been able to gain access. In the past I had been successful by presenting my visiting card and making a polite request of whether it might be possible to take some pictures from one of the upper storeys or even the roof. I am not really the reporter-type and did not dare press one of the bells to ask the inhabitants, via the entry phone, if they would kindly admit me. I realized the limitations of my situation and considered whether it would not be wiser to give up my anonymity and ask one of my local contacts to guide me. I was certain that I would find the necessary assistance; on the other hand I was loath to give up my freedom.

On the way back to my hotel I felt quite content as the afternoon light was most favourable for all sorts of subjects. A young Chinese student observed me in my activity and his questions indicated that he knew something about photography. Our conversation turned to my difficulties in Aberdeen and he understood my problem immediately and offered to help. He thought he would not find it too difficult to gain entry to one of the apartment blocks so that I could get access to the roof.

When I went down to the hotel lobby next morning to meet him, as arranged, I was surprised to see that he was not alone but that there were three other people with him. He introduced them as two friends from the University and his girl friend. John (that's what he called himself) explained that his friends were also interested in

photography and would like to watch me during my picture taking.

I agreed reluctantly, but the arrangement did have its advantages as I was now able to take two more Leica bags. In one we carried my Leicaflex SL 2 with the short and medium focal length lenses; in the other the 90mm Summicron-R and the very fast 180mm Elmarit-R f/ 2.8 plus my 2X extender which would take both of these lenses into the super telephoto range. I only took this bag if I could be reasonably sure of its safe transport. If I had gone on my own I would only have been able to take the M3 with the three essential focal lengths: 35, 50 and 90mm. Instead I was able to distribute almost my entire equipment between my four companions. The natural way in which these strangers offered their services made me feel quite at ease; I could not have expected the same sort of assistance from one of my official contacts.

On my wanderings the previous day I had marked out one of the high buildings from which I could imagine pictures of the bay from the bird's eye perspective. John managed to get us inside and the lift took us up to the top floor where a small staircase led up to the roof, the only barrier being a small trapdoor secured by a simple bolt. John climbed the stairs, unbolted the door and stepped out onto the roof. Then, with a bow and a theatrical gesture, he invited us to follow. The roof was flat but the snag was that the view was barred by a 2.5m high parapet wall. I thought our attempt had failed but John told me to be patient and that he would go and look for a ladder.

I started to get my equipment ready, fitting lenses that I thought might be useful to both cameras. One of the students stood close to me and inspected my equipment with surprising expertise. He remarked approvingly that he agreed with my decision to hold on to the Leicaflex SL 2 as this camera was still highly regarded but was more expensive than the newer, electronic Leica reflex cameras. We then discussed the methods of exposure metering with the practical Lunasix meter and it was nice to hear that he too preferred the integral metering method.

After a while, John returned with a simple wooden ladder which he leant against the wall – it was a bit rickety but my first glance through the viewfinder made me forget everything. My shooting position was ideal, exactly what I had hoped for. I would be able to take not only a good overall view of the harbour but also very nice small sections with the longer focal lengths. The sunlight was glancing in from the side and everything was perfect.

The knowledge of my assistants was very good. I did not even have to get down from my ladder to change lenses, I simply handed down

the camera to the student who knew the Leica system and asked him to take out the 50mm lens and change it for the 180mm, which he did with agility. When I looked through the viewfinder I realized that the 90mm lens would give me a better framing and asked him again to change the heavy Elmarit for the less bulky Summicron-R 90mm. Then I dedicated myself to my task of selecting picturesque scenes from the lively activities in the harbour, hardly pausing between shots.

I Will Never Know

I was so engrossed in my work that it was some time before I turned to say how pleased and grateful I was that they had helped me to find this excellent place. To my astonishment I noticed that John's girl friend was nowhere to be seen and the other three stood close together talking, not very far from the trapdoor, and with my two Leica bags slung over their shoulders.

My first terrified thought was that they were going to rob me, the possibilities raced through my mind — they knew about photography, the value of the equipment, and the girl had already disappeared. Once through the trapdoor, securing it by the bolt, they would be off with my equipment and I would be left up here on the roof powerless to do anything about it. What to do? Should I leap off the rickety ladder and try to snatch all my equipment from them? But would I be quick enough?

I realized the potential danger I was in but at the same time I acted quite intuitively — I raised my Leica to my eye, focused on the group of students, and called to them. "Hello boys, keep smiling please!" Automatically they all turned round in surprise and looked straight at the camera.

Trying to appear nonchalant, I said I thought it would make a good picture and be a reminder of my stay and their wonderful help, and would they please keep still so that I could take another two shots! After a glance at the frame counter I lied that the film was used up. Then, in full view of the watching students, I rewound the film, took it out of the camera and put it safely in my trouser pocket.

I don't know to this day whether I was the victim of sudden paranoia or whether, by my presence of mind, I really did forestall an attempt to rob me. We continued our conversation over the next few hours and the more I talked to them, the more I became convinced that I must have been mistaken. Thank goodness I did not show my terrible suspicion.

I recovered my composure, and my equipment, and felt sufficiently happy to take more pictures of Aberdeen on a newly-loaded film. As I knew that my companions liked to watch me taking pictures, I allowed them plenty of opportunity of climbing up the ladder to look through the Elmarit-R 180mm at the floating restaurants. This also gave me the chance to invite them all for dinner on one of them.

In the meantime John's girl friend returned and, in view of my recent suspicions, I could not suppress the remark that she must have left because we four photographic enthusiasts were too boring for her. She seemed to be embarrassed about replying so John had to explain the reason for her disappearance; she had gone in search of the "Ladies".

When I told this story to some friends they congratulated me on my quick thinking. If the students had run off with my equipment there would not have been the slightest chance of identifying them. The most attention the incident would have received would have been a short paragraph in the local newspaper, in which the local reports might have remarked on the amazing naivety of European tourists in Hong Kong.

How I Impaled Myself on Bali

It was in the spring on 1969. I had nearly finished a project on the people of Bali; how they used to live, dance and celebrate their local festivals. I realised that my collection lacked proper coverage of the very beautiful and impressive Balinese landscape. I also wanted to make use of the beautiful light which I had already found fascinating when taking pictures of the markets in the villages or of the colourful temples. As every landscape photographer knows, direct sunlight in an open landscape produces a haze which results in poor contrast in distant shots.

After a heavy rainfall the sky was blue with nice cumulus clouds. I looked around me, the atmosphere was promising so I decided to make a trip across the island. I was assisted by a capable interpreter and guide who also drove the car. He was an older man who had been brought up in Indonesia during Dutch colonial times and although he spoke only Dutch he had no problem understanding my German. On the day in question I did not really need him for interpreting as I had no intention of talking to anyone but I knew from experience that keeping a look-out for a good picture while driving was not wise. I instructed him to keep to a steady speed of 30-40 km.p.h. all the time, except on less exciting routes when he

could drive as he pleased. Generally speaking it would be difficult to find such a patient driver as my Indonesian 'Dutchman' who was experienced in dealing with difficult visitors like myself.

We explored the island from one end to the other and we drove to the famous or — in view of its high activity — infamous volcano Agung. The local population had suffered a lot of grief and devastation, even in recent times, due to the eruptions of this volcano. I was very pleased to get the chance to take pictures of some religious ceremonies which were traditionally performed to assuage the angry gods.

We parked the jeep at a convenient place. It seemed the right spot to take a typical landscape photograph with the smoking volcano under a deep blue sky highlighted by dramatic cloud formations. I turned the polarising filter in front of my eye to check the effect. This would be even more striking if I could position myself so that the sunlight came from the side. Only 30m from the car, across a field of dwarf beans, was a small group of date palms with broad fan-like leaves. If I moved a bit closer they would present the ideal framing for the volcano in the background. My little bag with the 35, 50 and 90mm lenses was at hand together with an ASA 64 colour film and, of course, my M3.

Without further ado I jumped out of the car and started across the field in a direct line to the group of palm trees. I was to find out very soon why the driver shouted to me to be careful but at first I rushed on eagerly. I tried to concentrate on where I was treading and to walk in the barely visible furrows between the plants, but my caution was in vain. Suddenly I was forced to stop by a terrible, shooting pain in my right leg. To free myself I made another step forward with my left foot; this attempt being rewarded by a sharp pain in my left leg. I looked back at the gesticulating driver who was desperately entreating me to come back. I gingerly retracted one leg after the other from the dense growth where some knife-like objects were hidden and picked my way back very carefully along a clearly visible furrow. By now my beautifully white trousers were turning red with my own blood and my shoes were starting to feel wet and slippery.

I managed to get back to the car where my Dutchman helped me onto the back-seat. War memories of being under fire in Russia and on the Italian front and the experience of the transport of wounded comrades flashed through my mind; I had to act fast. I stuck my injured legs over the side of the jeep and pulled up the trouser legs to check whether I had suffered any serious injury. Luckily no major blood vessels were broken but I was gripped by a terrible pain.

Later I was told that it must have been bamboo spikes which I had run into, hidden in the dense undergrowth by farmers to protect their crops against thieves. I'll save you the gory details: the first-aid dressing in the next village, the ambulance to the small town, the X-ray plates, the urgent advice to seek immediate treatment to remove all the remaining bamboo splinters from my wounds and finally, back in the hotel, the injections I received to ease my ever-increasing pain.

Only a few days before this incident the manager of the hotel had proved to be real Leica fan when he showed me his brand-new M4. He also proved to be very efficient when he arranged a flight to Djakarta and from there a connecting flight to Amsterdam within the next 48 hours. At both airports I had use a wheelchair and I continued my journey to Amsterdam's Schiphol airport in this way, being very well looked after by the KLM stewards. I cabled my son from Djakarta to meet me at Schiphol with the car − it often happened that I asked for this little service when I returned after a long and usually exhausting journey.

I was pushed in the wheelchair by a steward through the luggage reclamation area and the customs hall, and I saw my son, towering above the crowd, long before he saw me.

Among the crowd of arriving passengers my son was looking for a man of average height with the obligatory beret on his head and gadget bags dangling from both shoulders but, of course, he could not see me. To minimise the shock I asked to be pushed right in front of him where I approached him from below, as it were, and after his initial reaction he saw the amusing side of the situation.

Dark Side of the Rio Carnival

I suddenly decided to fly to Rio de Janeiro for the carnival in 1977. Apart from the fact that I had never been there before, I made up my mind to go ahead and act fast because my ZEFA agency was lacking in good recent pictures of the Rio Carnival.

Until a few years ago we had a regular and reliable photographer colleague in Rio who used to provide new colour slides with Brazilian subject. It was tragic when he lost his life in an air crash over the Andes. All of us were very shocked; not just because we had lost a gifted and very hard-working colleague but also because, being relatively young, he still had so much to live for.

It was at the time of my Leica lectures that he had kept on asking me to come over to Brazil to photograph the sights of Rio at Carnival time. Now he was dead so I would have no guide to show me round.

He would definitely have been able to prevent some of the unfortunate experiences which culminated in this report on Rio's seamier side of life. I had to go to take up-to-date pictures as his work was no longer available to keep us up with the times and we could not offer our long-standing clients the same old subjects a second time round.

On arrival in Rio, I thought that armed with a testimonial composed in Portuguese describing me a "representative of a leading German photo agency" I would be welcomed with open arms. I soon noticed, however, that the relevant press agencies preferred their compatriots so I could not even count on an unrestricted press pass during the forthcoming grand carnival procession.

There is no better way to witness the climax of the Rio Carnival than from a grandstand seat. Tickets were obtainable only on the black market and the hotel porter produced one at the last minute. The price of about 100 Marks seemed a bit steep to me but I had no choice.

The city of Rio, with its population of many millions, goes completely mad for something like 100 hours at Carnival time. The grand procession is a unique show and virtually unbeatable in its splendour. Gigantic figures, made of plastic or *papier maché*, recall events from the country's history. Decorated floats, decked out with great showmanship, pass under triumphal arches festooned with garlands of flowers, while groups in fantastic costumes dance to relentless samba, rumba and bossa nova rhythms. Meanwhile the night-time venue of the procession, a street which is over two miles long and 100yds wide, the Avenida Presidente Vargas, turns into a seething cauldron of chanting, exuberant, dancing people.

These turbulent scenes bear no comparison to our carnivals back home. Biting wind in the bitter cold, freezing spectators with coat-collars turned up and bright red noses are the more likely background whilst, on the very same February day, the South American summer provides completely different ingredients. Because of the heat the procession begins in the evening and lasts throughout the night into the early hours of the morning.

That is why I had to apply different yardsticks, including my choice of photographic equipment. I had with me more than enough colour slide film, including Agfacolor CT 21 which, along with other makes like Super-Anscochrome, was one of the most sensitive colour films at the time. It was with some envy that I later saw reporters putting even faster ASA 400 negative film into their cameras. They had no need for colour slides, so essential for high-quality illustrations, for

their newspapers and magazines.

As I was working right at the frontiers of photographic feasibility with DIN 21/10 (ASA 100) film for night shots, I had secured the help of a colour lab back home that was experienced in forced development — the procedure is usually termed "pushing" in order to achieve one whole f/stop extra, or even more, in speed — so I already had the assurance of being able to expose my DIN 21/10 (ASA 100) films as if it were DIN 24/10 (ASA 200) if the light was particularly poor.

Naturally, the need to deal with night-time subjects called for fast lenses. With the Leica M2 and the shorter focal length lenses, I would have suitable equipment for my grandstand view of the street scenes. This meant the Summilux 35mm, f/1.4; the Summicron 50mm, f/2 and the Tele-Elmarit 90mm, f/2.8.

Should you, as a Leica fan, scorn my choice of camera and lenses at that time, assuming them to be "old hat", please believe me that for the predictable hubbub of people whirling and twirling in confusion and profusion being snapped under trying lighting conditions, my choice, even in 1990, would be no different. The rangefinder system is superior to any ground-glass focusing in very bad light. This was borne out when, beyond the relatively well-lit procession, with the M2 and mounted flashgun I was able to follow and focus on the glittering samba girls as they darted past.

I had taken a look at earlier Rio photos and discovered that the carnival procession in the early hours of the morning had something to offer the longer focal length lenses, so I took along my highly-regarded Leicaflex SL2 with the Elmarit-R 135mm, f/2.8 and Elmarit-R 180mm, f/2.8. The combined weight of 1,325g struck me as excessive even counting its relatively high speed.

To make up for the certainty of a sleepless night ahead of me, I decided on a quick afternoon nap. My hotel was set back from the road and proved so quiet that I did not rouse from my slumbers until 8 o'clock in the evening, instead of 6 o'clock as I had intended, so after hastily slipping into my jeans I immediately caught a taxi to the grandstand.

I hurried to the section that contained my seat in Row 4 but there was no point in trying to find it because someone else was bound to have taken it ages ago. No-one even deigned to look up at my attempt to draw attention to my rights by holding up the ticket. I was acting like the cartoon German on his first holiday in the sunny south, ranting on about law and order and shaking his head over lack of discipline when he cannot find a stalwart policeman to complain to.

A spectator nearby promptly enlightened me in broken English. "Forget your place, hurry up and try to find some space in the upper rows." Motioning with his thumb up behind him, his attention quickly back to the events unfolding on the Avenida below where samba groups were beginning to sing and dance.

"Up there" was Row 14, or even higher, which I squeezed into with restrained anger but without audible protest because at least there was a free seat. I immediately surveyed the view of the street from up there — it was bounded left and right by dense trees. This was just the beginning of my ever-deepening disappointment. Even attempts to stow my two camera bags were proving impossible and even dangerous as the board under my feet was barely 6in. wide. I could see the ground beneath quite plainly, and it reminded me of my experience as a child on the cheapest benches, right at the back, at the circus. There was no choice but to wedge one bag between my legs and somehow stop it falling to the ground and keep the other bag, containing the M outfit, on my lap as there was no room on the bench with everyone squeezed up tight against each other.

A friendly person seated next to me, who quickly understood my plight and tried to console me with some pigeon English, was very helpful. He reckoned that one or more places would become free during the night and that, if I was patient, I might even find a seat in the front row at 3 or 4 a.m. There were always some people who did not want to stay until the morning and who could leave in safety as they had their own chauffeur-driven cars standing by. To my remark that a taxi would be easier, he replied. "Taxis are few and far between on carnival nights; they are hard, if not impossible, to find." I said that I had two legs for walking which earned me a concerned and amazed look with the rebuke. "Yes, but don't you know how dangerous Rio is on nights like this — especially someone like you with all your expensive camera equipment?"

He spoke of the various dangers lurking for tourists. Every year the tally was about a hundred dead and injured, caused by accidents and fights, and the countless assaults usually committed by small gangs who mainly came from the poor districts. Sometimes this happened almost under the noses of the police. The victim, usually a lone pedestrian, would be surrounded by five or six of the muggers making it difficult for passers-by to see what was going on and forced, at knife or gun point, to hand over money and valuables. Locals knew that there would be no reprieve and quickly paid their way to freedom, but anyone defending himself or refusing to comply could end up as a statistic in the tally.

I understood and prepared to stick it out until the light of day in my photographically hopeless situation right at the back of the grandstand. There was now plenty of time to make some test measurements but then I blocked people's view as I stood in the aisle further to the front so I gave up on the idea of serious photography. However, the result of my measurements showed that exposure was possible between $\frac{1}{30}$ and $\frac{1}{125}$ sec, at an aperture of f/2, with the light of the fluorescent lamps. These measurements were only good for the distance from which I held the light meter at the scene but what good was $\frac{1}{125}$ sec in view of the seething exuberance down there on the streets! I returned to my cramped place and alternated between psyching myself into action and daydreaming about taking pictures. I felt rather like a chess enthusiast without a board, imagining a certain way of castling and cogitating over the next moves.

Using the exposure measurements just determined I knew every-thing which could be done photographically from the front rows, but I was unable to move from the seat. Instead of pointlessly trying to catch the far-too-fast movements of the samba and rumba dancers with the far-too-slow $\frac{1}{125}$ sec, with the constant dread of underexpo-sure, the inevitable blurred images could be beneficial. The idea was to make a virtue out of necessity; to conjure pictorially-beguiling blurred images with varying shutter speeds between $\frac{1}{30}$ and $\frac{1}{8}$ sec. Even so, I had no tripod and I could not contrive any form of support for my shake-free long exposures.

It was gone midnight when I felt an urgent call of nature and my friendly neighbour gave me directions to some conveniences behind a food and drink kiosk. I asked him to try and keep a space for me and because I was embarrassed about taking both camera bags for such a short journey I told him a white lie; I said I wanted to take some photos at the kiosk.

Now that I had actually arrived at the kiosk, lit by carbide lamps, it seemed that my continuing frustration was starting to turn into peckishness. I sat there, not far from the grandstand, in the wings of a seemingly carefree world, whose revelry in noise and song could be clearly heard. But at the same time I observed scenes of the bitterest poverty. Figures were on the prowl, in the dim light, for remnants of food. I saw a poverty-stricken old man who was dragging along a ragged sack in which he was collecting discarded odds and ends. He keenly gathered up pieces of wood and even old newspapers, scattered all over the ground, were stuffed into the sack. He finally swung the full sack over his shoulder and wandered off; a pitiful sight.

I stood up in order to take a closer look at my surroundings. Still dazzled by the harsh light, I inadvertently put my left foot straight into a pulpy mess which had probably derived from a discharge from the kitchen and turned into a thick slurry with the soil. I carefully extracted my foot, mindful of losing my footware, to behold a trouser bottom and shoe stuck together by the indefinable morass.

I now had to clean everything under running water, hot if possible, before I could venture again amongst people. Amongst people — did I really want to go back there — to that grandstand with the seat simply taken away from me? Into that photographic dead-end, from which there would be no redemption until the morning — that useless seat in the heights with one camera bag on my lap and the fear that the other bag might get knocked off the plank and fall to the ground?

I suddenly only had one wish; to get away from there, away from that night which had been completely pointless from the outset for my photographic intentions! I wanted to go home, or at least where I had a home for the moment — back to the hotel!

Then I conceived a plan which should have occurred to me earlier when observing the old man who vanished into the dark with the sack on his back. I wanted to walk the streets anonymously, incognito, with both Leicas plus five expensive lenses in a dirty sack. This would not appeal to the thieves and street-robbers who were indeed lurking all over the place and looking every passer-by up and down because a dirty sack wouldn't be worth anything!

In an effort not to be observed during my metamorphosis I ducked behind a wall to find myself in a back-yard in which there was nothing but rubbish; cardboard boxes, metal canisters, and empty coal sacks. I grabbed a sack and put both hands inside — they came out covered in the most effective make-up! It did not need much imagination to see how well I would be disguised if I smeared coal dust all over myself.

My black beret, a head-covering much in evidence around here, had fallen off my head while I was searching about. I found it lying in a tin of mouldy flour but its appearance now only added more credibility to my disguise.

I then made a nice upholstered nest, out of rags and wads of newspapers, in the coal sack for my leather camera bags so that their angular shape would be undetectable to prying eyes. Finally, to complete the picture, I went back to the kiosk and stuck my other foot into the muddy pulp — it came out with a satisfying "plop"!

I was now ready to return to my hotel which was situated next to

the famous Copacabana beach. I had a rough idea of how to get there because I still had the main points of the taxi ride in my head and I did have a good sense of direction. To start with, I had to keep to the festive Avenida and then turn into a street which would lead to the Atlantic, recognizable by a view of Rio's famous landmark Sugarloaf Mountain in the distance.

Not a lot happened to me on this journey, which was indeed a very long walk, extra long perhaps because of wrong turnings! No-one took any notice of me because such filthy, pitiful figures are ignored. I myself caused the only incident: a taxi for hire was coming towards me along a relatively deserted street. I realised immediately I had done it that the determination with which I jumped out from the pavement into the road to hire it, was completely out of context with my appearance. The taxi made no attempt at all to slow down let alone stop. Instead the driver swerved the taxi so that it was heading straight for me. Whether this was done to goad me or just for fun I knew not, but it was a very effective message to get out of the way − which I did with alacrity!

Finally as I drew nearer to the Sugarloaf, whose mighty silhouette stood starkly against the sky, I recognized the rest of the route back to the hotel. It was about 3 o'clock when I stood in front of the locked door of the hotel; I had taken my watch out of the Leica bag. After extracting my equipment I threw the coal sack into the gutter.

I then had to gain entry. The night porter had already seen me through the glass door and directed me back to the street with his outstretched finger before withdrawing into the interior. I fished two US dollar bills out of my socks, which I had hidden there with other money earlier in the evening, and waved the notes like a bunch of flowers. The porter's answer from his counter was merely a tired wave of dismissal whilst tapping his finger on his forehead. A gesture I seldom saw outside Germany.

It then occurred to me that in the Leica case I had the hotel card with my room number on it so I began another attempt, waving the card and pointing to the two Leicas now strung around my neck. Holding the hotel pass to the window, I pressed the bell non-stop, because the only other thing he could do was call the police.

But he came back a third time and saw the card which made him unsure because he then hesitantly unlocked the door and let me pass the card to him. His English was as bad as my Portuguese but internationally-recognized words like "photo" and "Press", backed up by my two Leicas, seemed to make it clear to him that I was no tramp. He even escorted me to my room where I showed him my

passport so that he could be sure that he had not let in a criminal.

Next morning the day porter reacted to the story of my night-time escapades with the exclamation. "They should be reported to the newspapers!"

Invitation to China

In the spring of 1983 an invitation from the official Chinese XINHUA News Agency was sent to my address at ZEFA in Düsseldorf. In this invitation I was asked whether I would give a lecture to Chinese press and professional photographers, as well as "hand-picked" amateurs, who would welcome the opportunity of assessing the quality of colour photography as required in the West. This wording contained a hidden objective that their own photographers might learn how to produce quality photographs for their own market. Up to then photographic reports had been covered only by foreign photographers and the Chinese Press Agency was keen to train their own people. It was quite natural, therefore, to invite an expert from abroad in order to be able to export their own pictures in the future.

How they came to choose me became clear after a while. A small delegation from the Peking Agency XINHUA had been told by the London branch of ZEFA that their Chairman was still alive and that he used to give interesting lectures with slides about colour photography before starting the ZEFA agency 25 years ago with his stock of 4000 colour slides.

I reacted with a spontaneous affirmative to the question of whether I was interested in delivering such lectures in China. With the best will in the world I could not speak Mandarin so it was agreed that I would give my commentary in English which would be simultaneously translated into Mandarin.

The XINHUA Agency had very little experience in how such a lecture was delivered and the type and volume of the information that it contained. Their hazy suggestions reminded me of a few other clients' vague instructions to our photographic agency to "show a small section of slides of beautiful landscapes and typical views of cities all over the world".

We had some 700,000 colour slides available in the ZEFA archives so it was no problem to put together a lecture tour in China. I finally short-listed about 1000 with the assistance of the highly-trained women working in the archives. These were, of course, of the best photographic quality: with saturated colours, extremely sharp, and with excellent composition. Above all I had to choose subjects that

would be eye-catching and have a broad public appeal. In the end I presented a series of slides which would have been equally suitable in Western countries so as to satisfy the audience's demands regarding quality and variety.

Not all the short-listed pictures were 35mm slides. About 40 slides in the final selection of 300 were in 6x6, 6x7 and 6x9cm formats. The 6x6cm slides were reduced to quite reasonable 4x4cm slides mounted between glass in 5x5cm frames. Thanks to improved laboratory techniques the others could be reduced to technically-perfect 24x36mm slide duplicates. The proportion of original Leica material was considerable and borrowed from earlier lecture collections. My usual slide projection technique ever since 1953 involved using two slide projectors and two screens so that I could demonstrate comparisons to the audience. The ability to make comparisons was absolutely necessary for my lectures and my method had been part of the reason for my invitation to China.

When I had put together the 300 slides for the lecture tour it became obvious that in order to keep within the 90 minutes time limit, I would have to show some of the slides in quick succession as a small series. The Pradovit projectors make such fast sequences possible.

A bigger problem was the rather cumbersome method, suggested by the Chinese, of simultaneous translation of the English text. This gave rise to considerable discussions with Beijing. What seemed quite strange was that the people at XINHUA insisted quite stubbornly on the idea of simultaneous interpretation. My argument that even a strictly condensed English text, together with an equally strictly compressed Chinese translation, would extend the duration of my lecture to at least 130 minutes was of no avail. To my mind the proposed process would make it impossible for the lecture to achieve its purpose of explaining how to produce better pictures.

The dispute was finally settled by a simple ploy: I stopped making any more comments. I followed my own advice — he who asks a lot, gets a lot of answers. I decided to force the Chinese agency's hand to make the right decision and worked out the following plan. My text had to be translated into Mandarin, the language of the intellectuals and scientists, and this should be recorded on a tape.

Thanks to contacts with journalists in Bonn, I heard of a Chinese interpreter who had emigrated from China a long time before the Mao era. He recommended a female announcer who worked for a German radio station; she was a wonderful speaker and her daily announcements could be received as far away as China. It goes without saying that she spoke Mandarin. The manuscript for a 90

minute talk delivered in Chinese comprised sixty pages of hand-written Chinese symbols. Thanks to the direct translation it contained some really useful information on photographic technique. We then had to place electronic markers on the tape at suitable points to indicate exactly the sometimes very quick slide changes. The charming Chinese speaker, who spoke fluent German, first listened to my German lecture, with simultaneous projection of the slides, to understand at which points of the Chinese version to place the markers to cue the tape; this was a very difficult but essential task and kept us busy until just before my departure.

On the day of my arrival in Beijing I was showered with protests from the XINHUA agency, who insisted on the originally-agreed procedure. I suggested I be allowed to present my slides with the taped Chinese commentary to a competent consortium of the Chinese agency for their approval, and I promised that I would be bound by the final decision of this body. I set everything on this, my one and only argument; the well-prepared and concise tape-assisted lecture. To put my guests at ease, I invited the 12 members of the consortium into my spacious hotel room which I had blacked-out with two woollen blankets hung over the window. I managed to deliver the show with two Pradovit projectors and two bed sheets as screens in an almost perfect professional manner.

During a short break when I changed the magazines over, one of the delegation, a leading and influential personality, stood up and came towards me with his hand outstretched and a sideways glance at his colleagues as he said. "I have no objections, the text is good, the language is good and so are the pictures." The rest of the consortium applauded their agreement – I had the go-ahead I had worked so hard for.

When I had selected the pictures for my talk I had been careful not to include provocative or ostentatious pictures of Western prosperity. I excluded luxury cars and private swimming pools, fashionably dressed or undressed girls. I had to avoid a confrontation between consumerism and communism. On the other hand, my lecture had to demonstrate examples of technical points such as good and bad exposure or integral and selective exposure metering.

The Matterhorn in Switzerland, a well-known sight even in China, represents a wonderful example for selective metering with its distinctive peak rising from the dark valley in the bright morning sun. Many subjects were popular in China, such as Tower Bridge, the Eiffel Tower and the Acropolis, and they all helped to stimulate the audience and lighten the otherwise technical tone of my lecture. A

5m-wide projection of a really good shot of the Great Wall of China was particularly well received and earned me a spontaneous round of applause. I managed to convey the feeling of an all-embracing common factor as the essence of the many examples, despite the different technical points they were making. They all had one thing in common: regardless of how far technology advances and how far we can progress in our creative endeavour, it is always the person behind the camera who is the decisive creative mover, his human endeavour forms the essence of the picture.

Snapping Up the Projected Images

My audience had been selected by the strict criteria of the Chinese press agency. Some of the visitors had come well prepared with several tripods erected in the auditorium, demonstrating the intense interest that my visit had generated. A few really clever ones even flashed the images on the screen. Well, I did not want to spoil their fun but I wondered whether I should tell the interpreter to instruct them on the pointlessness of their action, but decided against it because the loss of face might have been more embarrassing than their failure to get a picture.

On each of the three days, when we started the lecture in the hall at 9 o'clock (in the morning I'll have you know!), there were 1200 people already sitting there in anticipation before the applause to welcome this visitor from far-away Europe, which required the speaker to participate, as in Russia. When I started to project the slides on the 5m-wide screen the tense silence conveyed a kind of resonance and the audience seemed to hold its breath, interrupted occasionally by a suppressed groan. The intense interest was almost tangible when I showed sights they had never seen, for example, a Hawaiian surfer poised on the crest of a wave illustrating the incredible force of the water, or the Sphinx at Gizeh, taken by a long exposure, in the full moon. My short reference to the reciprocity-failure effect may have registered with some but it was generally ignored.

I would like to point out, however, that despite their obvious delight and admiration at the sights I could show them, my Chinese photographer friends were in no way ignorant about photography in general, nor did they accept everything unreservedly.

The critical appreciation of my audience became obvious when I showed them some slides that I counted amongst my favourites because of their technical brilliance. These pictures were immediately

recognized for their high quality, which was confirmed by the loud clicking of cameras in the hall. Funny animal pictures or childrens' portraits were greeted with spontaneous laughter, which quickly relapsed into silence again because it was important to hear and understand everything. Naturally we could not have foreseen and included pauses for laughter in the text when it was originally edited at home.

After one of my lectures I had the opportunity of speaking to an English photographer who was attached to some diplomatic body. He explained that colour slides of such excellent quality and brilliance, projected to such a size, were completely unknown there because it was inconceivable that anyone would have a slide projector in their tiny flat. It was a completely new experience to the people there and their mouths literally hung open with astonishment!

In response to some urgent requests we staged another show at the University which was attended by about 2200 students, including some people from third world countries, and this occasion was a lot noisier. When I took my lecture to Shanghai we had to immediately announce two more dates to accommodate the great interest.

When I returned home I received a letter from China which read. "...your slide presentations have aroused great interest among photographers. We have received many requests from various units in Beijing and other parts of China eagerly demanding presentations of your slide show. We would be obliged very much if you send back the slides and recording tapes to us..."

EPILOGUE

Paul Wolff did not live to see the rangefinder Leica M3, and he would have had to have reached an age of more than 75 years to hold the first Leicaflex in his hands. The great authority which he wielded in the evaluation of the Leica system and its possibilities in those early days makes one wonder whether Wolff would have preferred to exploit the versatility of the modern reflex camera or to remain faithful to the rangefinder. I believe he would have done as I have done for many years.

I was brought up in the "school of Wolff" and I cannot help carrying his principles constantly in my mind. For some years now I have counted the Leica M6 among my friends because of its lighter weight and its quietness. The minimal equipment in a relatively small bag is almost always at my side. The handy shape of the M6 reminds me vividly of the first Leica I handled in 1930 — the Model I, but without the raised "finger" of the FODIS rangefinder. The range-finder is not the only thing which has been most elegantly built-in for some decades now. The built-in exposure meter saves me valuable time. I can pull the M6, complete with the little 35mm Summicron, from my pocket as discreetly as I could my Leica III 60 years ago. Being used to handling a large range of focal lengths, it took me some time to appreciate that a photographic outfit selected for minimum weight can be very useful: it forces one to concentrate. Together with the 28mm, f/2.8 Elmarit-M, the 35mm,f/2 Summicron-M and the 75mm,f/1.4 Summilux-M, my M6 sits in a small bag 25x25x12cm. When travelling on foot, I do without any further equipment. Sometimes the lack of a wider-angle lens bothers me, so I move the day's allowance of film cassettes and smuggle the 21mm,f/2.8 Elmarit into their space. The 21mm frame is not included in the fabulous bright-line viewfinder of the M6, so the special separate finder remains on top of the camera or, as befits its high value, rests in a special little leather bag.

When plenty of space and a car are available, the Leica R4 may come along, and with it the 100mm,f/2.8 Apo-Macro-Elmarit-R, the

135mm, f/2.8 Elmarit-R. In addition to these, the 2× Extender-R lives in a corner of the big and not exactly light-weight bag. And of course it would be a great mistake to take such incredibly versatile equipment without a solid tripod.

These somewhat conservative recommendations, especially the advice on the limited Leica M6 outfit, are to some extent due to the author's age. He hopes to celebrate his 78th birthday by the time you read these lines.

You may have noticed that I have sometimes used the term "Leica-format" rather than, say, 35mm. This seems to roll off my tongue much better and means more than just the format of the 24×36mm film. The emulsions of 35mm film have been tremendously improved since the days when Oskar Barnack used it in his prototype Leica. New emulsions, with a film speed of ISO 50, are being introduced in 1990 which will be far superior in sharpness and grain to anything previously available.

The wheel has turned full circle in sixty years. My early work with Leitz was to spread the gospel about the benefits of using Leica-format. At first this was a struggle until it began to be fully appreciated. But, looking back, I can see what I worked for has been achieved and editors are now accepting 35mm transparencies as the norm.

Transparencies which I put into the ZEFA archive, when I set it up 30 years ago, are still being used in many worldwide applications. My son, Klaus, with his tremendous enthusiasm and his speciality – he is a "people" photographer – has also added to one of the most up-to-date and actively-used pictures libraries in the western world.

New technology will change the way that colour pictures may be reproduced and distributed in the future. In the meantime digital image recording has been developed and it is even possible to produce original images by this technique. This means that a totally new image can be produced from several picture components. This new, digitally-stored image can then be transmitted by data communication (ISDN) and sent almost instantly to any part of the world. As a result a picture agency such as ZEFA can communicate and serve customers world wide by making their products available internationally.

BENSER LECTURES - 1956

DATE	CITY AND STATE	LECTURE HALL	TIME
Feb. 13 -	Norfolk, Va.	Monticello Hotel	8 PM
" 14 -	Charleston, S.C.	Rivers H.S. Aud.	8 PM
" 15 -	Atlanta, Ga.	Dinkler-Plaza Hotel	8 PM
" 16 -	Nashville, Tenn.	Peabody College	8 PM
" 17 -	Memphis, Tenn.	Goodwyn Institute	8 PM
" 20 -	Houston, Texas	Univ. of Houston	8 PM
" 27 -	Tucson, Arizona	Tucson H.S. Aud.	8 PM
" 28 -	Phoenix, Arizona	W.Phoenix H.S. Aud.	8 PM
Mar. 1 -	Albuquerque, N.M.	Albuquerque H.S.Aud.	8 PM
" 5 -	Pasadena, Calif.	John Marshall Jr.H.S.	8 PM
" 6 -	Long Beach, Calif.	John Evans,Jr. H.S.	8 PM
" 7 -	San Diego, Calif.	Balboa Park Recital Hall	8 PM
" 8 -	Burbank, Calif.	John Burroughs,Jr.HS	8 PM
" 9 -	Santa Monica, Calif.	Santa Monica City Col.	8 PM
" 13 -	San Francisco, Calif.	Nourse Aud.	8 PM
" 16 -	Oakland, Calif.	Oakland Aud.Theatre	8 PM
" 21 -	Portland, Oregon	Oriental Theatre	8 PM
" 23 -	Seattle, Wash.	Palomar Theatre	8 PM
" 27 -	Seattle, Wash.	Univ. of Wash.Campus	8 PM
" 29 -	Spokane, Wash.	Masonic Temple Aud.	8 PM
Apr. 3 -	Salt Lake City, Utah	South H.S. Aud.	8 PM
" 6 -	Denver, Colo.	Denver Museum of Natural History	(7 PM (9 PM
" 9 -	Colorado Springs,Colo.	Col. Springs Fine Arts Center Aud.	8 PM
" 11 -	Lincoln, Nebraska	Lincoln H.S.	8 PM
" 12 -	Omaha, Nebraska	Technical H.S.	8:30 PM
" 14 -	Des Moines, Iowa	Des Moines Women's Club Aud.	8 PM
" 16 -	Minneapolis, Minn.	North High School	8 PM
" 17 -	St. Paul, Minn.	Central H.S. Aud.	8 PM
" 18 -	Milwaukee, Wisc.	Hotel Antlers	8 PM
" 19 -	Peoria, Ill.	Masonic Temple Assn.	8 PM
" 20 -	Springfield, Ill.	Hotel St.Nicholas	8 PM
" 23 -	Chicago, Ill.	Oriental Ballroom	(7 PM (9 PM
" 24 -	South Bend, Ind.	Central H.S. Aud.	8 PM
" 25 -	Detroit, Mich.	Detroit Institute of Arts	(7 PM (9 PM
" 26 -	Flint, Mich.	Homedale Elementary School Aud.	(7 PM (9 PM
" 27 -	Grand Rapids, Mich.	Fountain St. Baptist Church Sanctuary	8 PM
" 29 - (Sunday)	Indianapolis, Ind.	Murat Temple Theatre	2:30 PM

BENSER LECTURES - 1956 (Cont'd.)

	DATE	CITY AND STATE	LECTURE HALL	TIME
KENNEY	May 1	- Louisville, Ky. ₂₀	Henry Clay Hotel	8:30 PM
	" 2	- Evansville, Ind. ₂₁	*CENTRAL H.S. AUDIT.*	*8.00 PM*
	" 3	- Cincinnati, Ohio	*EMERY AUDITORIUM*	*8.00 P.M.*
	" 4	- Huntington, W.Va. ₂₂	The Woman's Club	8 PM
	" 7	- Columbus, Ohio	East High Aud.	
	" 8	- Toledo, Ohio	Macomber Voc. H.S.	8 PM
	" 9	- Akron, Ohio	*UNIV. OF AKRON*	*8 P.M.*
	" 10	- Erie, Pa. ₂₃	Strong Vincent H.S.	8 PM
NAYLOR	" 11	- Buffalo, N.Y. ₂₄	Buffalo Municipal Aud	
	" 14	- Rochester, N.Y.	*COLUMBUS CIVIC CENTER*	*8 PM.*
	" 15	- Johnson City, N.Y.	Endicott Johnson E.Br. Rec. Center	8 PM
	" 17	- Boston, Mass. ₂₅	John Hancock Hall	8 PM
	" 18	- Springfield, Mass.	Technical H.S.Aud.	8 PM
MORAN	" 21	- New York, N.Y. ₂₆	Hunter College - Assembly Hall	8 PM
	" 22	- Brooklyn, N.Y.	Brooklyn Academy of Music	8 PM
HUISGEN	" 23	- Reading, Pa.	Rajah Theatre	8 PM
	" 24	- Harrisburg, Pa.	Scottish Rite Cathedral	8 PM
	" 25	- Washington, D.C. ₂₇	Geo.Wash.University	8 PM
	" 28	- Baltimore, Md. ₂₈	The Alcazar	8 PM
	" 29	- Wilmington, Del. *HACKENSACK, N.J.,*	*STATE ST. SCHOOL*	*8 PM.*
	" 31	- Philadelphia, Pa.	Bellevue-Stratford	8 PM

58 VANCOUVER B.C. 30
59 Toronto To 31
60 Ottawa 32
61 Montreal 33
62 Staudte Midland 34 Staudte

Hy Becker
E. LEITZ, INC.